INTERVIEW BY
LOU REED

MARK SELIGER

ESSAY BY
MATTHEW BARNEY

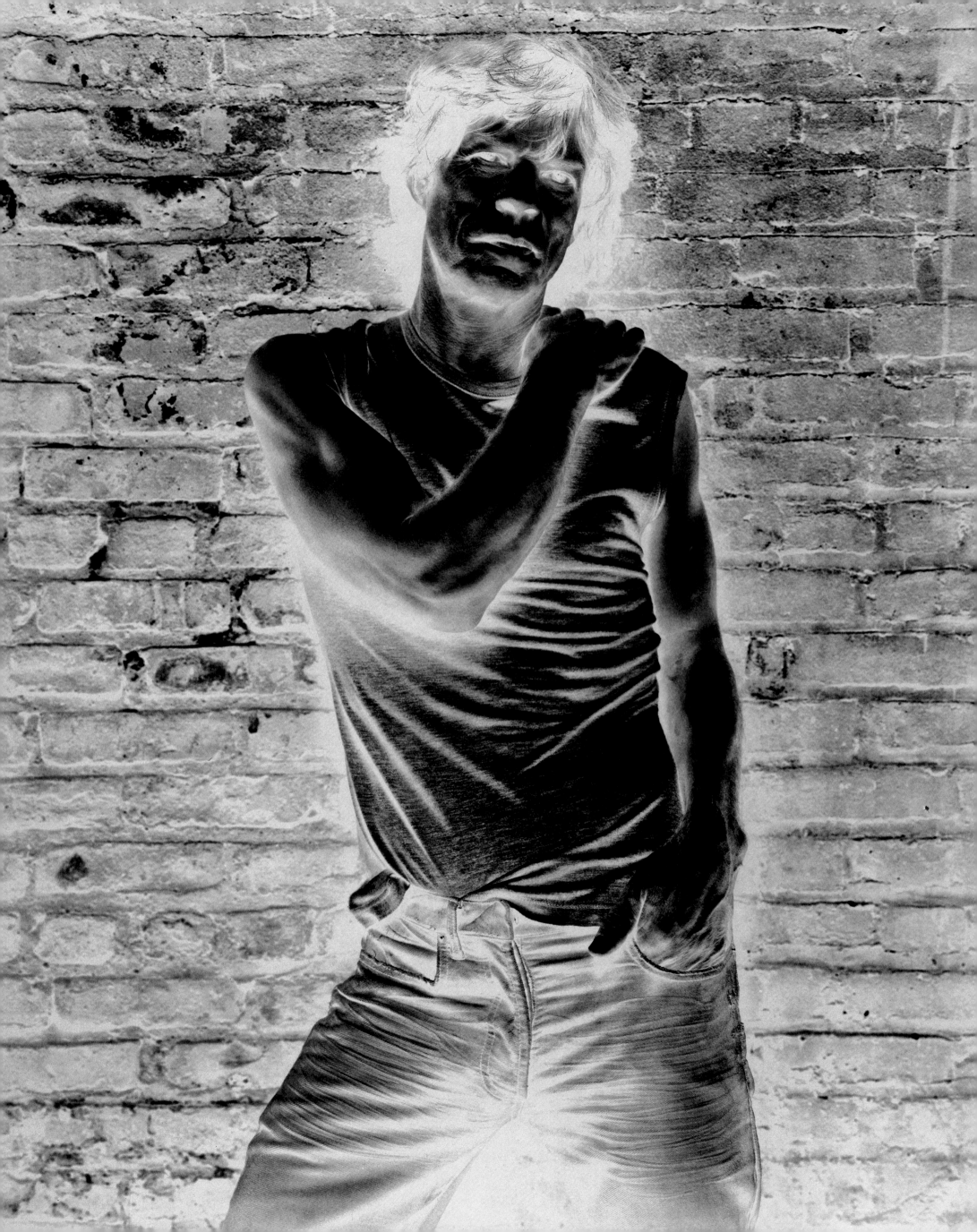

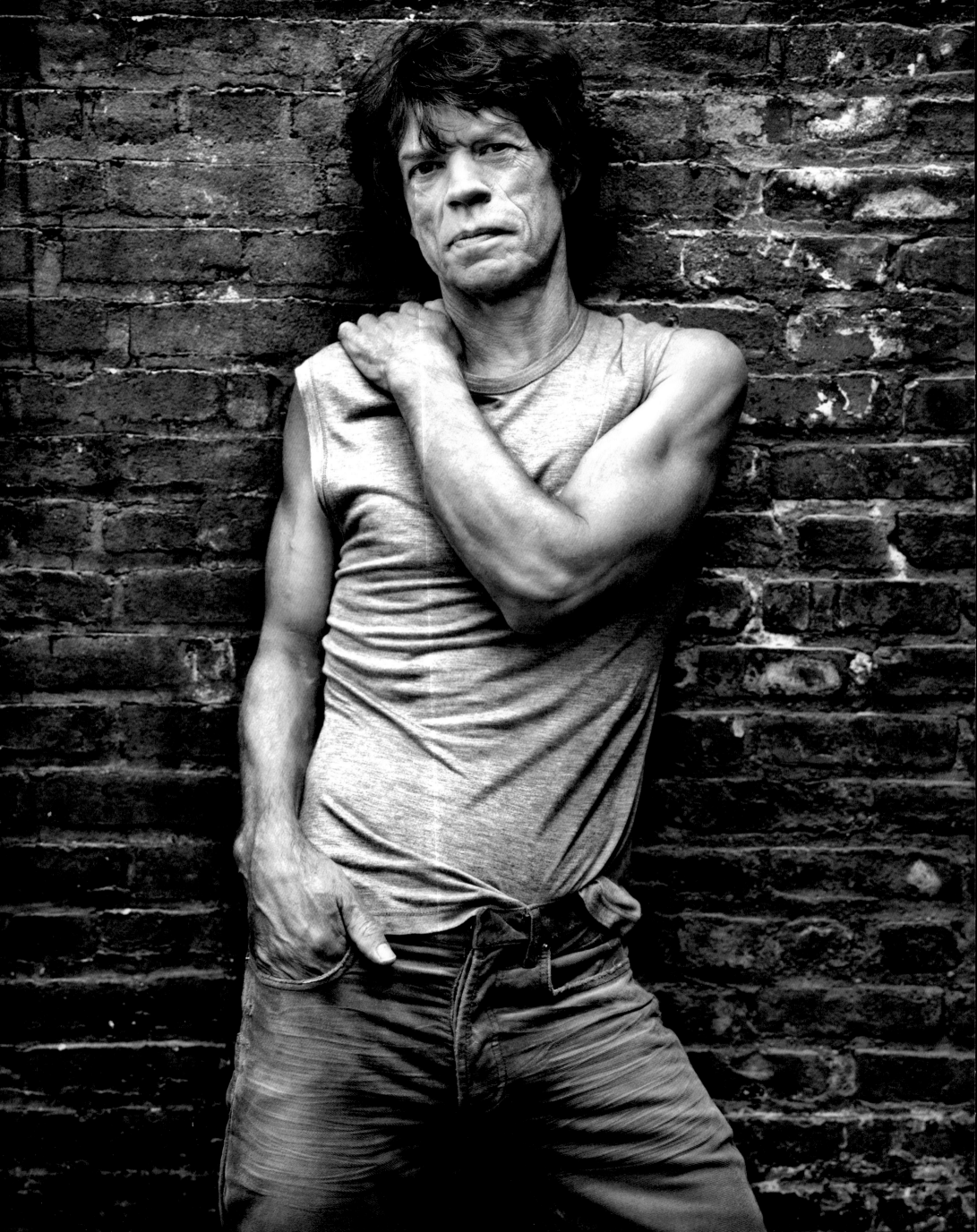

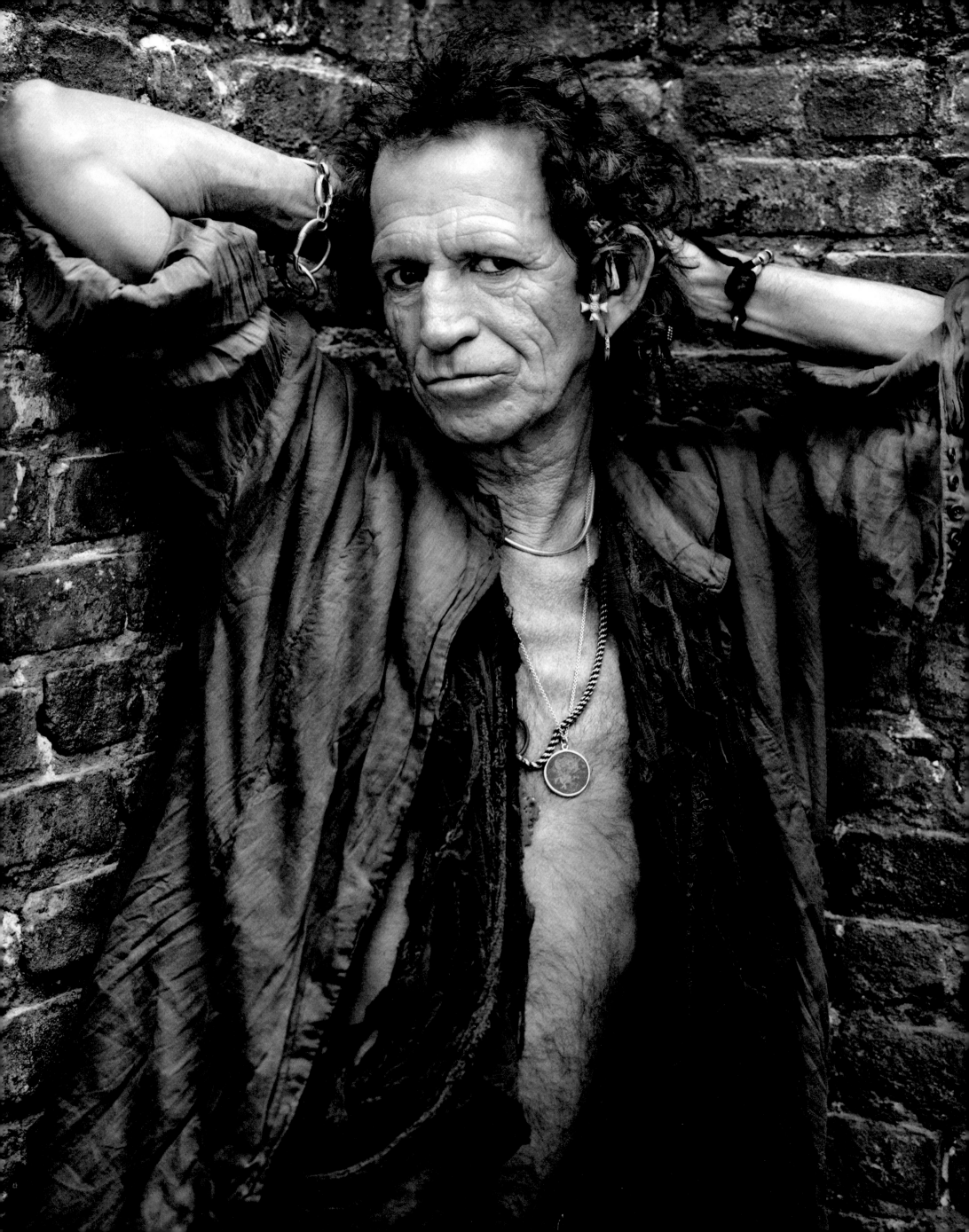

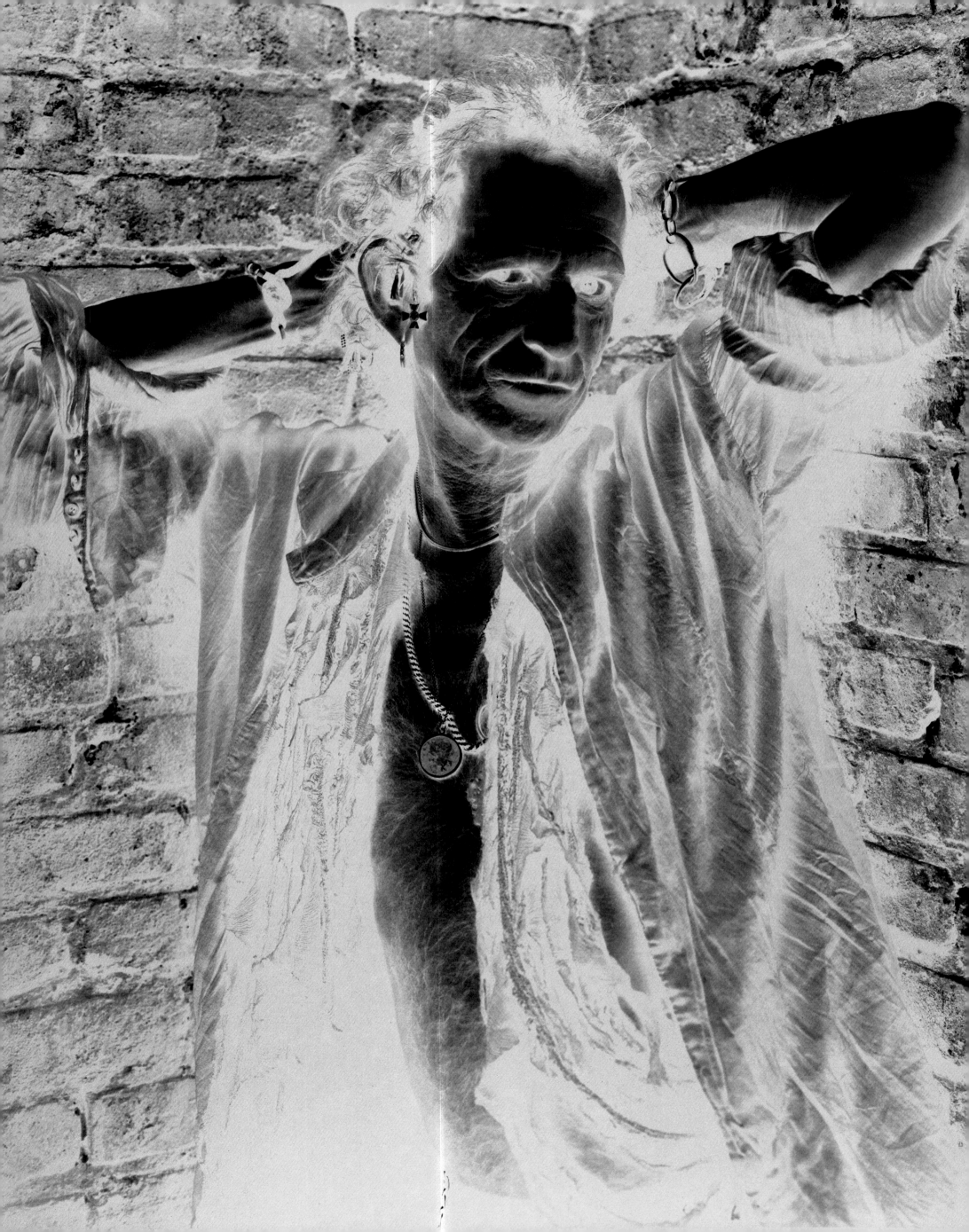

RIZZOLI NEW YORK

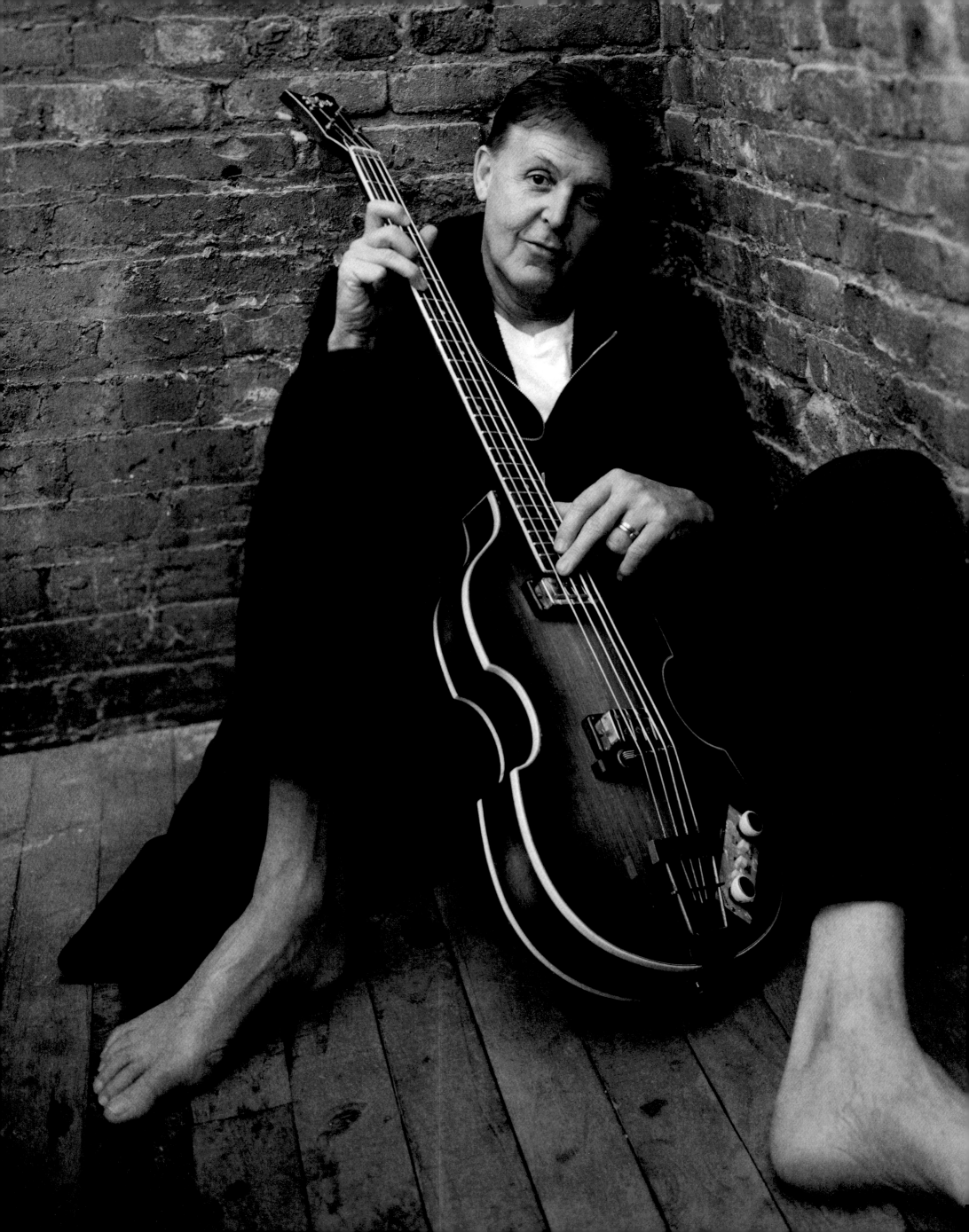

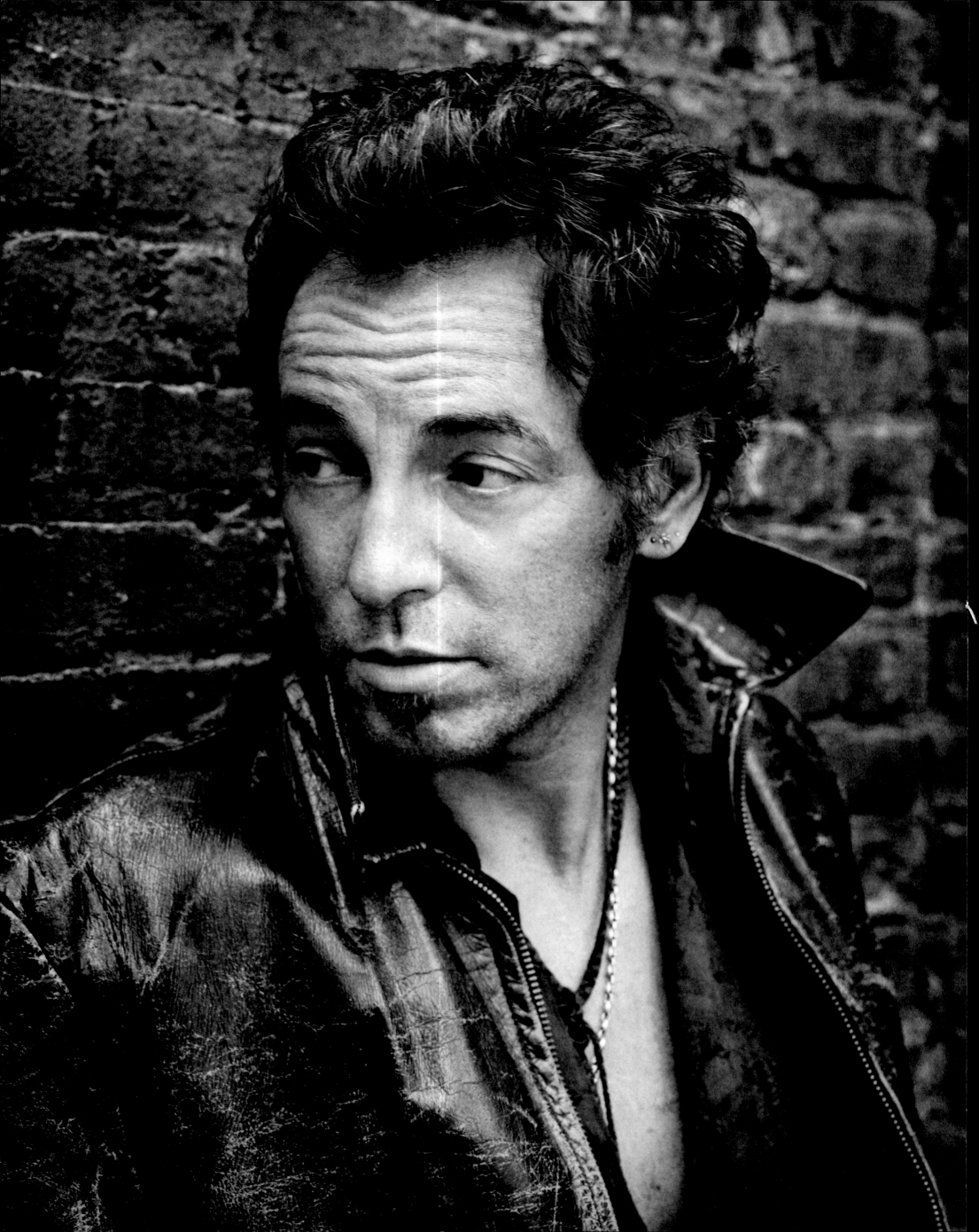

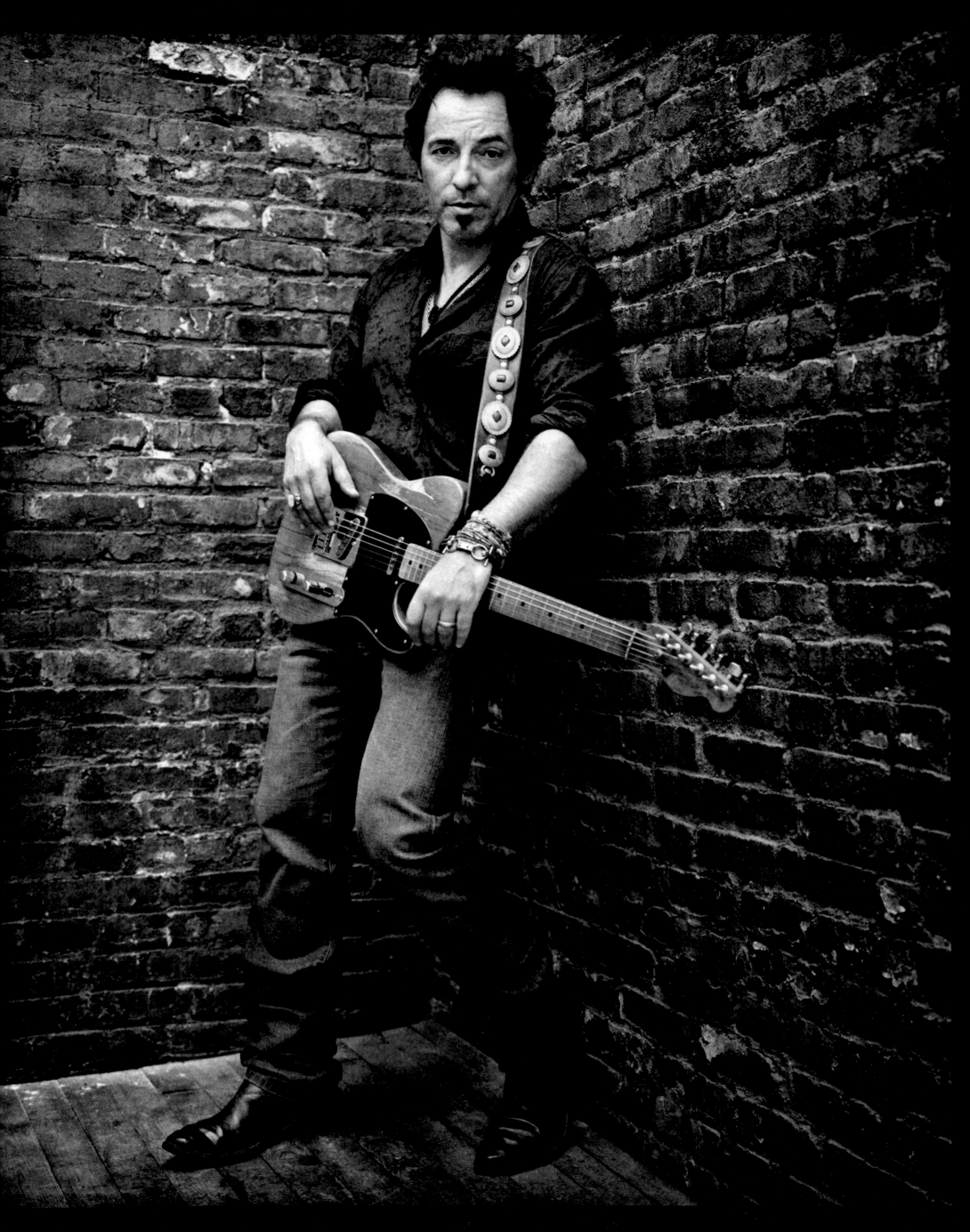

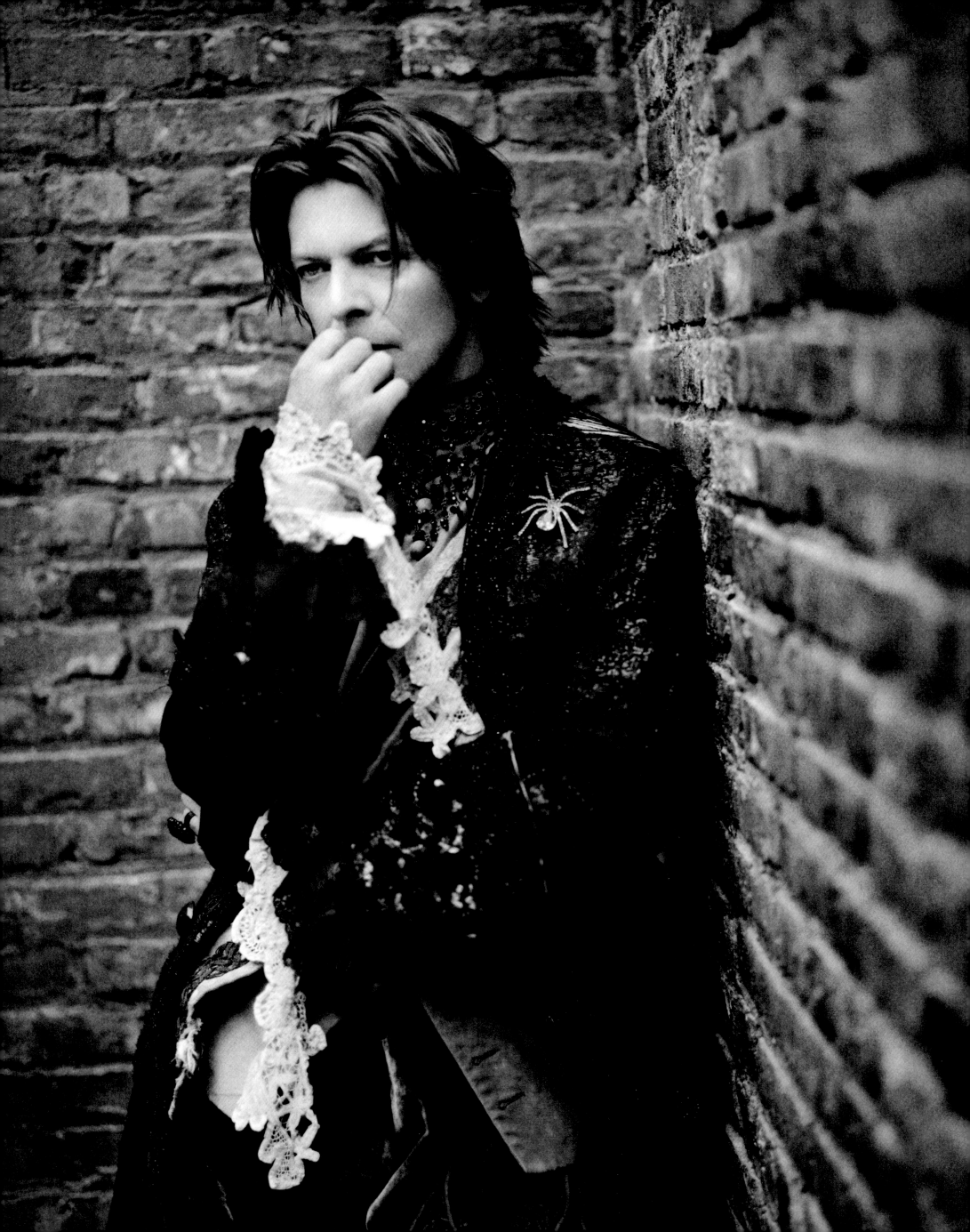

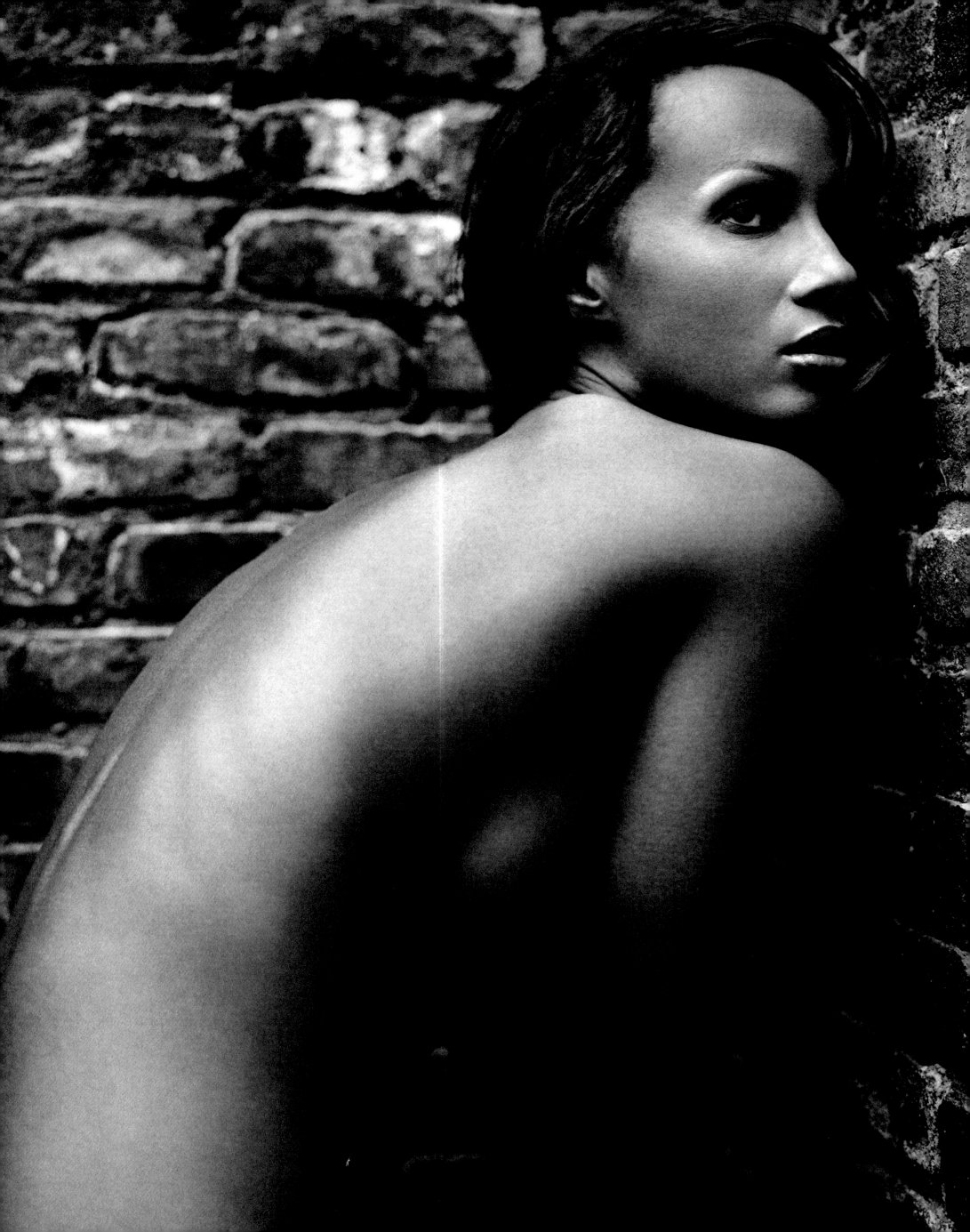

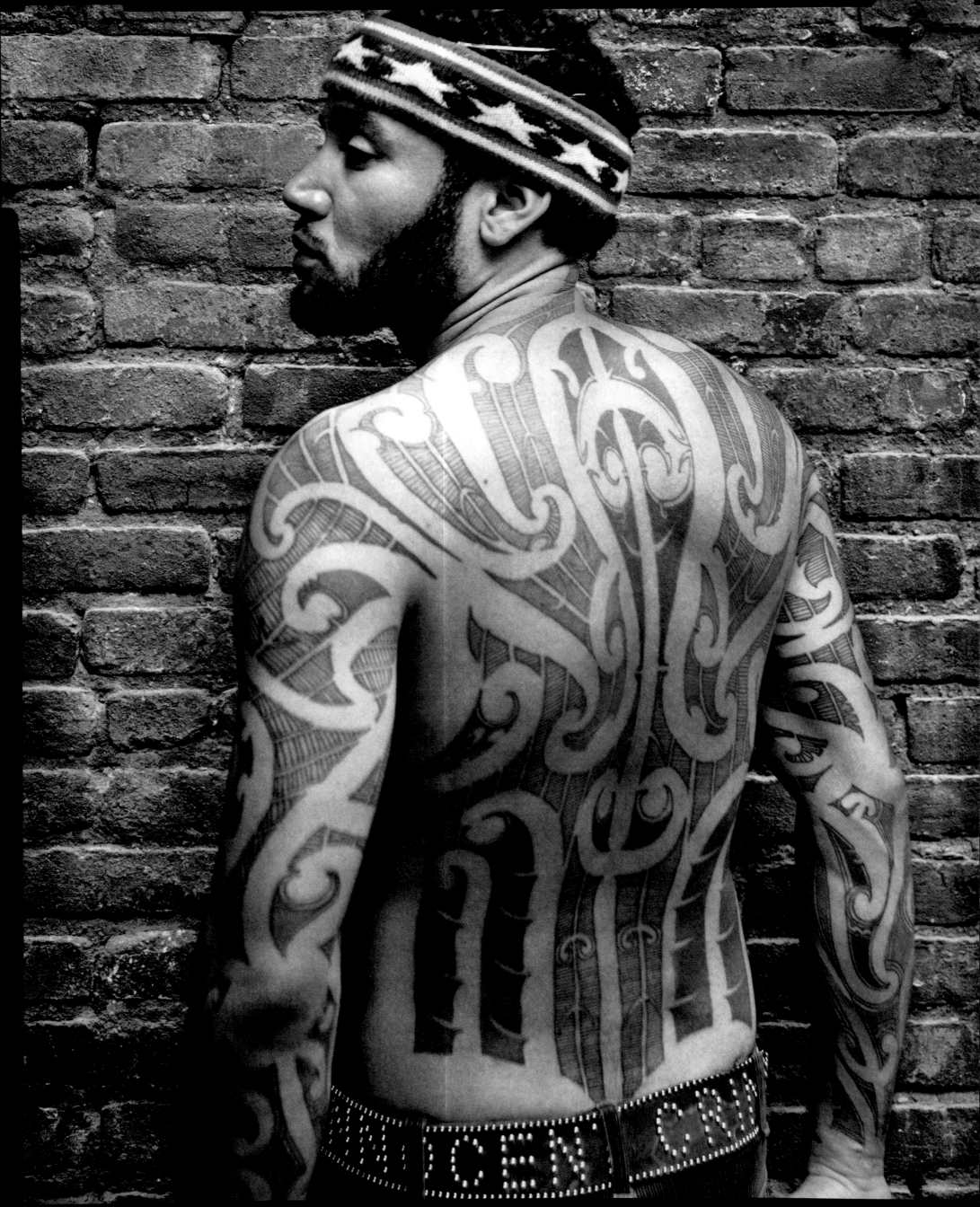

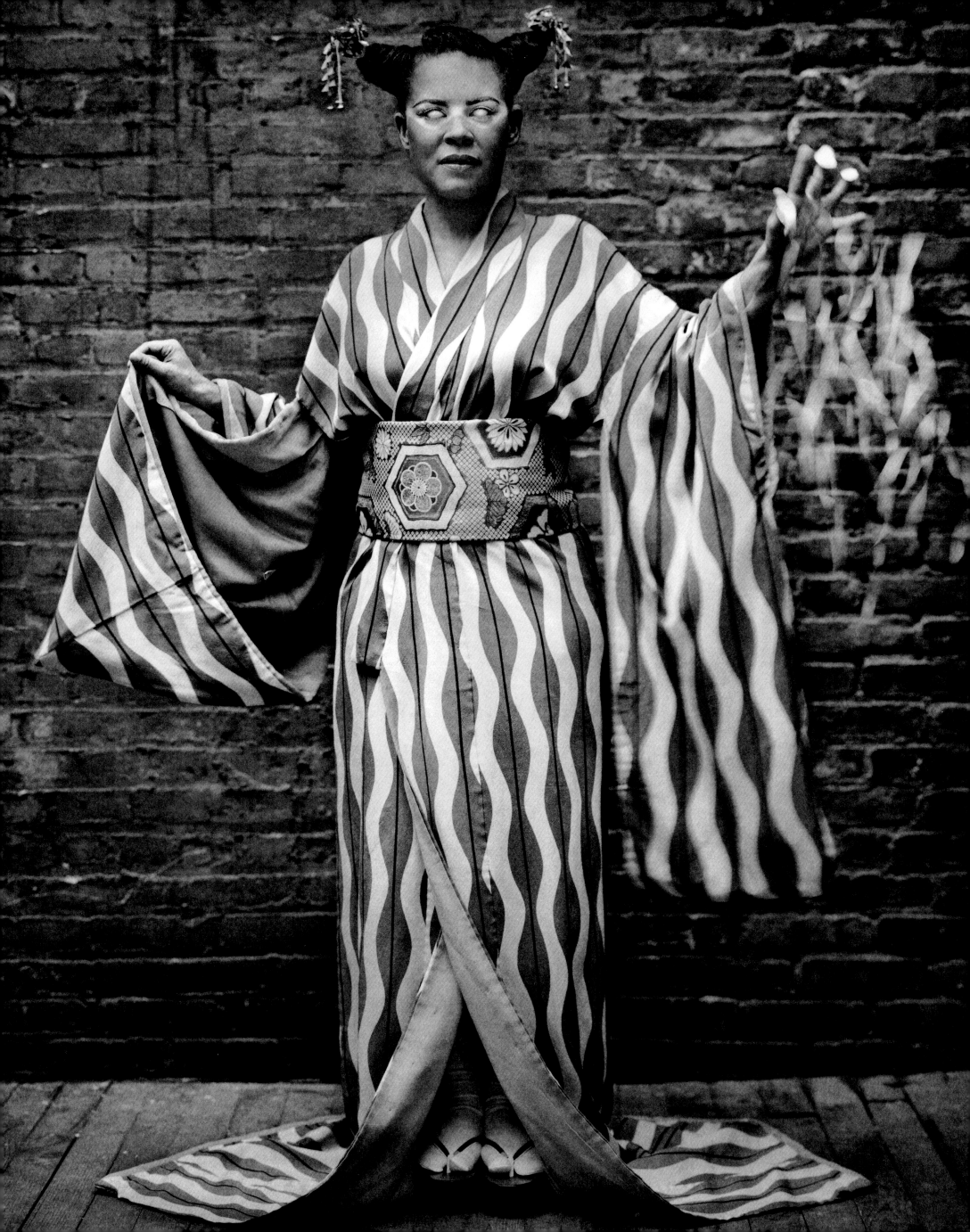

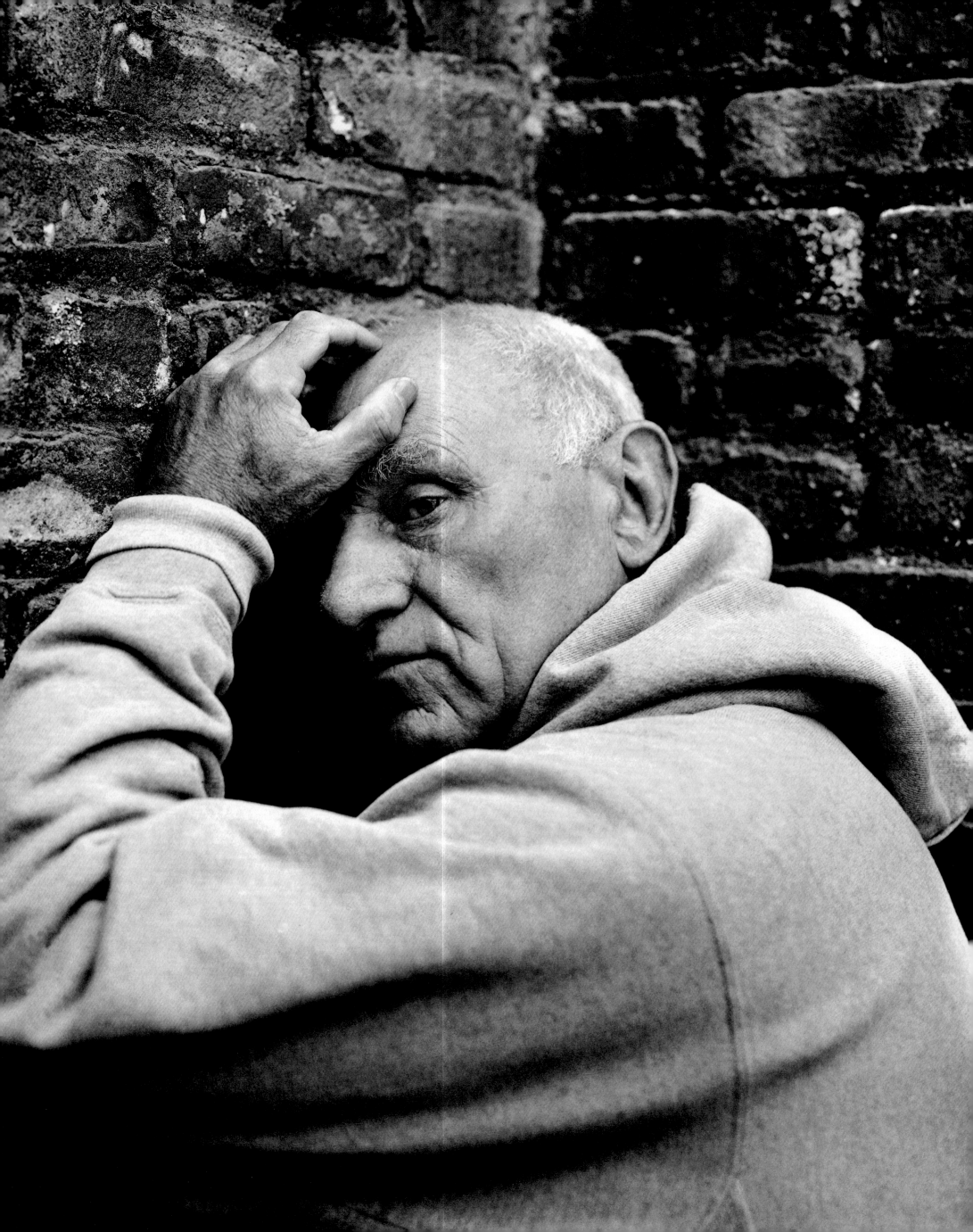

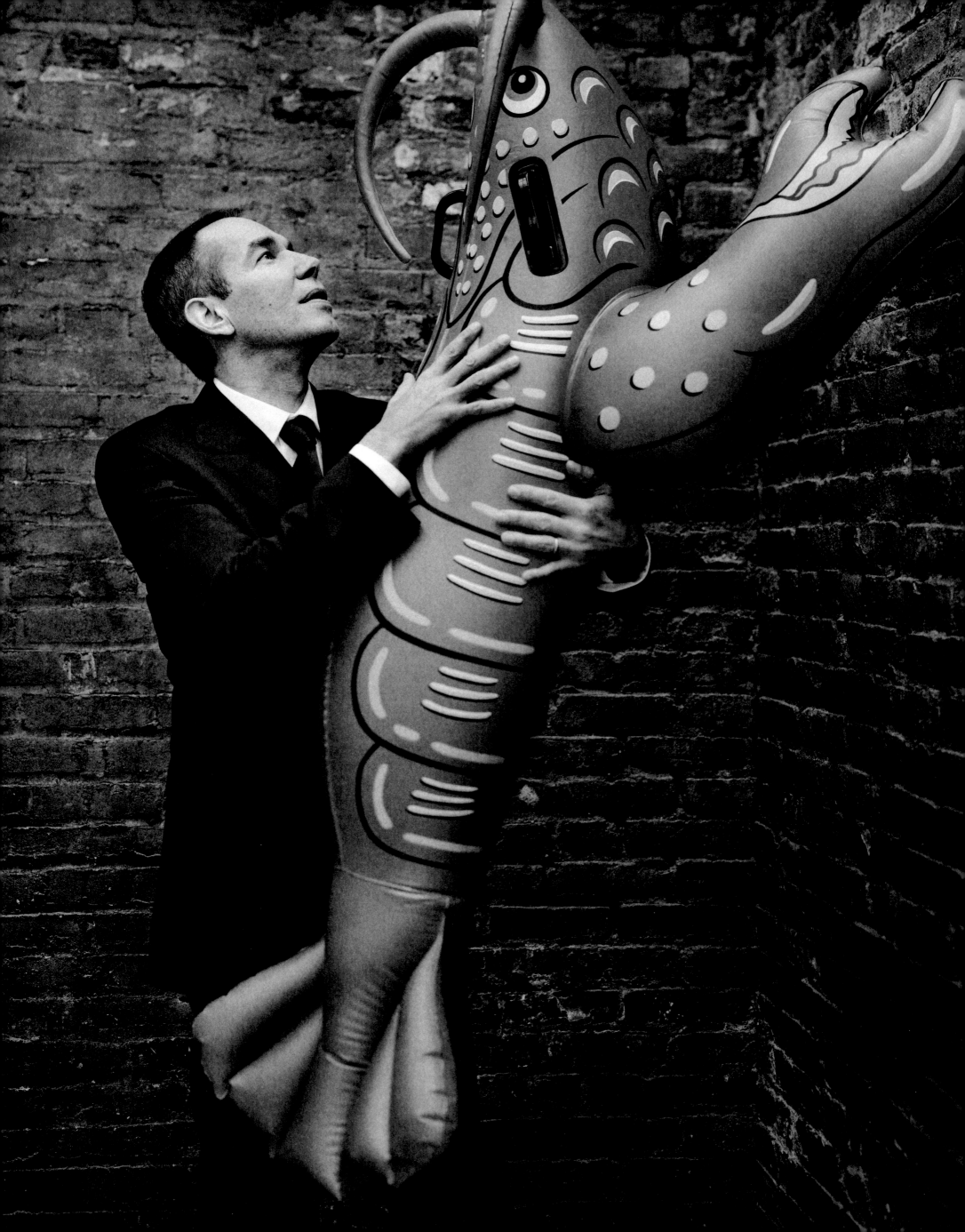

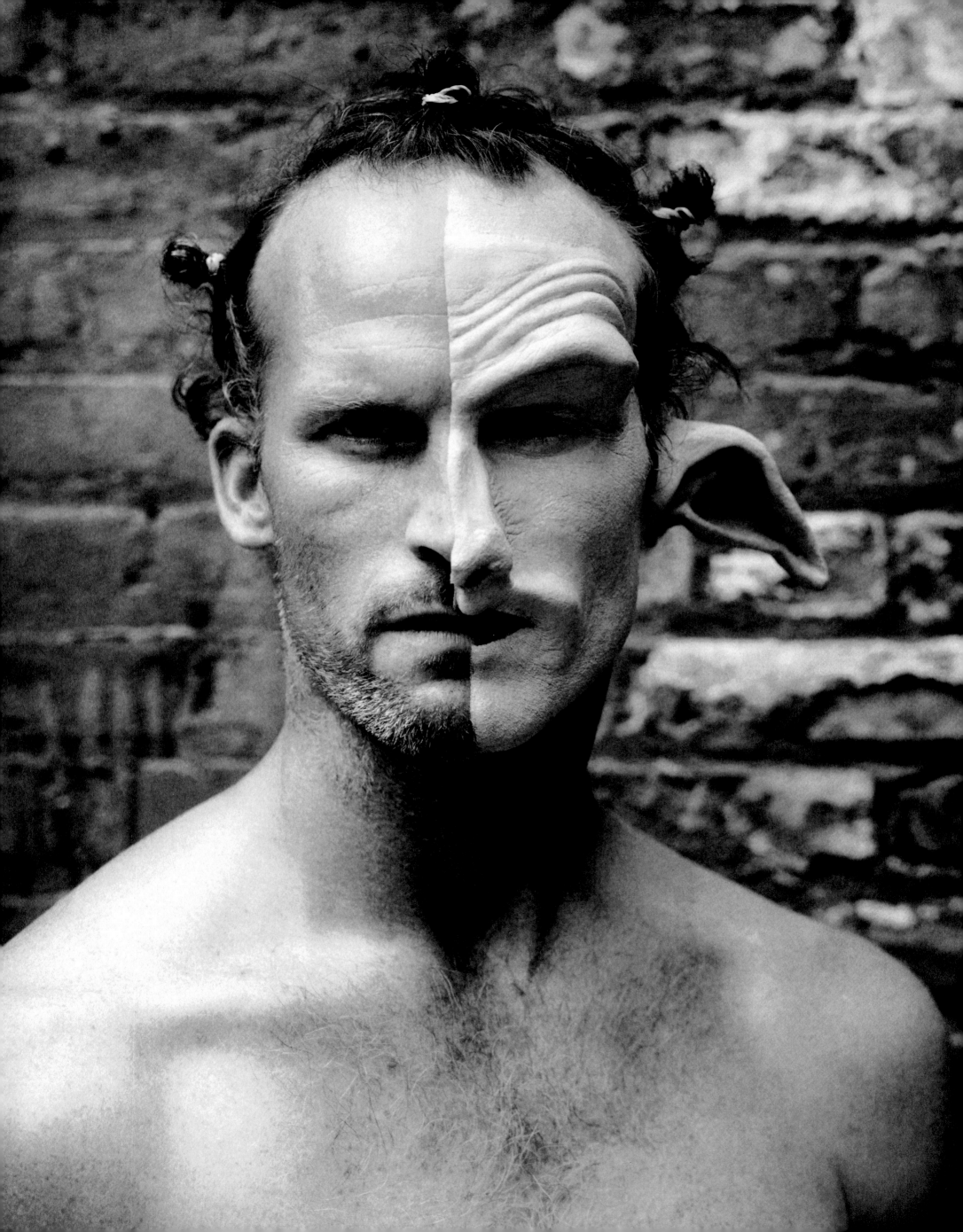

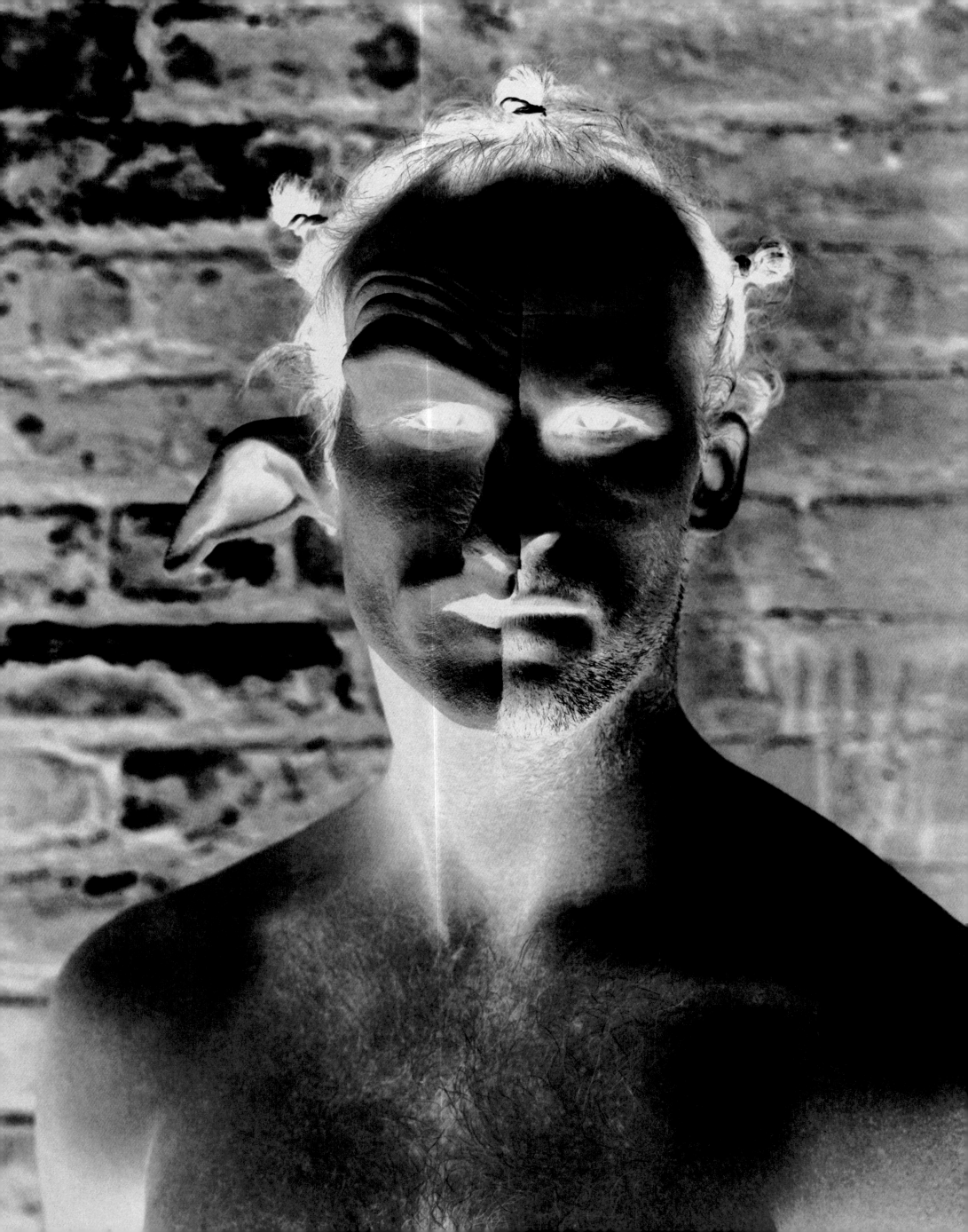

MATTHEW BARNEY

FROM PHOTOGRAPHY TO FOOTBALL:
MARK SELIGER AND MATTHEW BARNEY
DISCUSS THE ART OF RESTRAINT

MARK SELIGER: One of the great challenges of this book was tailoring each photo in order to accommodate the great range of individuals I worked with. Sometimes the shoots were conceptual and other times they had more to do with how the subjects viewed themselves rather than how I viewed them, and that was equally as interesting. In certain cases I had a very clear idea of what I wanted to say, and other times, it was much more intuitive or improvisational. When I go into a project, I am dealing with what I essentially experience as a blank canvas and I was wondering what that process is like for you?

MATTHEW BARNEY: Getting started for me always starts with a place. I can't really get started until that place is established. And once it is, I guess I go, somewhat like a tourist, to that place and try to learn as much about it as I can. From that point it is about bringing to that place all of the things that are already within my language, and then trying to inform them with all of the things that that place provides. Objects tend to come first, objects that are informed by the local mythologies of the place. Often that happens before the story is developed. It all happens very slowly. The research entails finding things that exist in the world, and hybridizing them—taking aspects of different objects or ideas, and grafting them together into hybrids. I would say in a lot of cases those hybrids eventually develop into characters. Insofar as filmmaking is concerned, that path has been very organic for me. It started by making simple performances and videotaping them. And, as that tradition tends to be, those tapes were real-time, and as a result, were pretty honest. These pieces were performed, but they weren't performed for an

audience and I taped them just to document what was happening. They were performances in a sense that they were about activating a space, or activating objects within a space. And that developed slowly into wanting to modify those tapes. I started editing them with the intention of leaving behind an aftermath in the spaces that had been activated by these performances, and for that aftermath to function as sculpture. I started to think about how the video had been used, as a way of describing what had been happening in a truthful way, but then started to think about how that could be undermined by editing something, and how it could complicate the space you are standing in to make it not quite clear what had happened. That started to become something along the lines of storytelling in a sort of abstract way. And from there, it was like a game of add-on, you know. It was like every project I did became more and more driven by that desire to tell a story rather than driven by the desire to tell the truth.

MS: I knew I wanted to give this collection a sense of consistency and I figured out, or decided that place, or rather, the specific space of the stairwell would provide a sense of familiarity for the viewer. In essence, the stairwell became the common denominator. In your five-film series *Cremaster*, we are often looking at things that are visually unfamiliar, yet at the same time because it is you who is featured in all the films, the viewers are in fact seeing something they recognize—you. In a sense, you are the common denominator. Do you create a story line around the things you have sculpted?

MB: The space between things is as critical as the objects themselves, and the first performances I made were really about activating those spaces between objects, and being a supporting character to the inanimate object, in a way. You can visualize place as a host body for other things to pass through. I wouldn't say that it is as simple as saying that the Chrysler Building from *Cremaster 3*, for example, is that body, but rather that there is an *abstraction* of the Chrysler Building. It's about visualizing either the individual project as a whole, or one's entire practice as a system that can take external things from culture and use them as raw materials and pass them through this system with the belief that they can be transformed into something else.

MS: The sculptor Richard Serra has said that art is not for the people, or that it is not democratic. It is the age-old conversation on what the function of art is, but film, of course, is the medium of mass culture. Is filmmaking a way for you to make your work more accessible for the viewer, or is it just a more effective way to express your ideas? Your films are beautiful and enticing regardless of whether or not one understands the narrative—can you speak to that?

MB: I think it's exactly the conflict at the center of these stories I am interested in telling, really. It is sort of about that conflict between making something that is internal and hermetic and makes perfect sense inside you, and the desire as an artist to communicate and how to balance that. I am in constant conflict over that. I am interested in how my work can live in that external, generous place and communicate while still functioning for me as a part of this other system

that you could say has more of an internal logic. I kind of want both of those things and I don't really know what that means in terms of the people. I think art can be for some people. It can't be for everybody.

MS: I conceive of the Stairwell Project as a body of work that documents a particular period of time. These photos serve to illustrate when something took place—a certain amount of it is documentation and a certain amount of it is purely aesthetic. Either way, it's an evolution. Having seen all five films in the Cremaster Cycle, I felt like I very much earned my visit to the Guggenheim and I experienced your films and sculpture as part and parcel of one very large creation. Do you view them this way or can they stand on their own?

MB: Individual works can be autonomous, I suppose, but I don't tend to look at artwork that way. When I see a piece of work, I think about everything else the artist has done, and how one thing relates to the other. In my own work, I am not really that interested in separating one thing from the other thing.

MS: In the picture that we have of you in the stairwell, you're hanging upside down in a Houdiniesque knot. In your *Drawing Restraint* series you're making art while you're actually being restrained. Creating boundaries and limitations and specifics helps me create a certain rhythm and discern when a piece begins and when it ends. But you take that to the level of actually imposing physical limitations on yourself—you wear many prosthetics that restrain parts of your body. Conceptually, how did that come about and why does it reoccur for you?

MB: The *Drawing Restraint* project
grew out of thinking again about
an athletic model, and thinking
about a physiological model—what
happens to your body when it's
under resistance. How muscles are
developed under resistance . . .
that muscle tissue is torn down by
resistance training, and subsequently
heals stronger and larger. That model
is useful for me as a way of thinking
about the creative process. There
have been a number of approaches
to *Drawing Restraint*, and it started
with those first experiments of
putting a literal restraint on the
act of drawing. Drawing without
a program had always felt a little
bit facile. That was probably the
beginning of the doubt that led me
to making narrative work, which is
not to say that placing something
narrative onto my practice is
necessarily a restraint. I think
it's quite the opposite. It really
liberates things, or it has liberated
things for me. Houdini has always
been a personification of this idea
of resistance as a prerequisite for
creativity. He's also provided a way
to visualize connection between
the athletic, hermetic foundation
of the work, and the more external,
theatrical expression of it. Houdini
really embodies that duality for me.

MS: You as the Loughton Candidate,
which you've described as part
Bob Fosse and part mythology, are
very appropriate for your stairwell
portrait and this book. It really
covers the span of what a diverse
collection of individuals has been
included. I wanted to use one of your
characters from Cremaster that was
visually striking and particularly
whimsical but I also wanted to show
you, as you. Can you talk a little
about that, about the Loughton
Candidate and your experience in
the stairwell?

MB: When I went to visit the Isle of
the Man the first time, I saw these
indigenous sheep in different fields
around the island. They have four
horns—typically the male has one
set of horns that go upward, and
another set that spiral down like
a ram horn. It was one of the first
things from the island that I used to
organize the story around—the story
of this character who exists in an
undifferentiated state between two
other character factions, one which
is defined as ascending and one
which is defined as descending. The
ascending faction would represent
the undifferentiated sexual system,
one that hadn't yet declared itself as
male or female. And the descending
would be the differentiated system.
So this Loughton character as
neither—or both—and wanting
to stay in that undifferentiated
space between the two. And he's a
candidate in the sense that his horns
hadn't actually started growing yet.
He has four sockets in his head,
but no horns. And, this character
was designed a little bit around the
idea of Roy Scheider's characters
in *All That Jazz* who looks in the
mirror every day and has an internal
dialogue with the angel of death.
Similarly, there's a suggestion that
the Loughton Candidate sits in front
of this vanity, and that in fact the
story never really left the mirror. In
that way, the entire thing was some
sort of reflection.

I was enthusiastic about the idea
that you had to apply half the
makeup of the Loughton Candidate
for your portrait, and working with
Gabe Bartalos, who has developed
prosthetic characters for both of
us, seemed like a natural way to
approach this. I'm really up for your
approach with this series of images,
where the same, strict condition is
imposed onto each picture. . . . That
the same stairwell had to be the
context for each portrait. It's like the
formalized stage of Noh theater, or
something, where the frame is always
the same. So, somehow the expression
of the individual is uncomplicated
by the luggage of the environment.
That's exciting. I guess it's nearly the
opposite of the way I work.

MS: My influences come from a very
broad range—from the storytelling
of Gillian Welch to the photographs
of Mike Disfarmer, Irving Penn, and
Guy Bourdin. My first epiphany with
photography was when I came across
the social documentary photos of
Henri Cartier-Bresson and that was
really when I knew that this was
what I wanted to do. I was wondering
what your first influences were and
what was the deciding piece that
propelled you to be an artist. How has
the athletic aspect of your life and
football influenced your idea of film?

MB: There's a production company
called NFL Films that makes team
highlight films for the National
Football League. They have a very
specific aesthetic. I think I took a
lot of cues from that kind of camera
work, with regard to low camera
angles and the use of slow motion
and the kinds of cutaways that they
use to capture the coach or the fans,
or the piece of equipment, or the
bloody hand. They really succeed in
capturing the emotional space out
on the field, and within the stadium.
You don't capture that sort of thing
by just describing the game; the story
needs to be told through textures. I
didn't realize how I was absorbing
that stuff when I was a kid. I would
watch loads and loads of those tapes
and I think it kind of seeped in. How
violence is sublimated in those films,
how violent action is transformed
into beauty. When I started using
athletic references in my work, I was
never really approaching it from the
outside looking in. It was something
that I had grown up with and had
internalized in a lot of ways, to the
point where it had really felt like
it was a part of my blood. When I
started making art, it immediately
came from a very personal place,
rather than a rational one. As
the language grew, more external
references started to come in. The
athletic structures and narratives
felt useful both as aesthetic models,
but also as autobiographical forms.
My work was basically supporting
this thing that I had already
internalized. I came of age on
the football field. It was really a
developmental place for me.

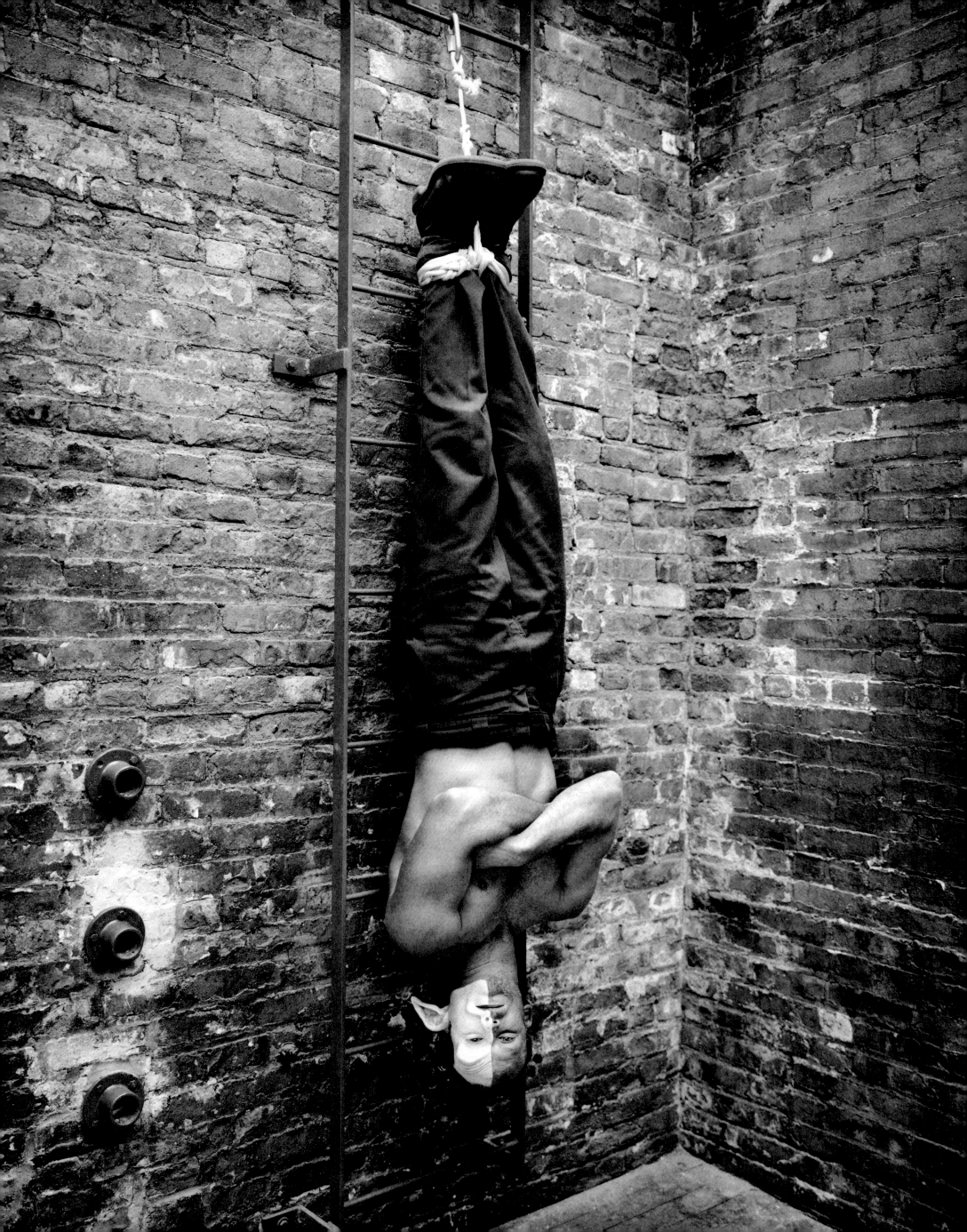

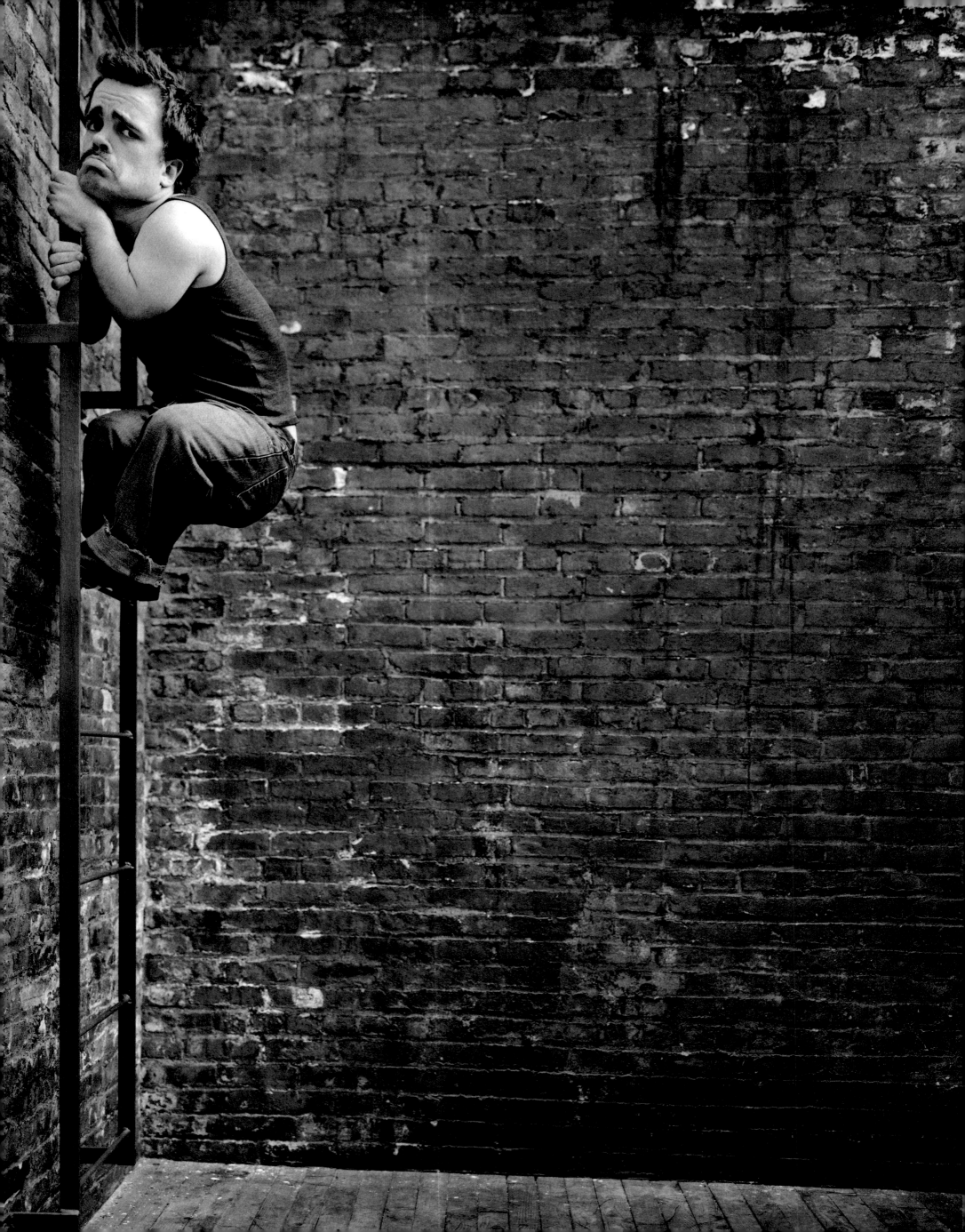

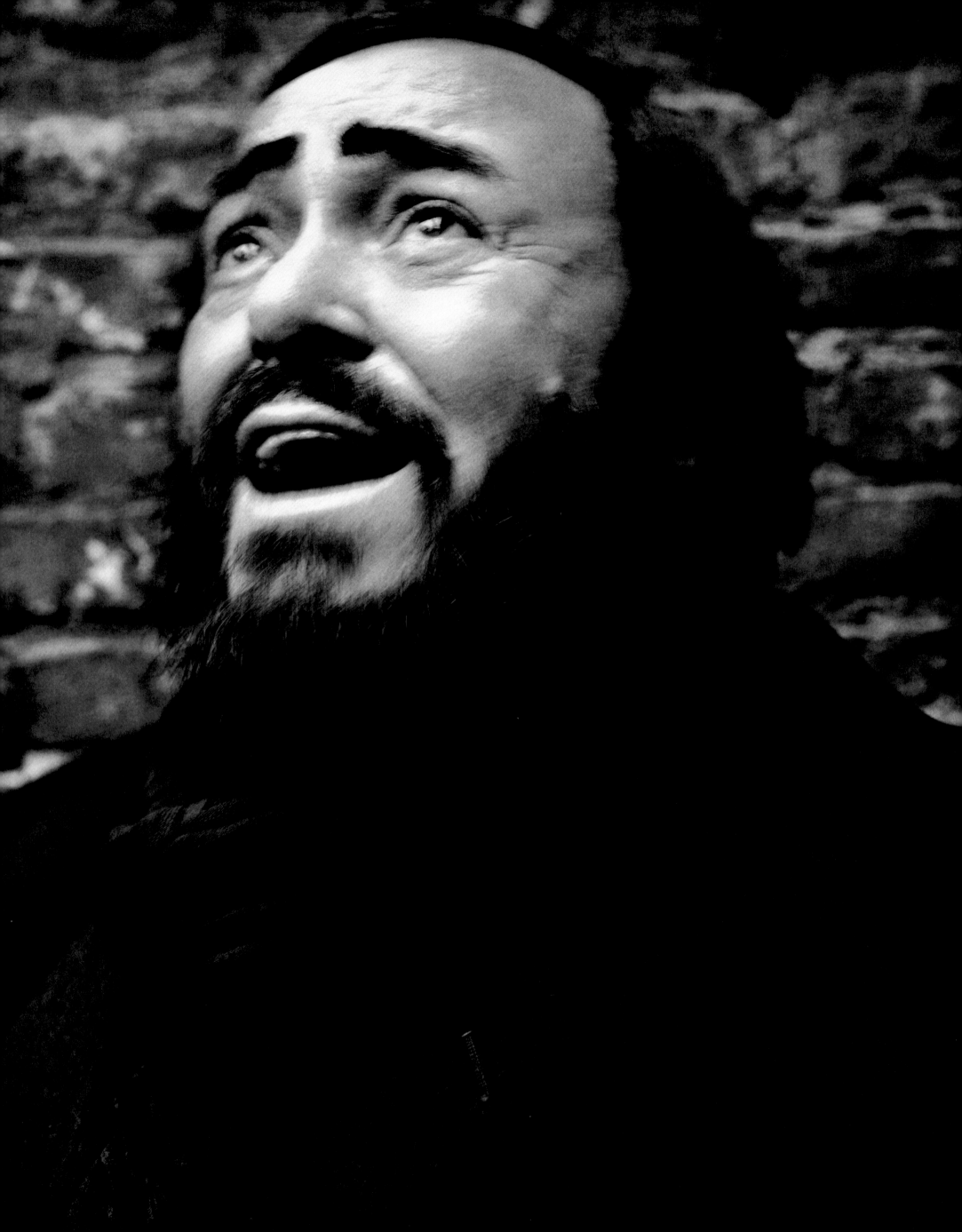

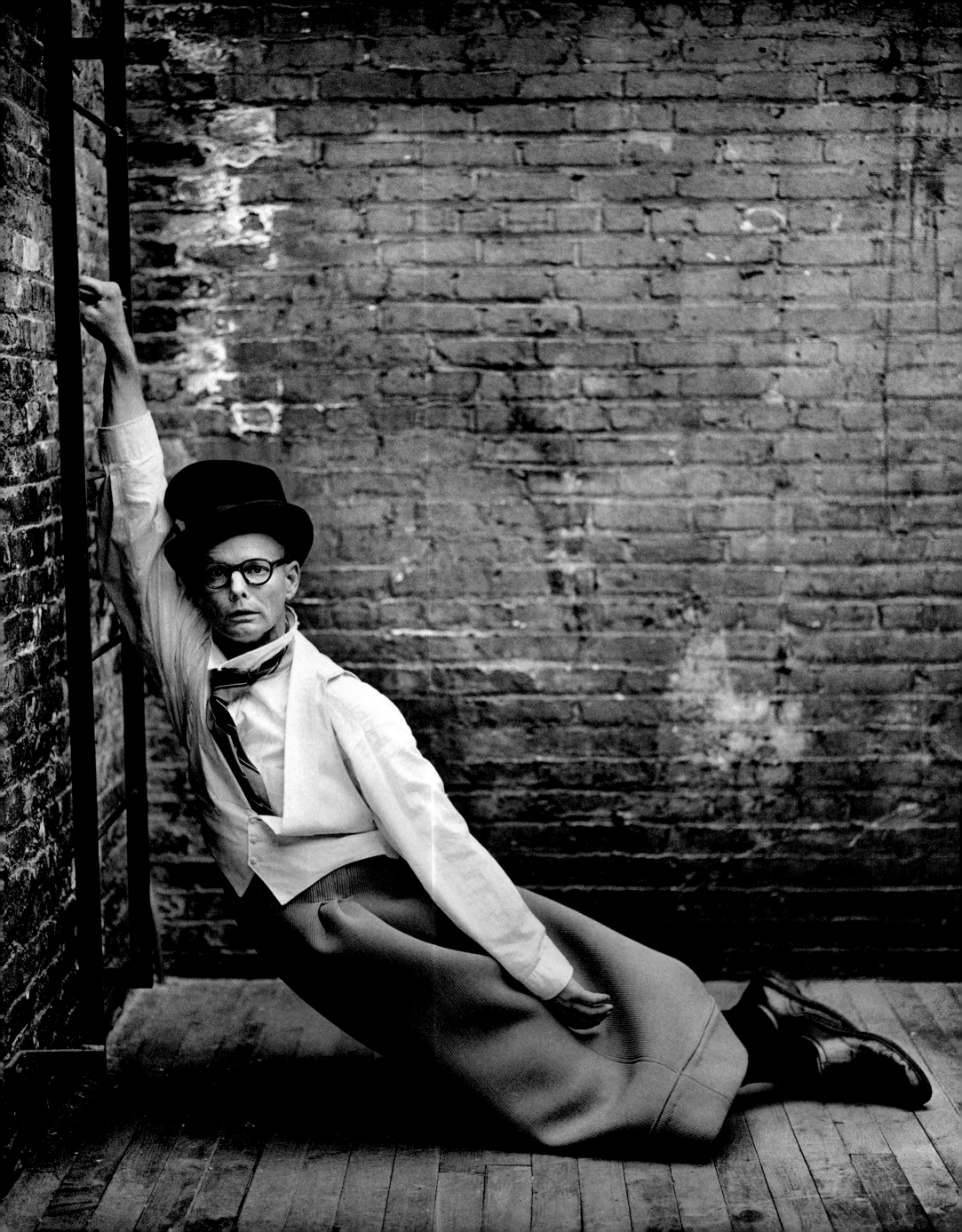

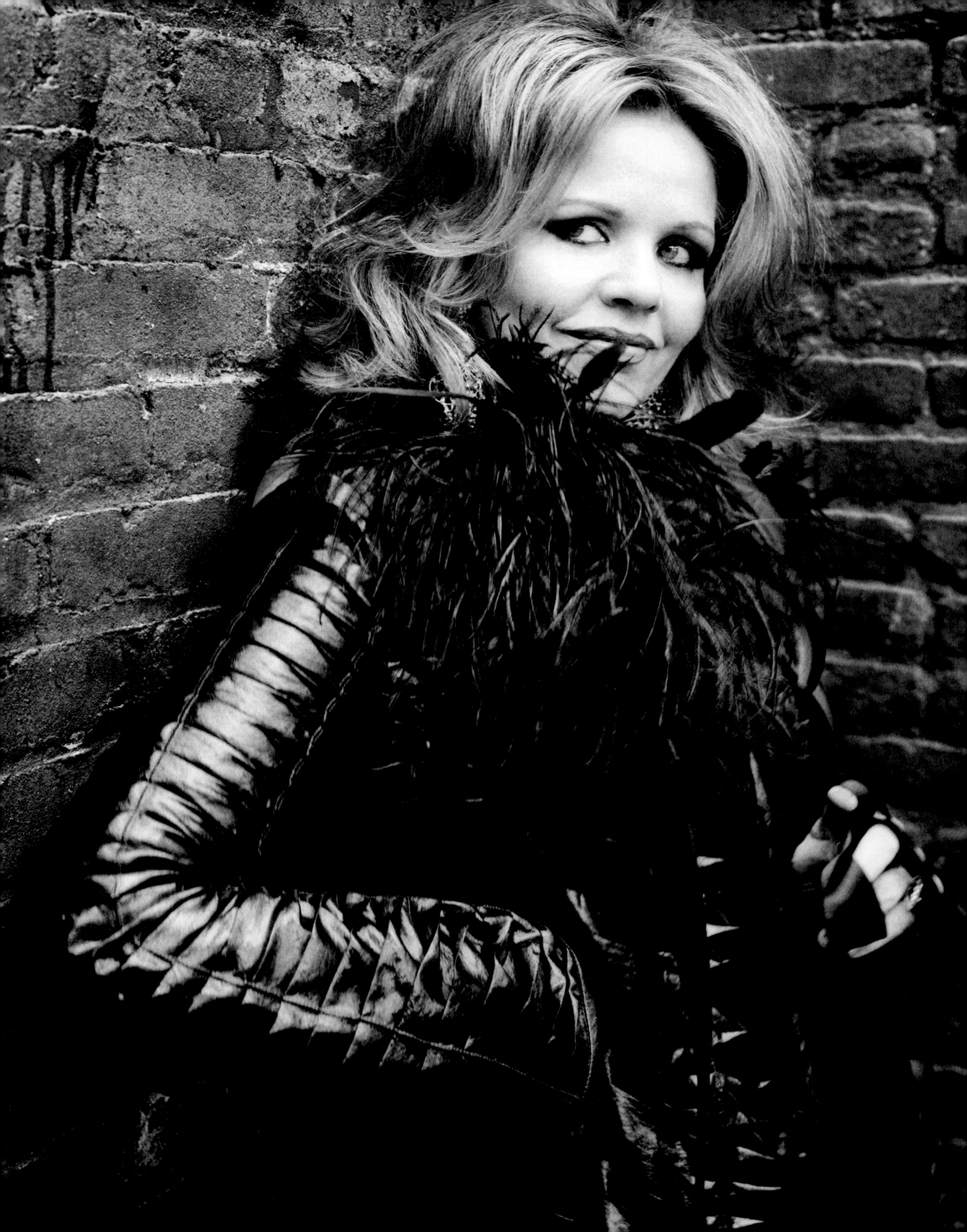

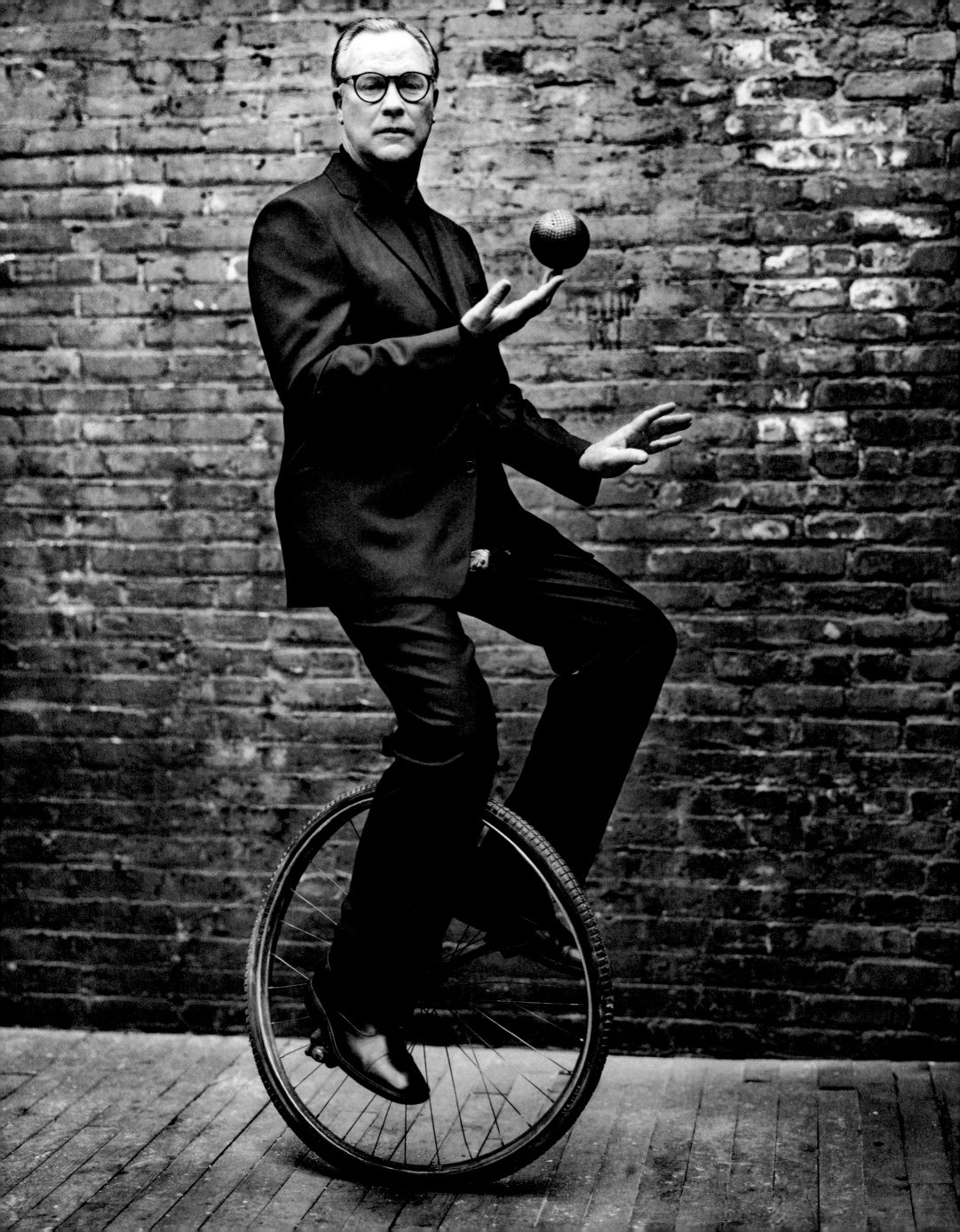

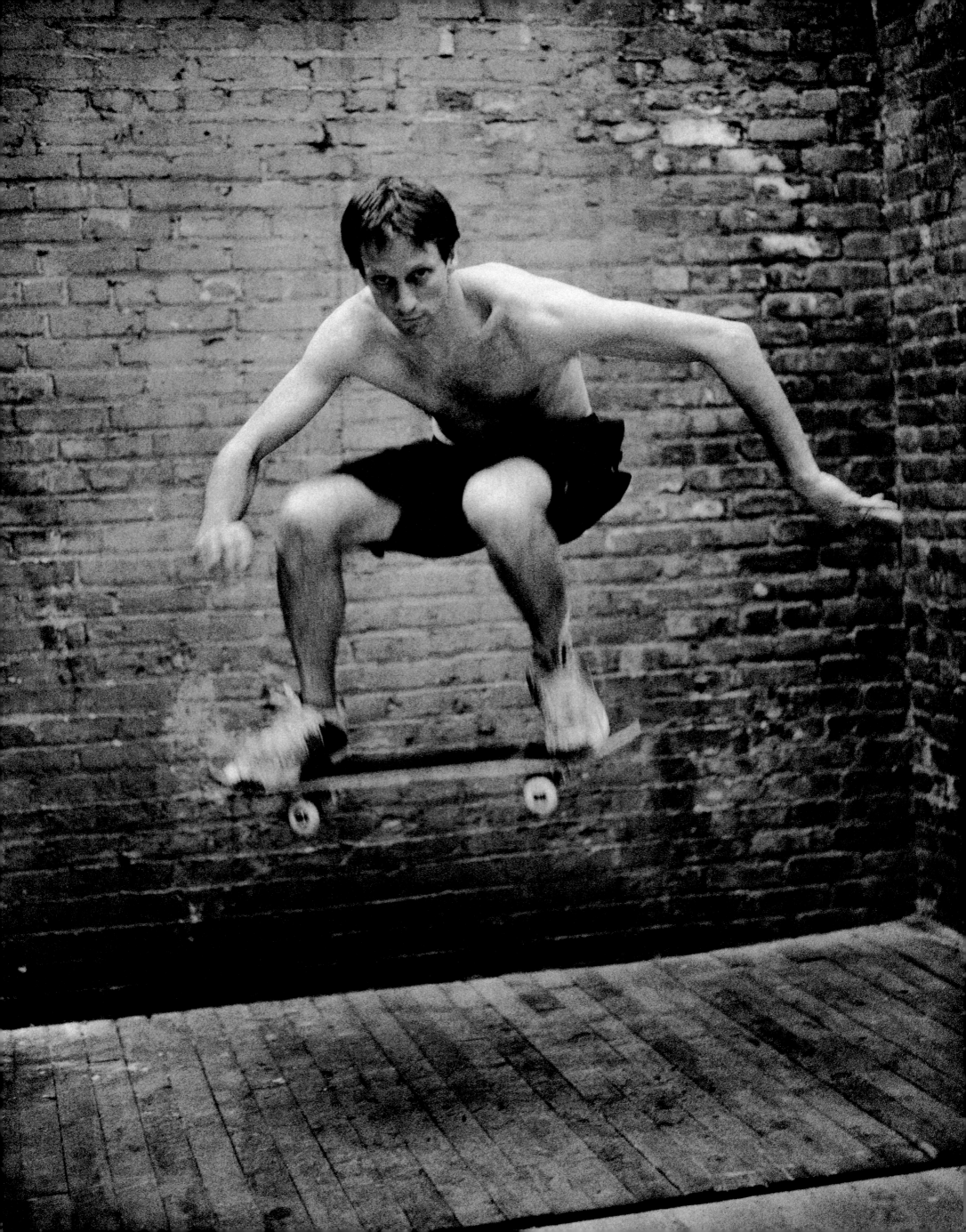

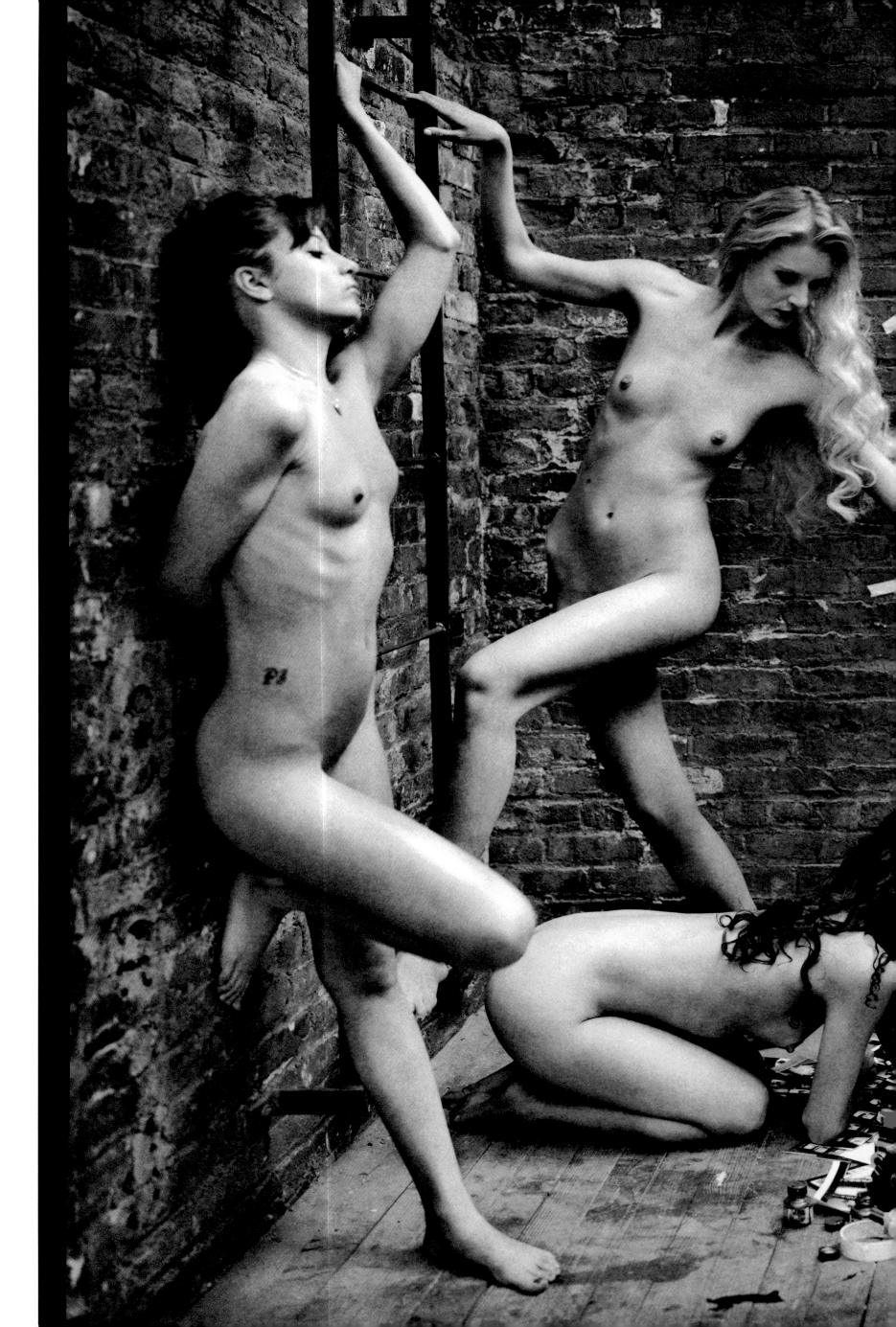

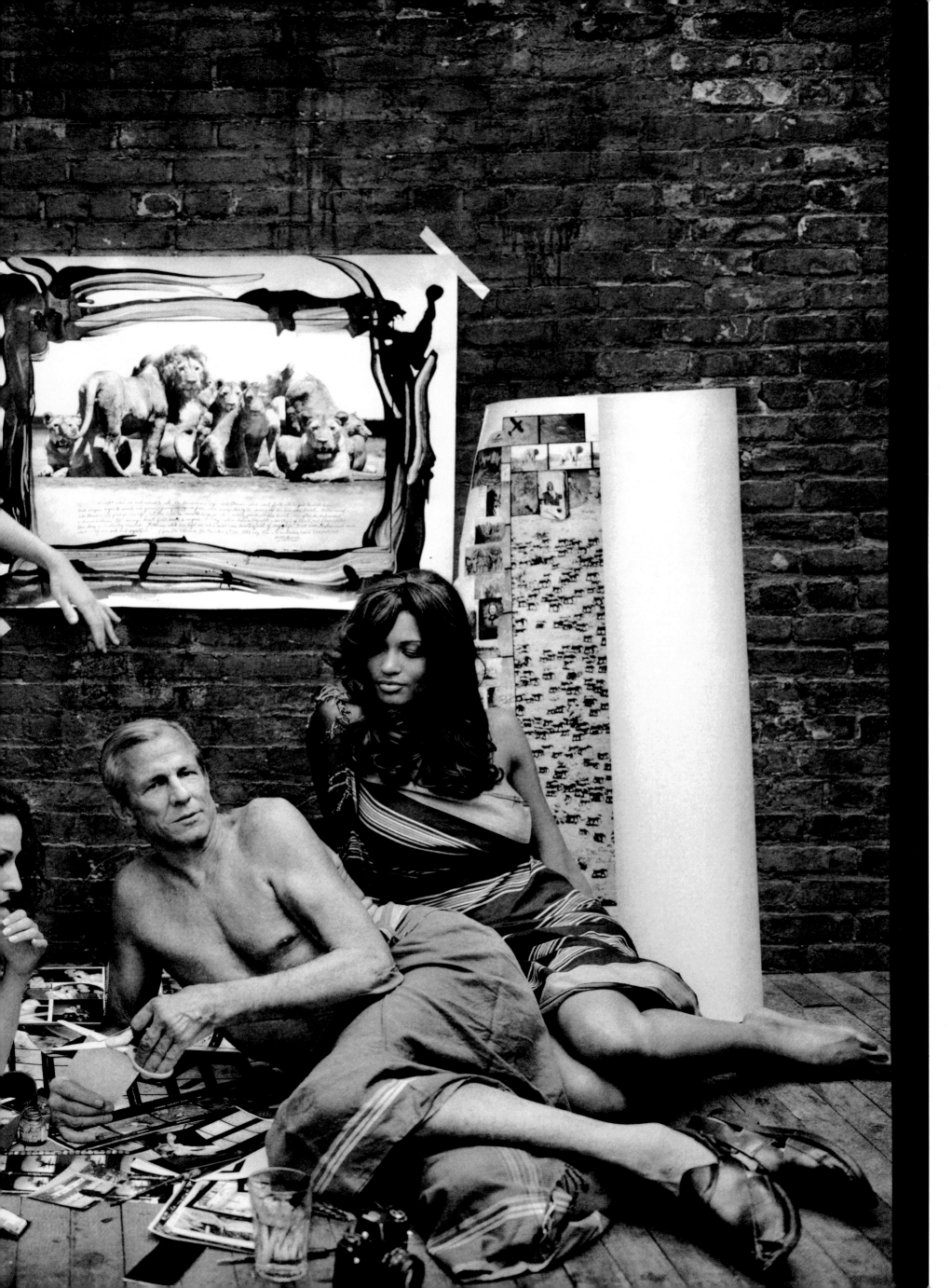

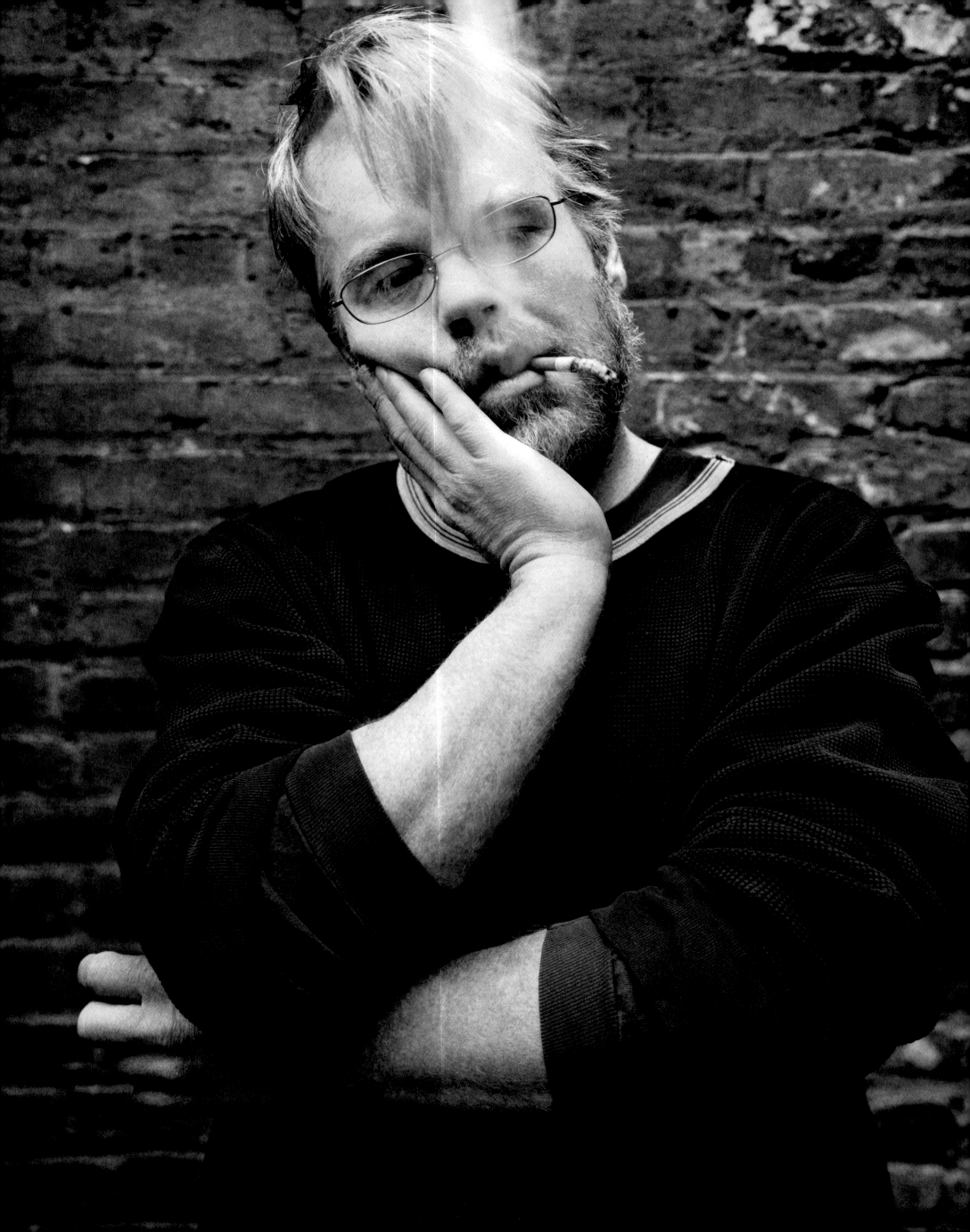

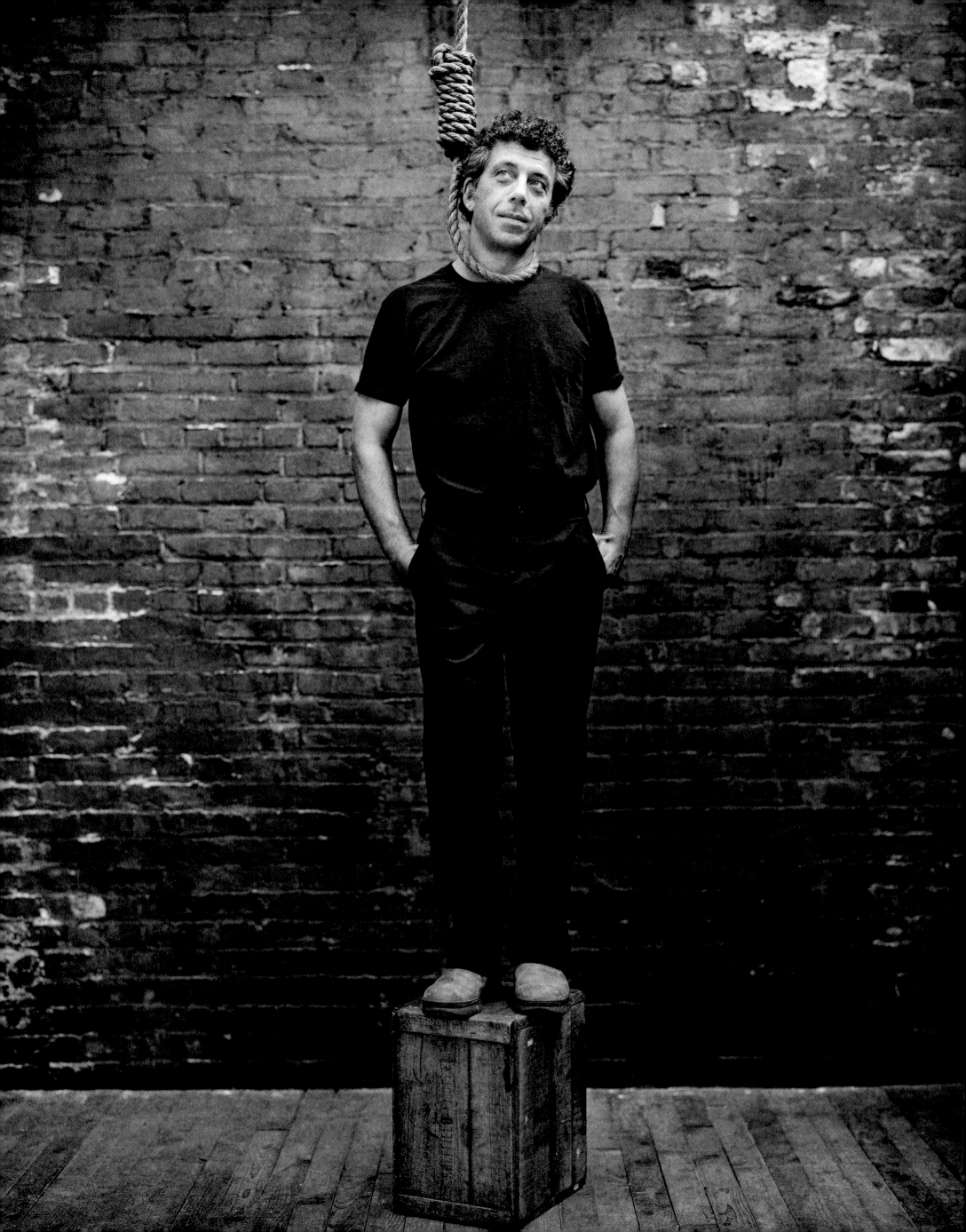

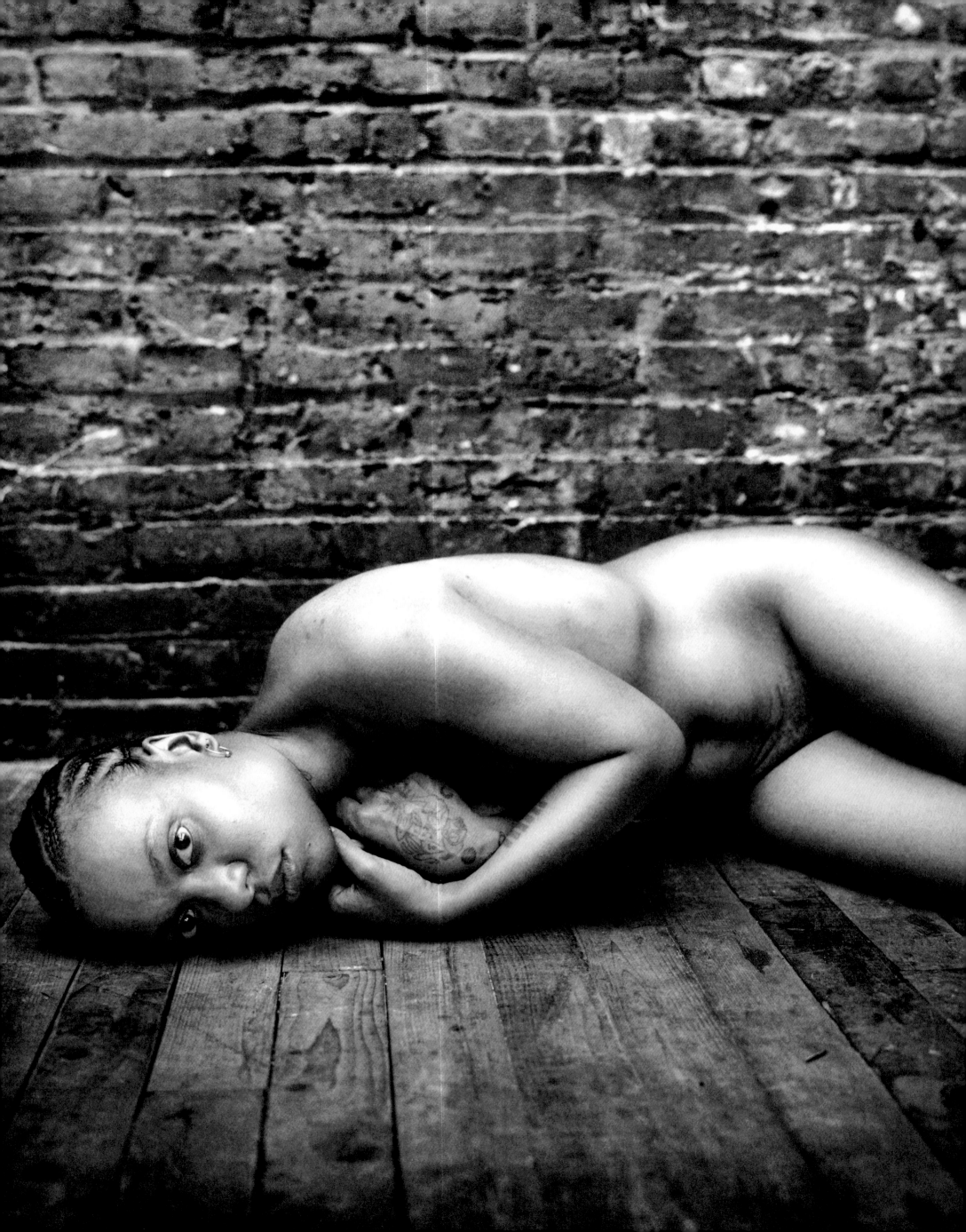

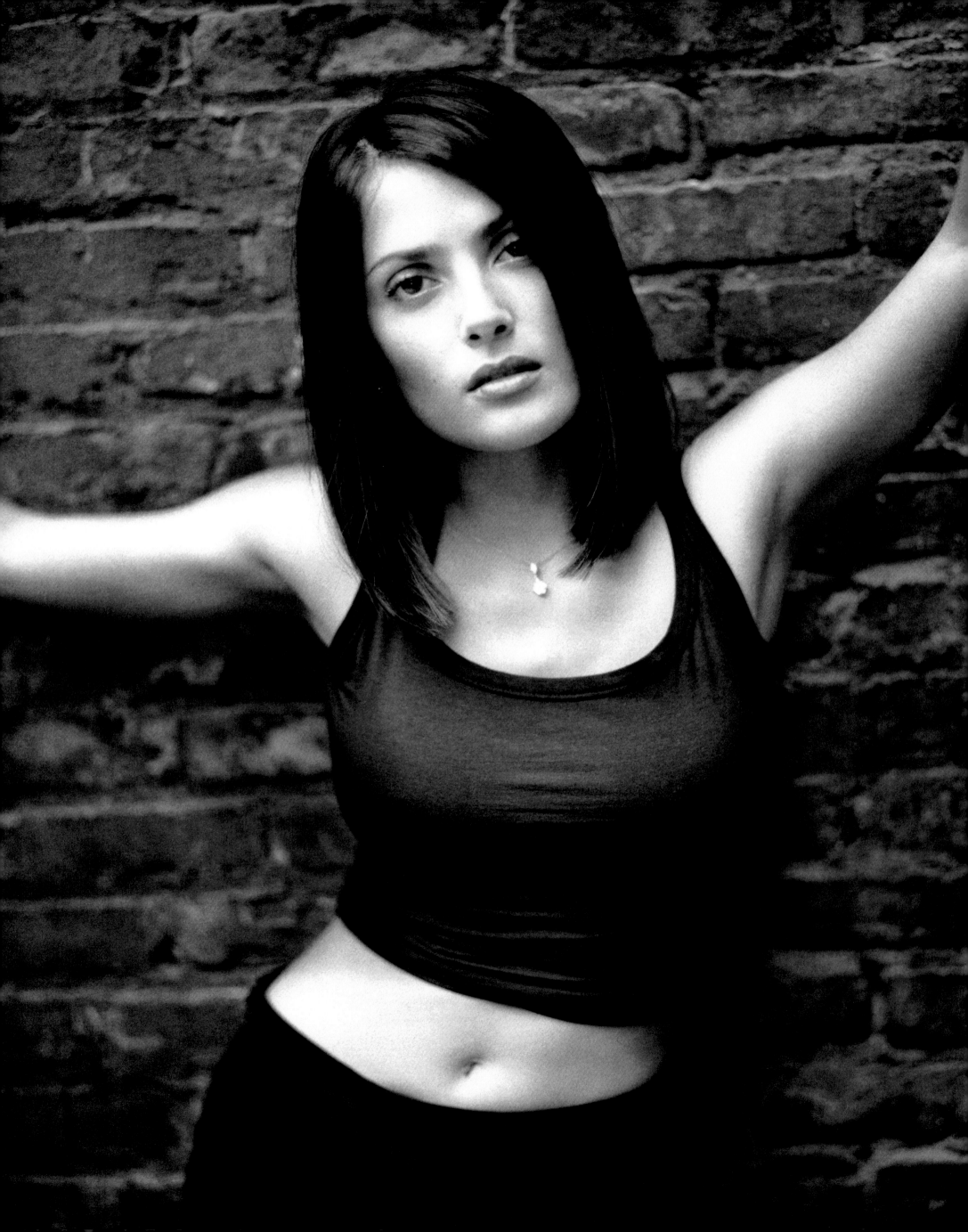

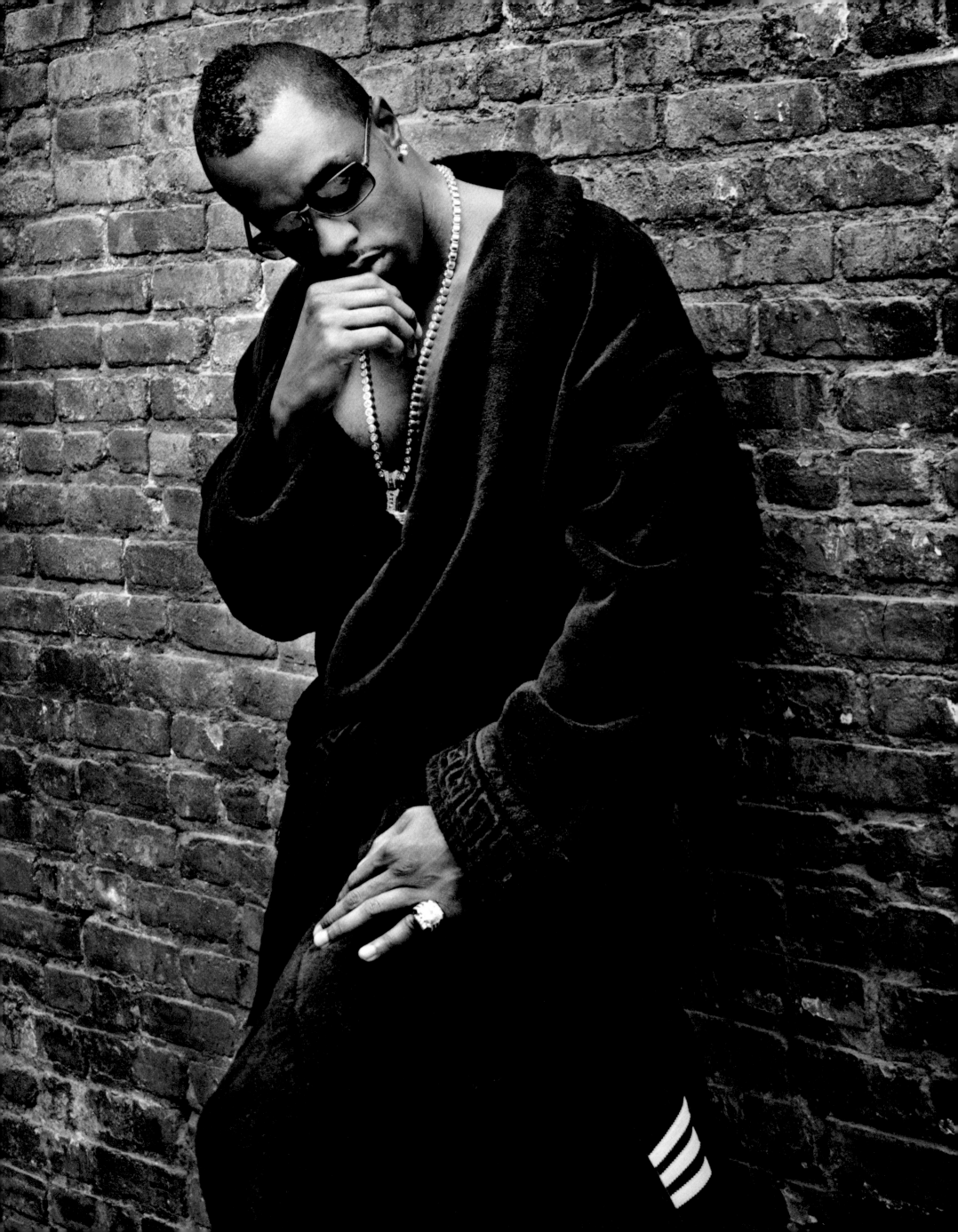

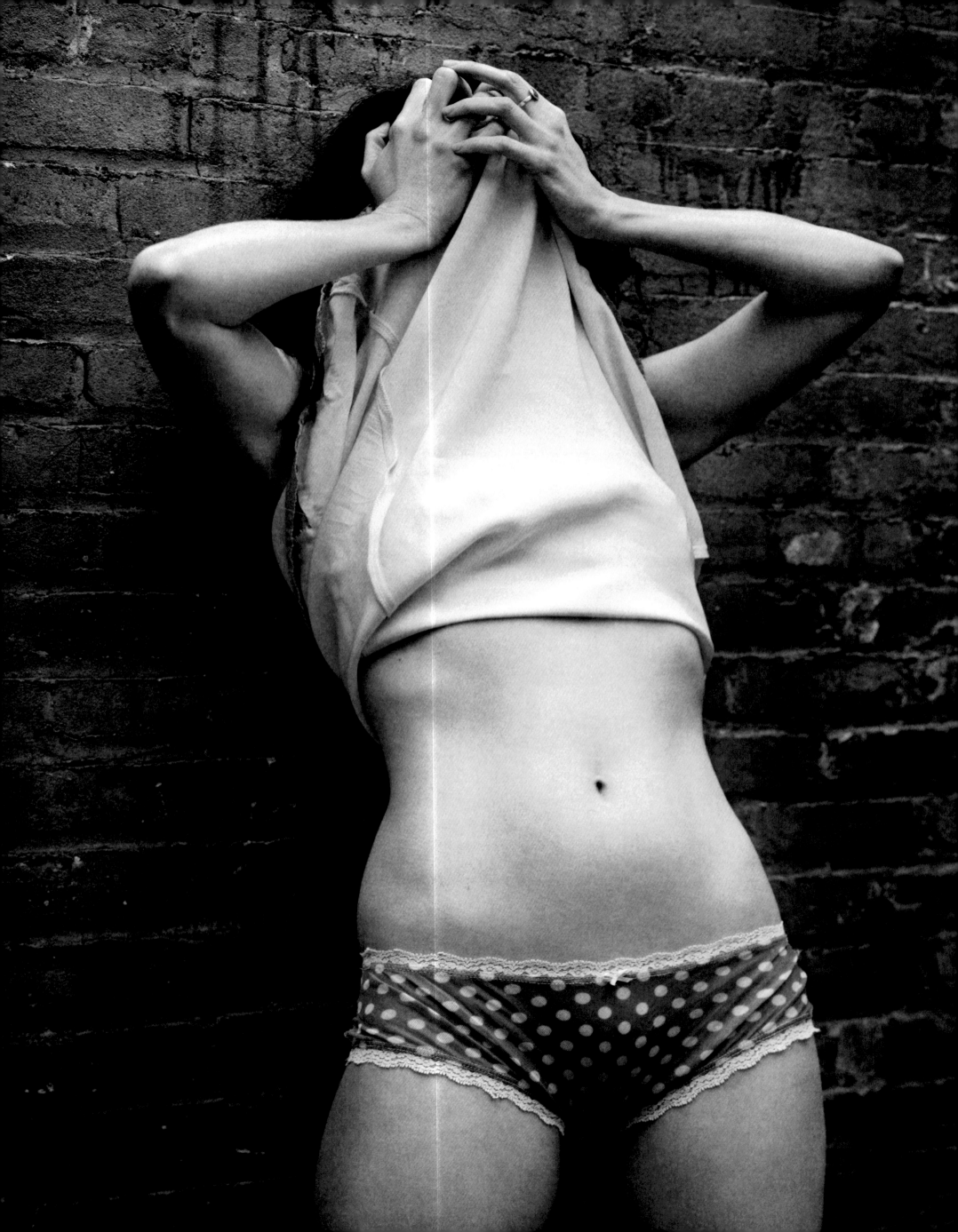

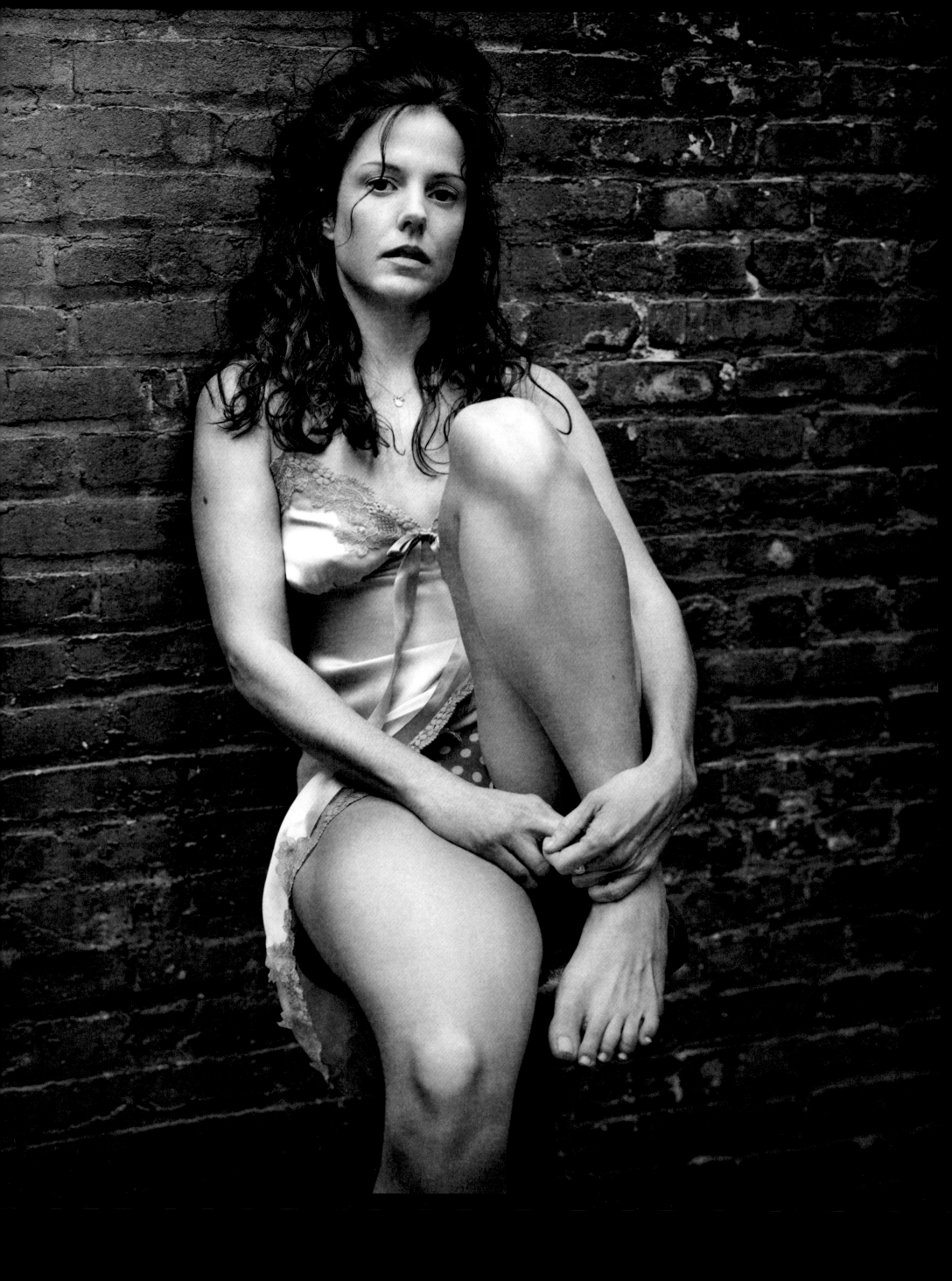

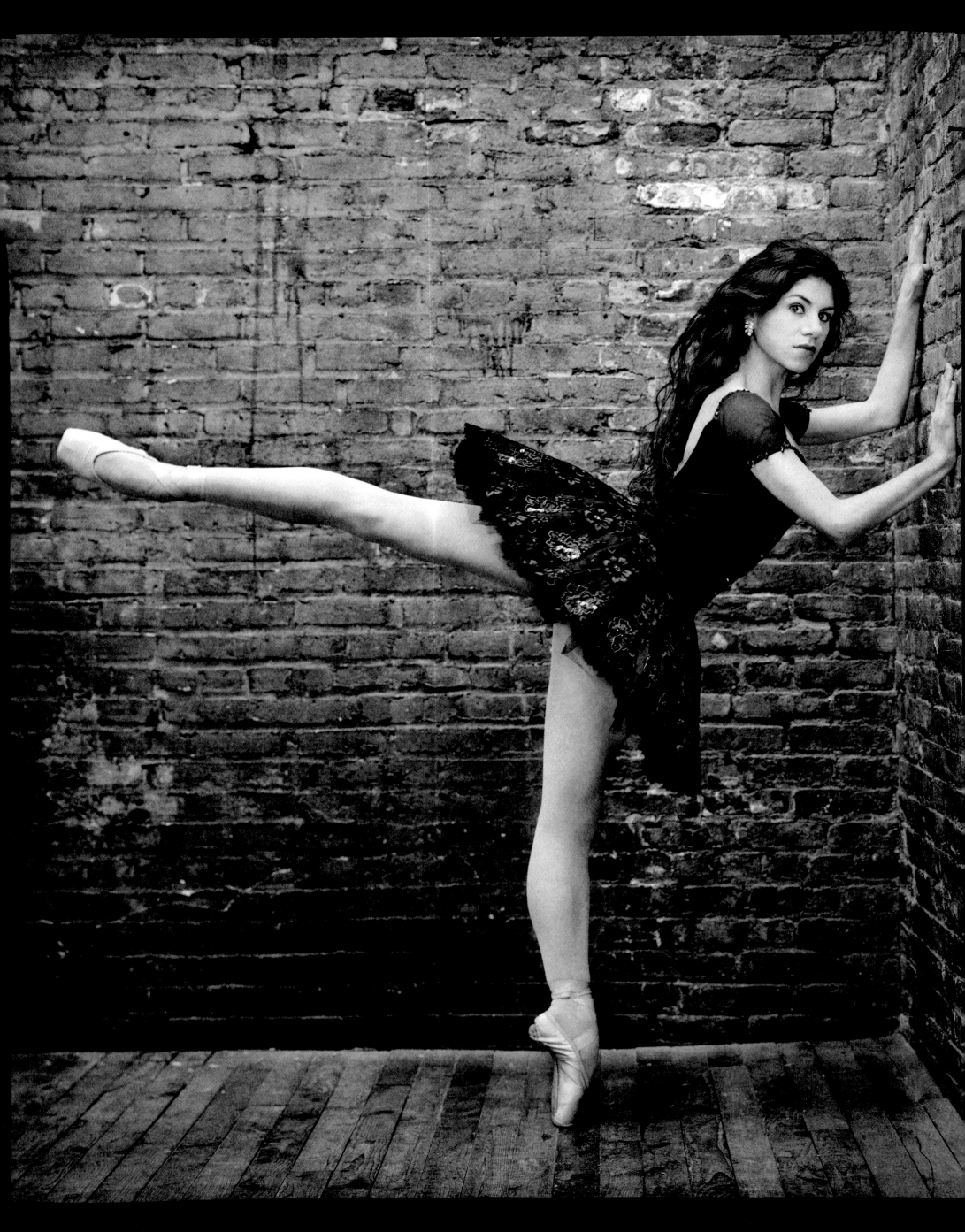

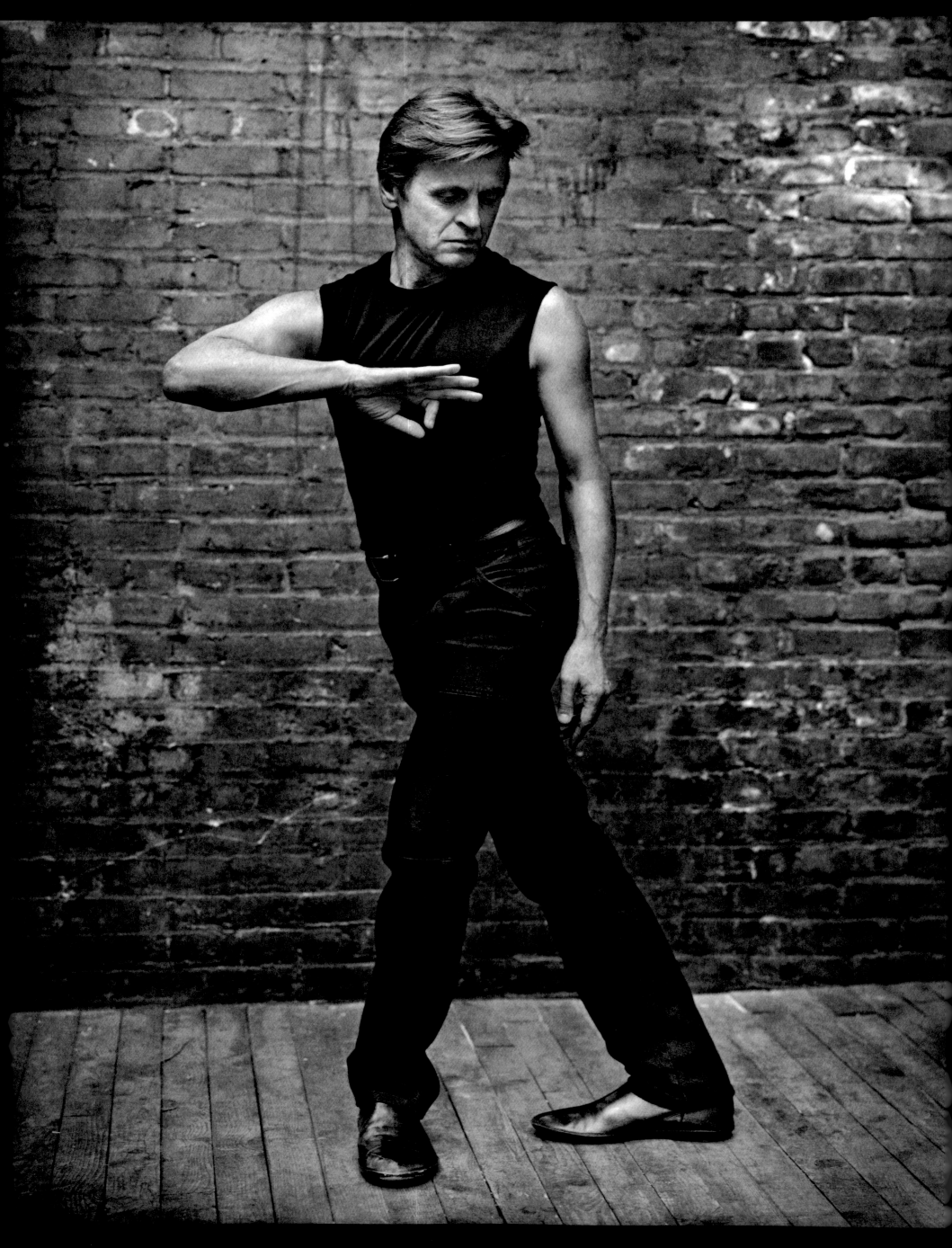

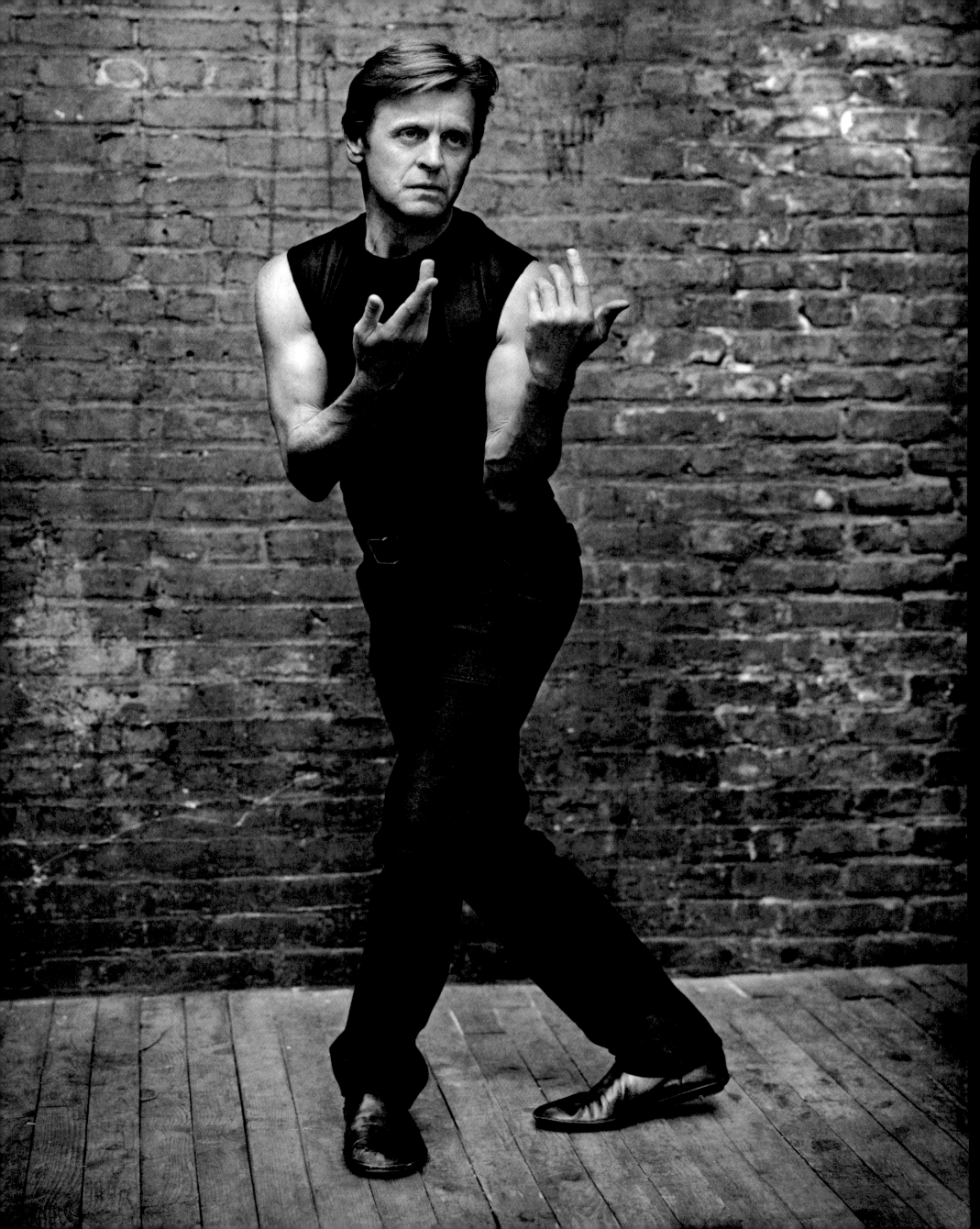

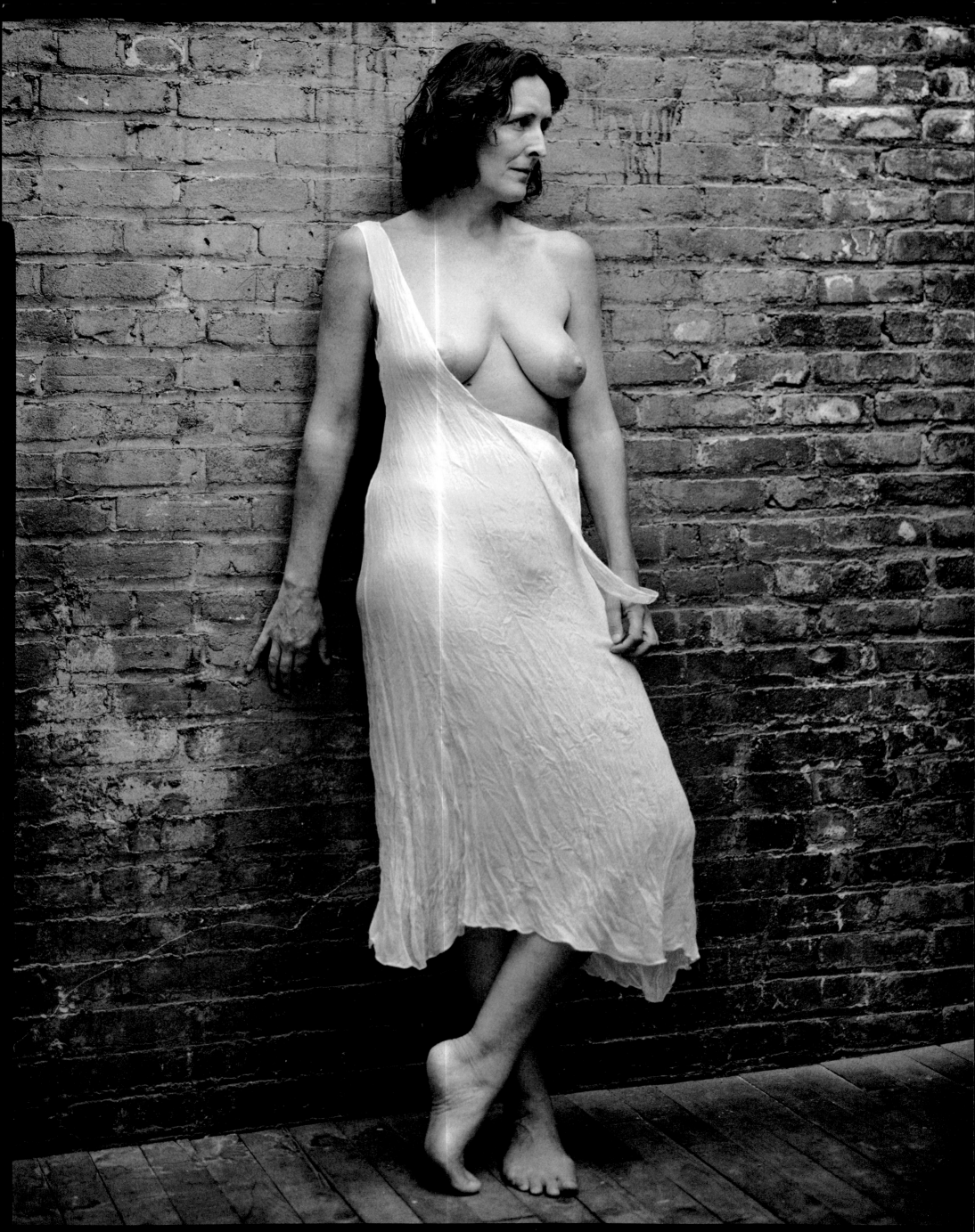

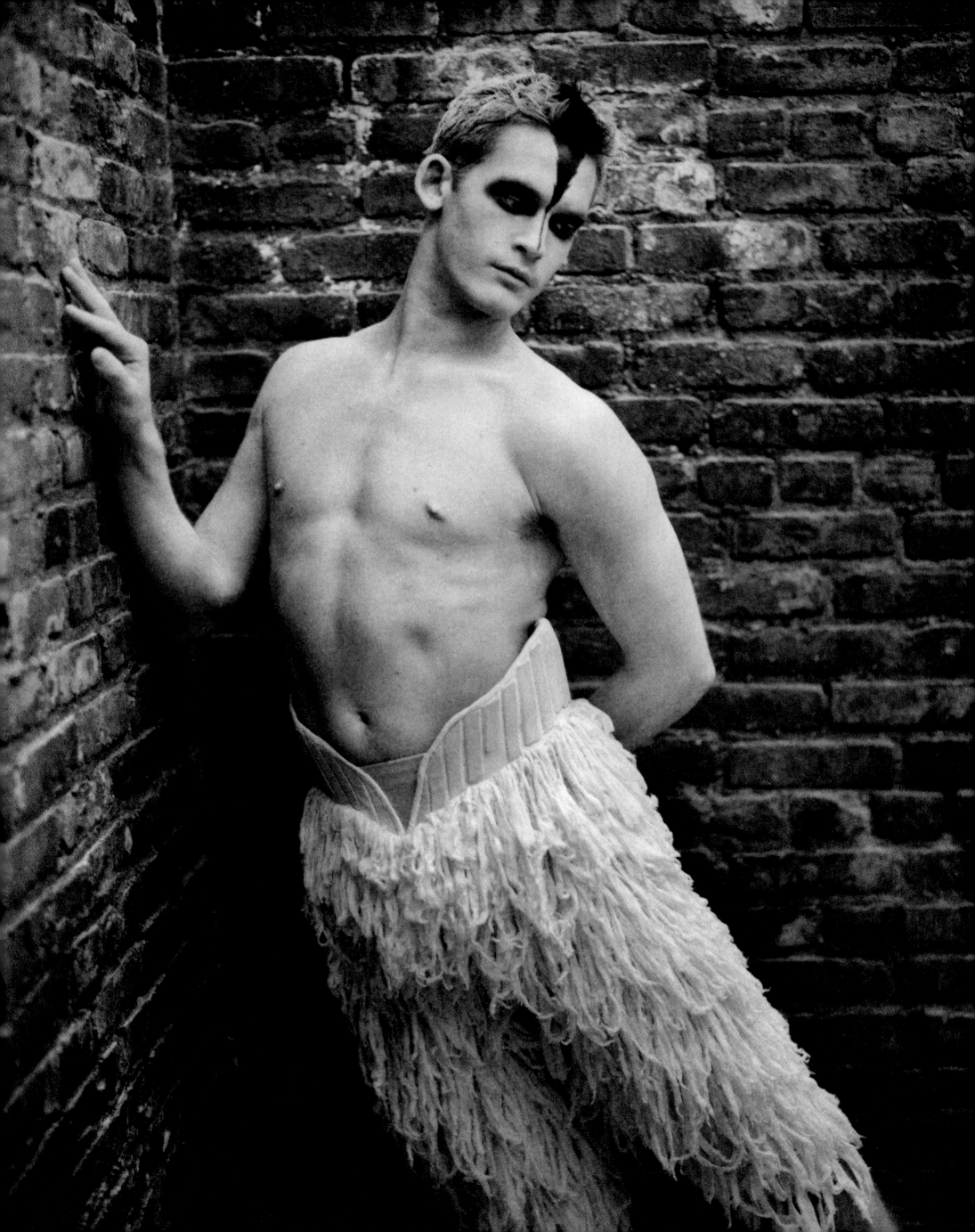

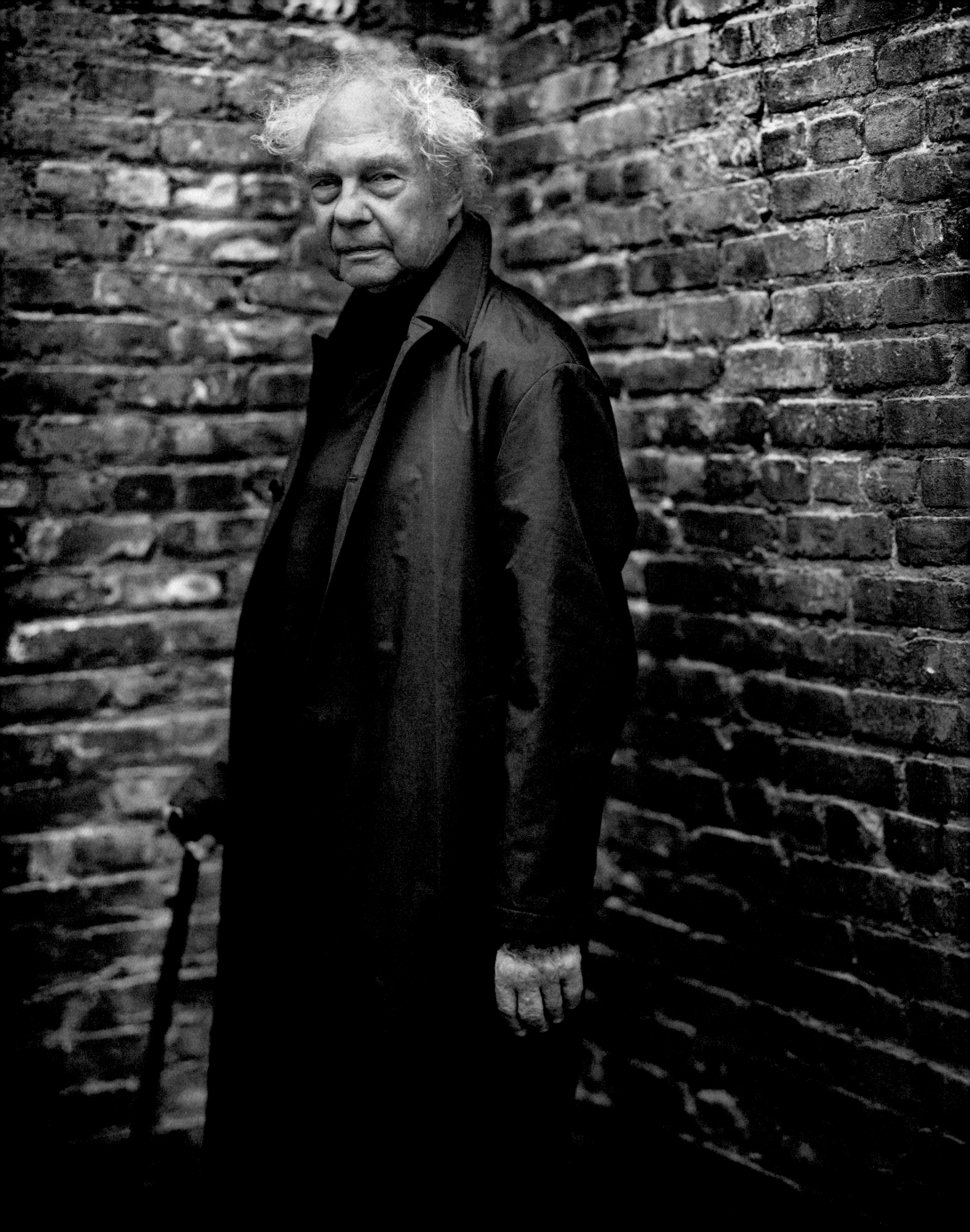

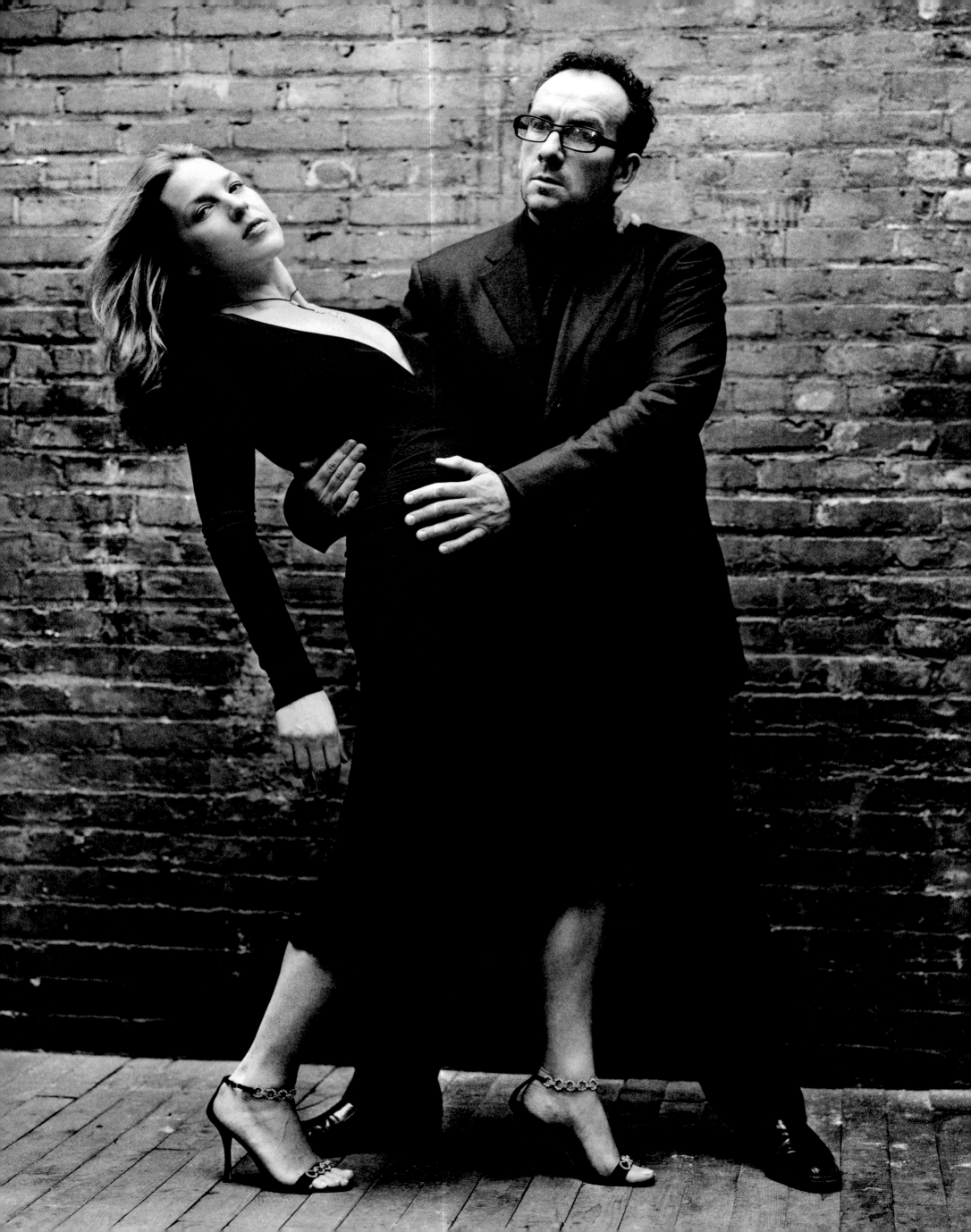

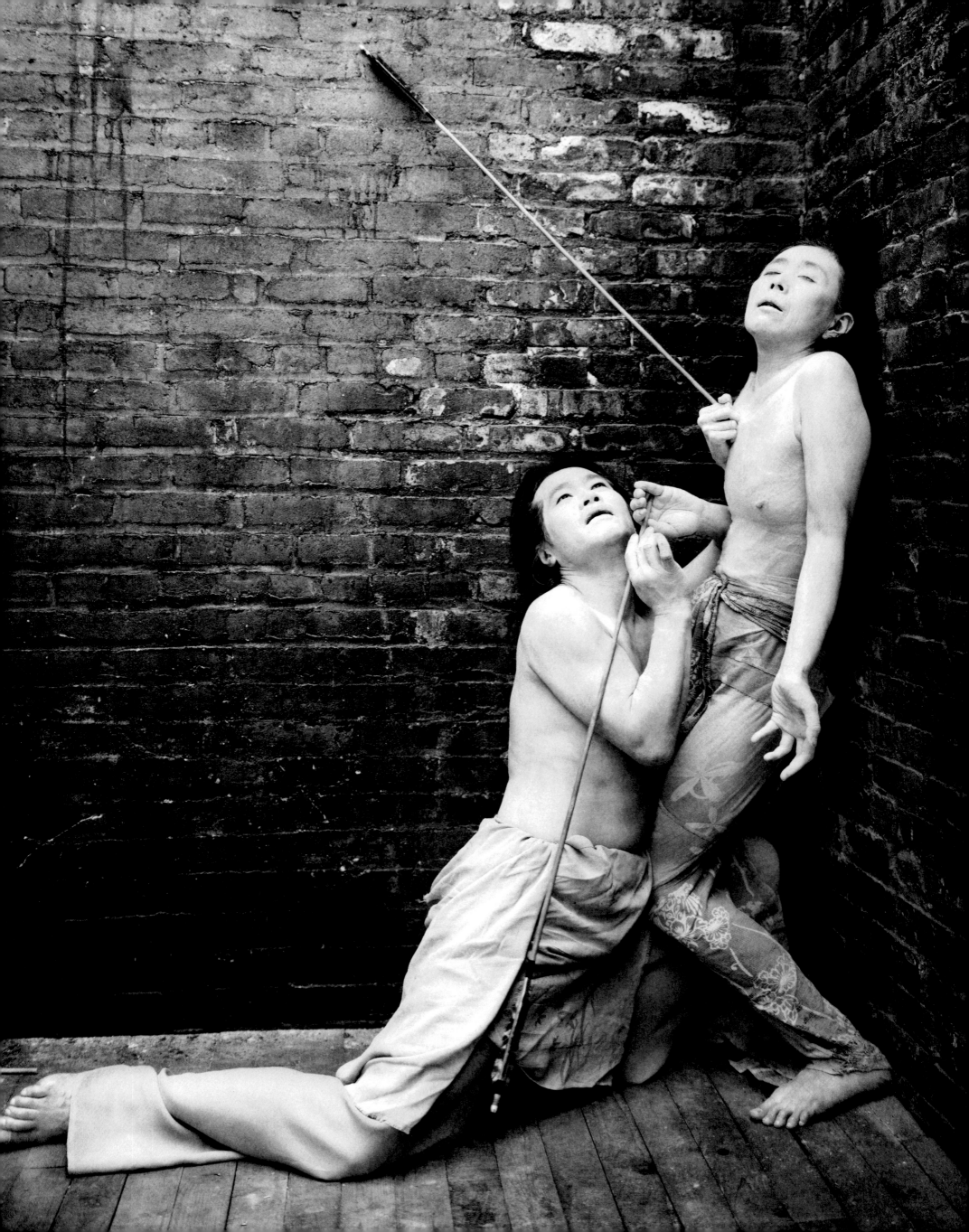

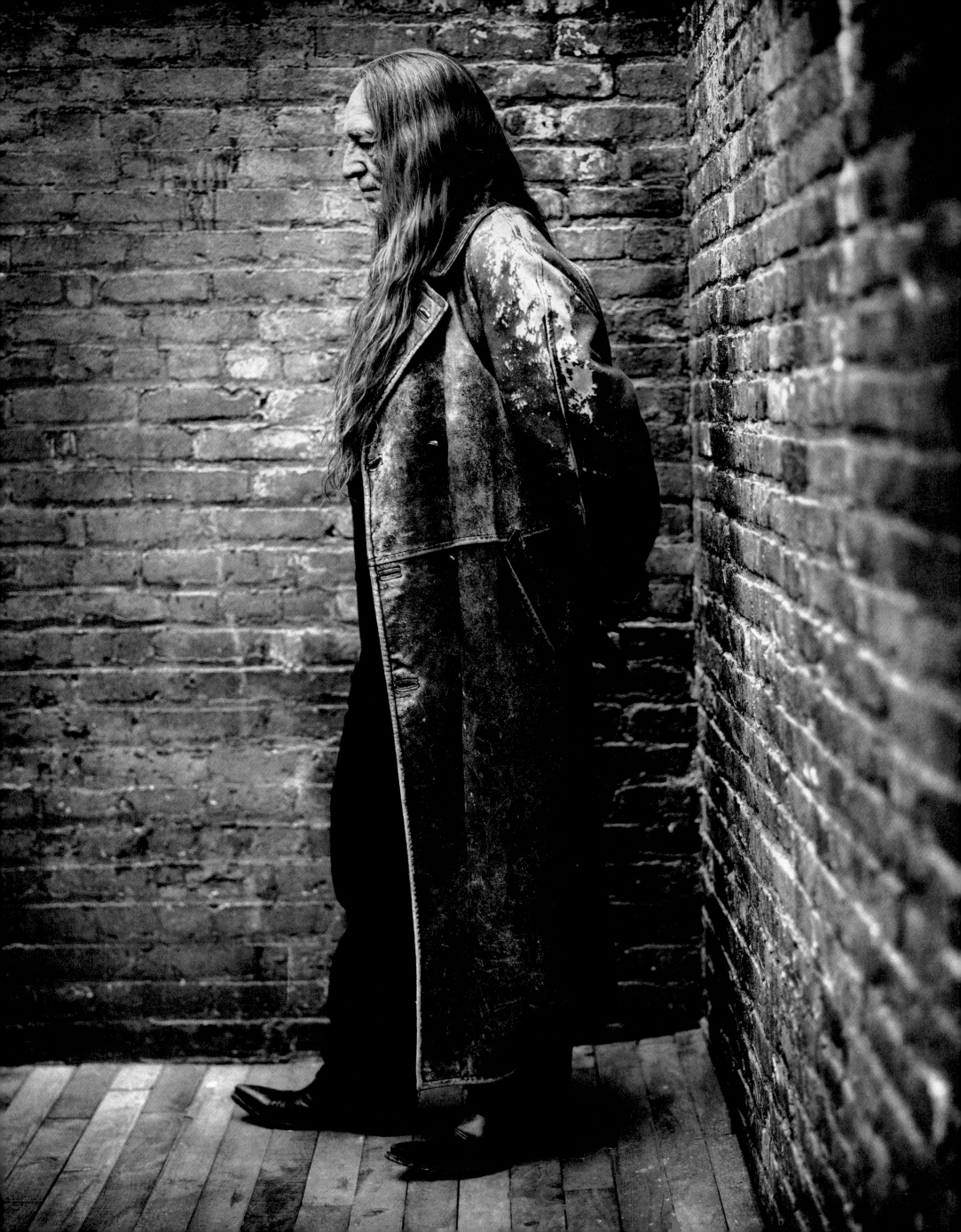

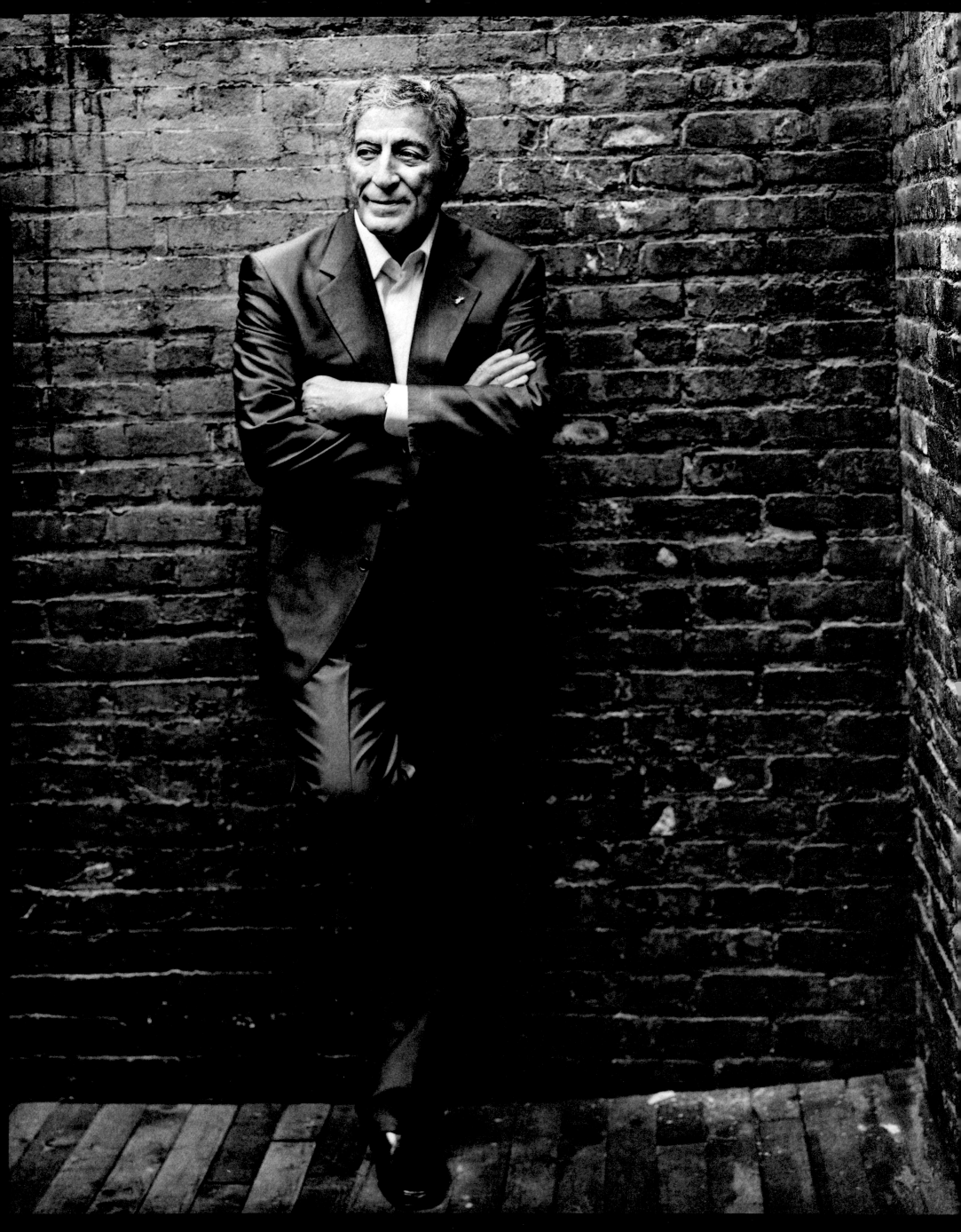

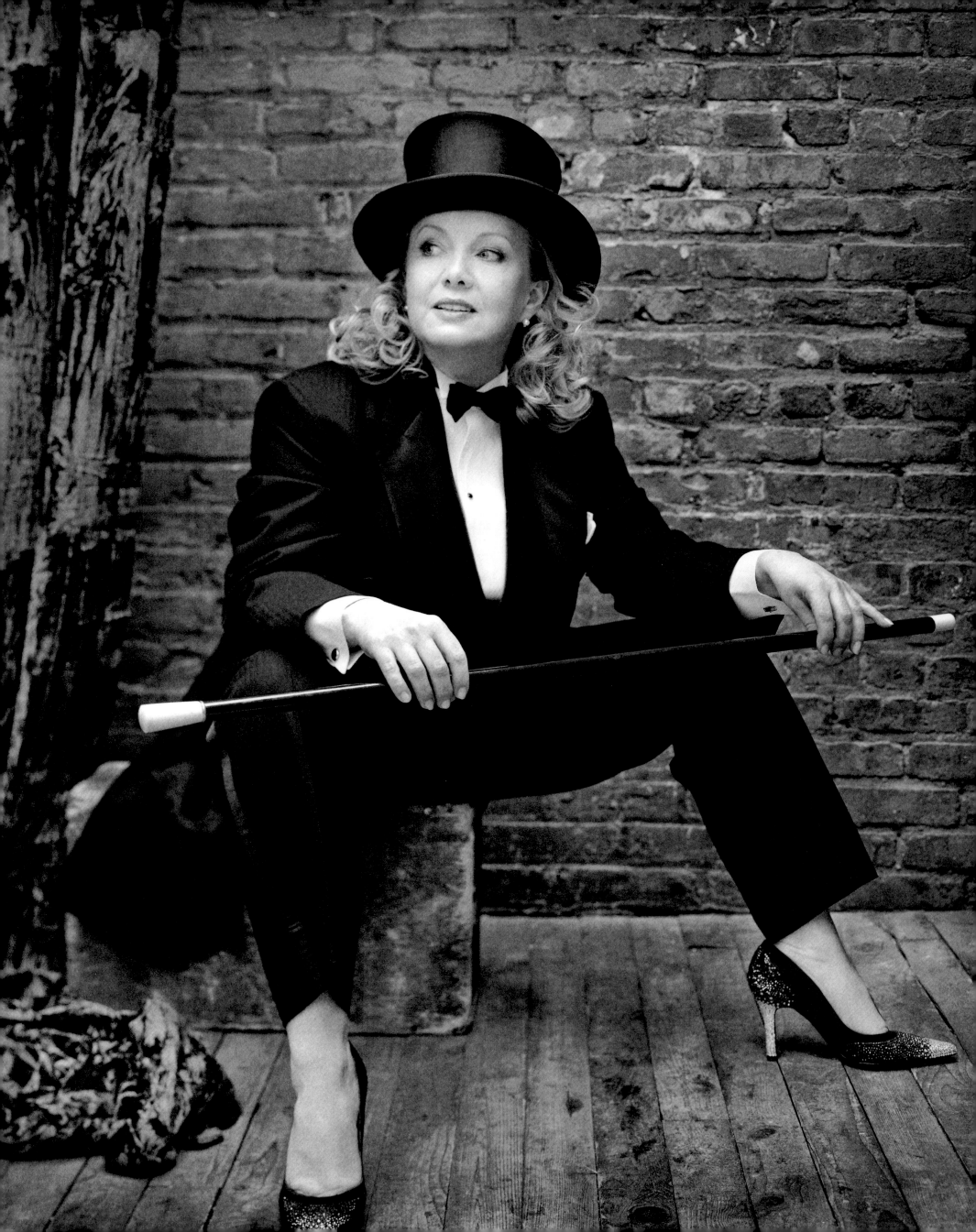

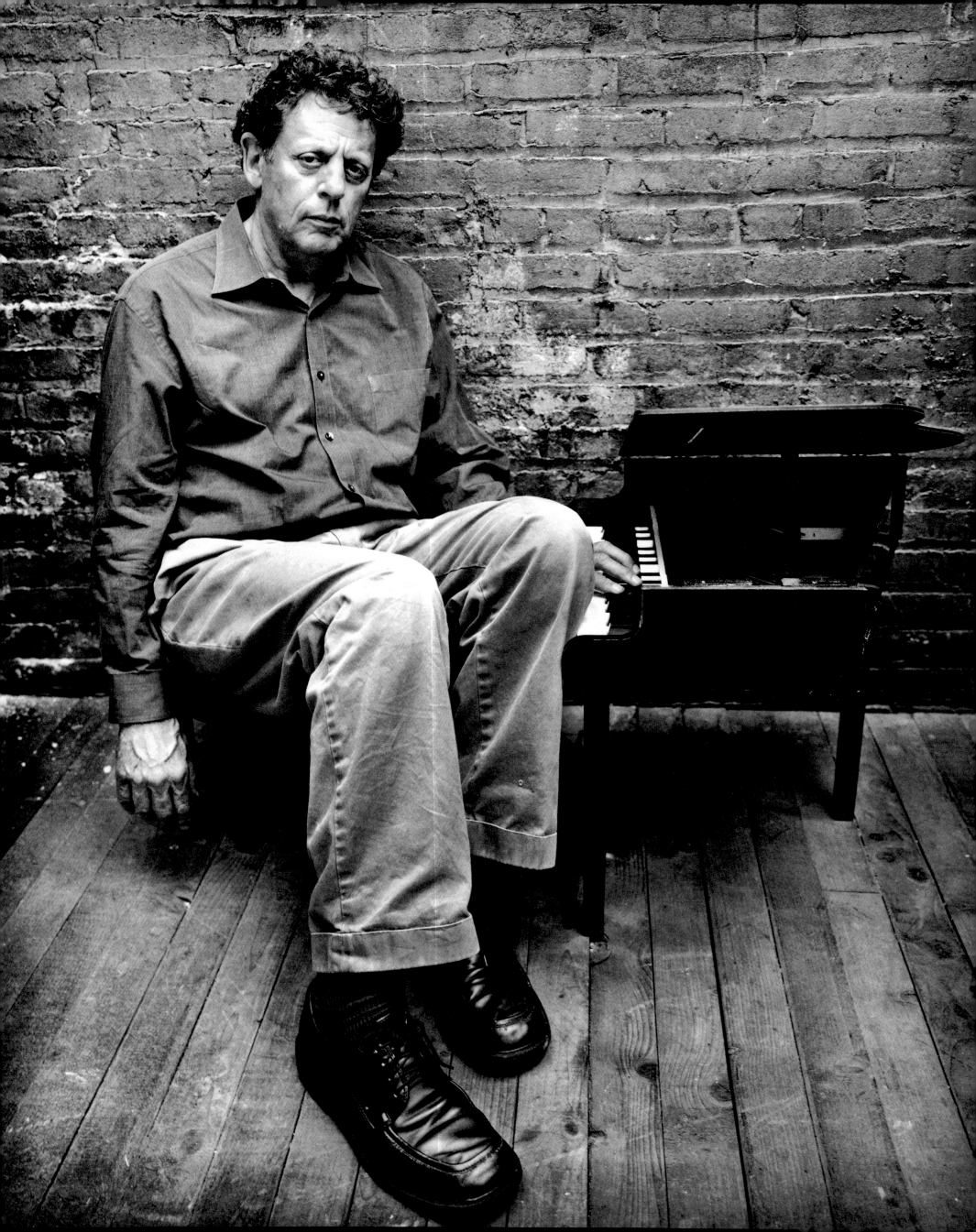

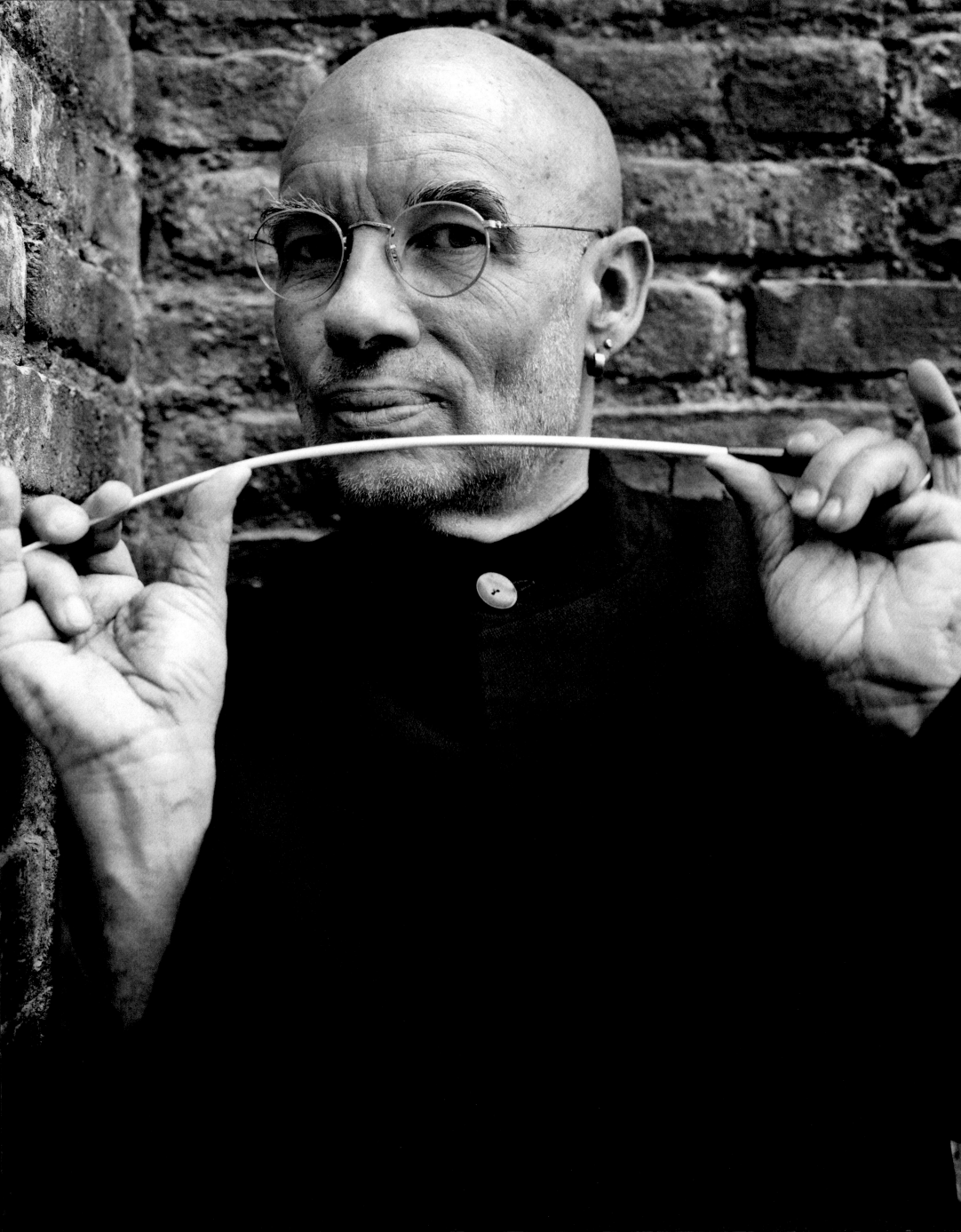

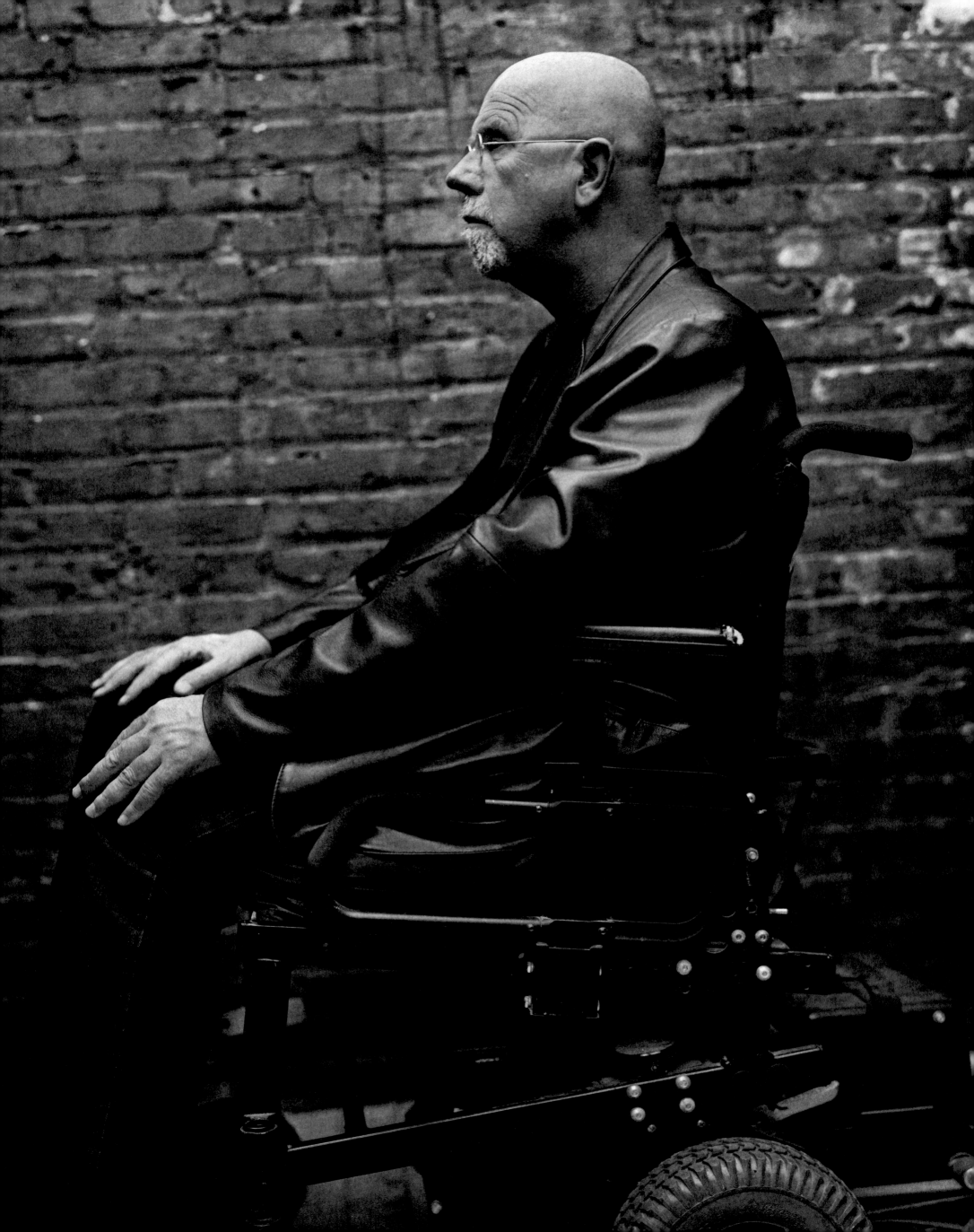

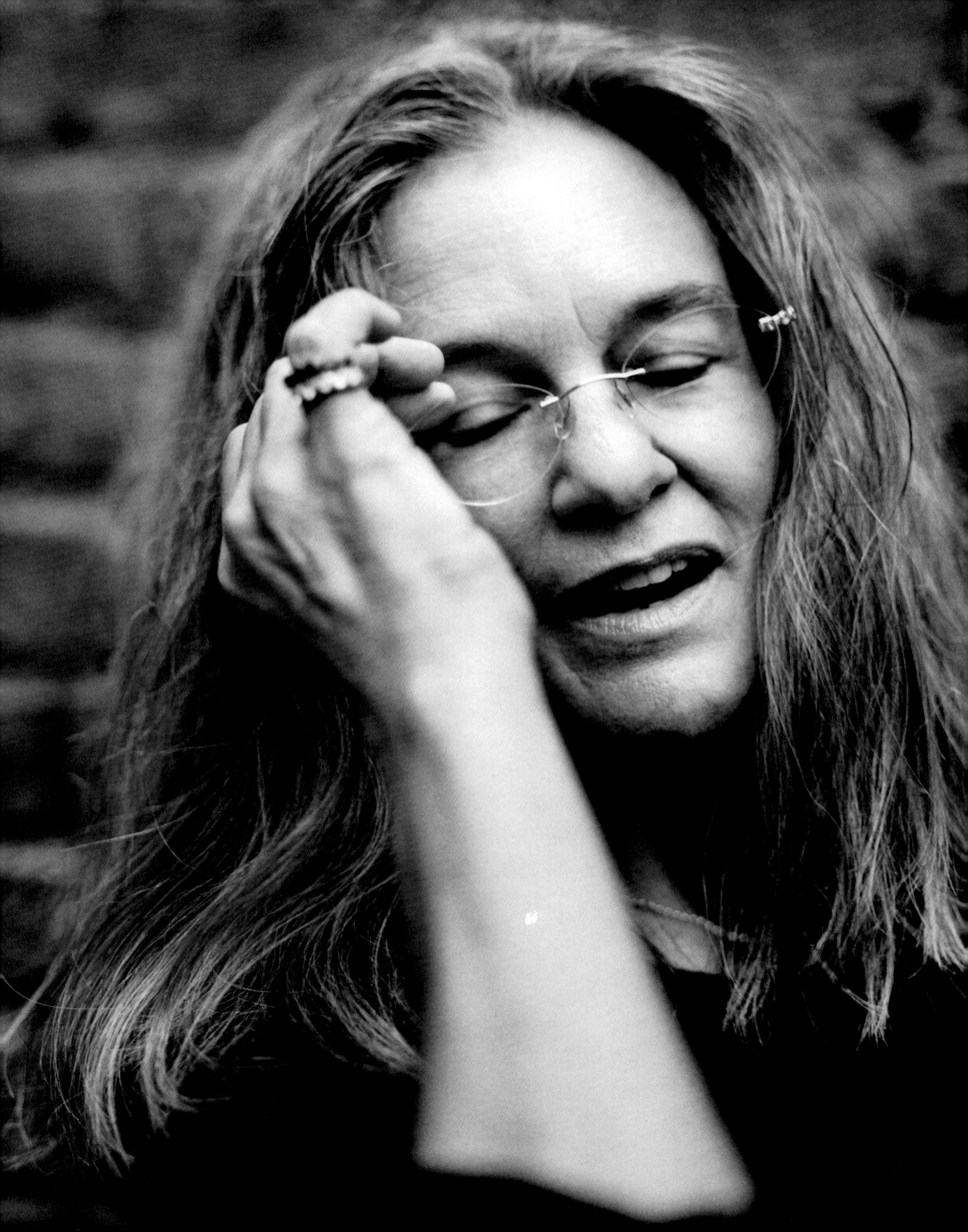

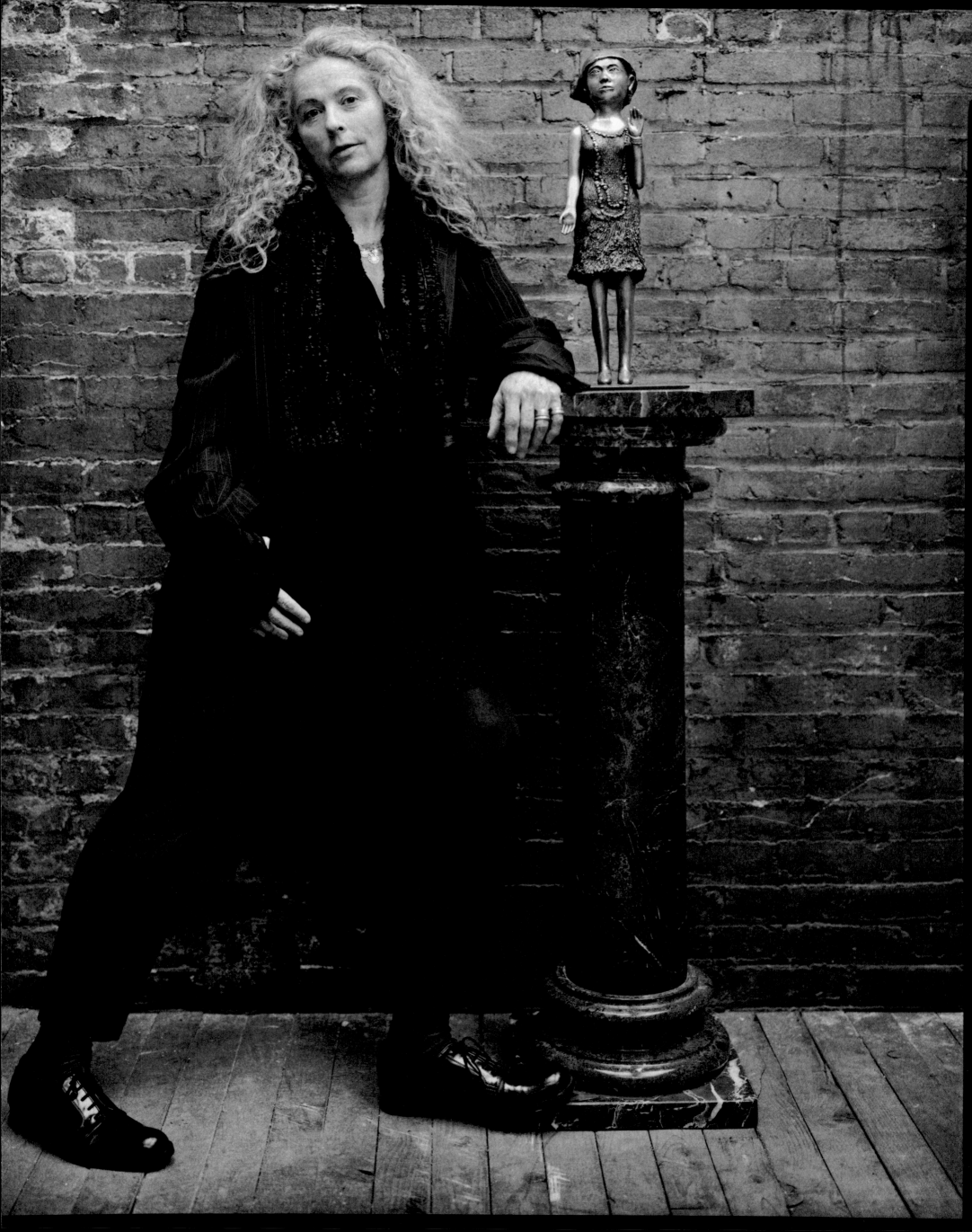

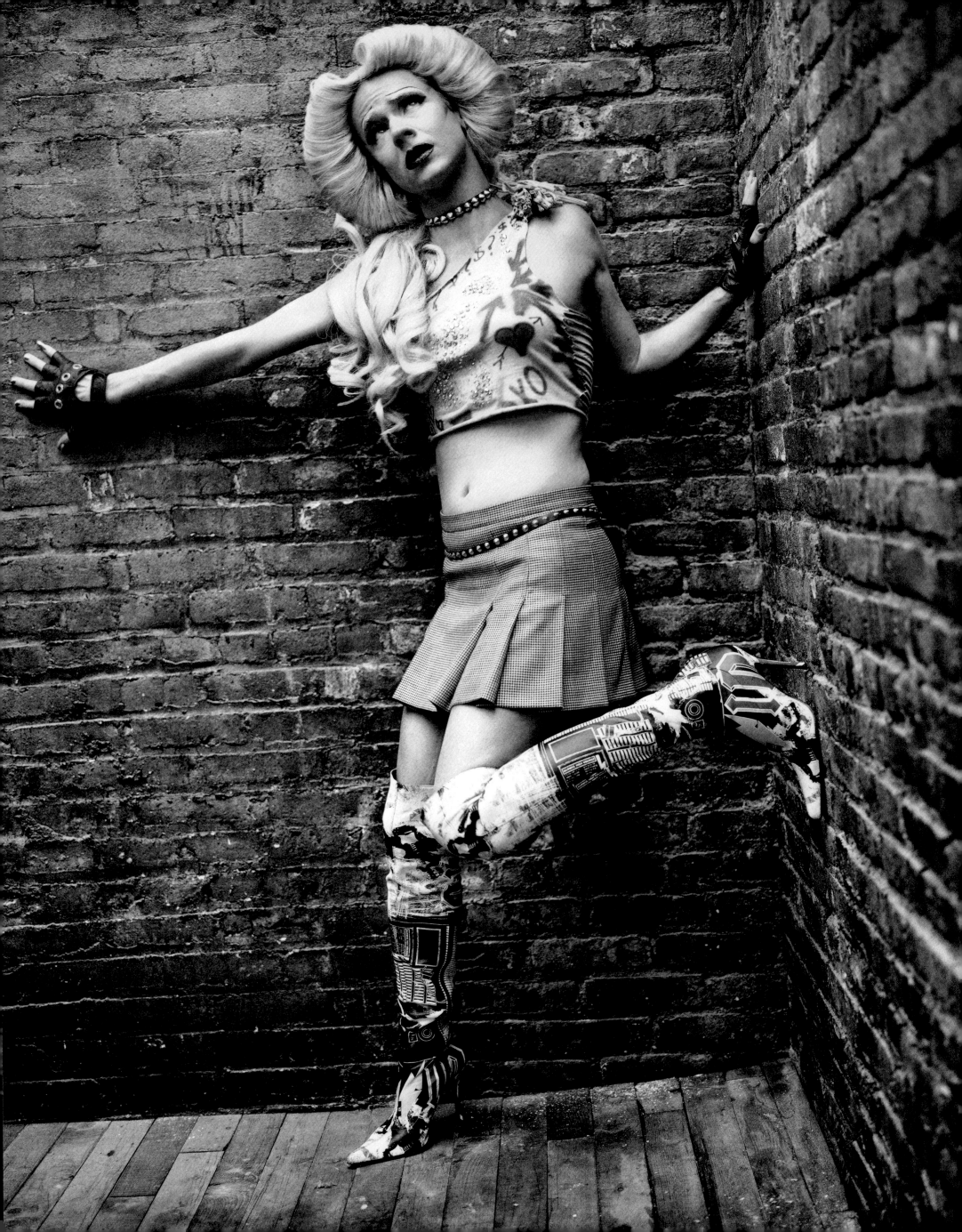

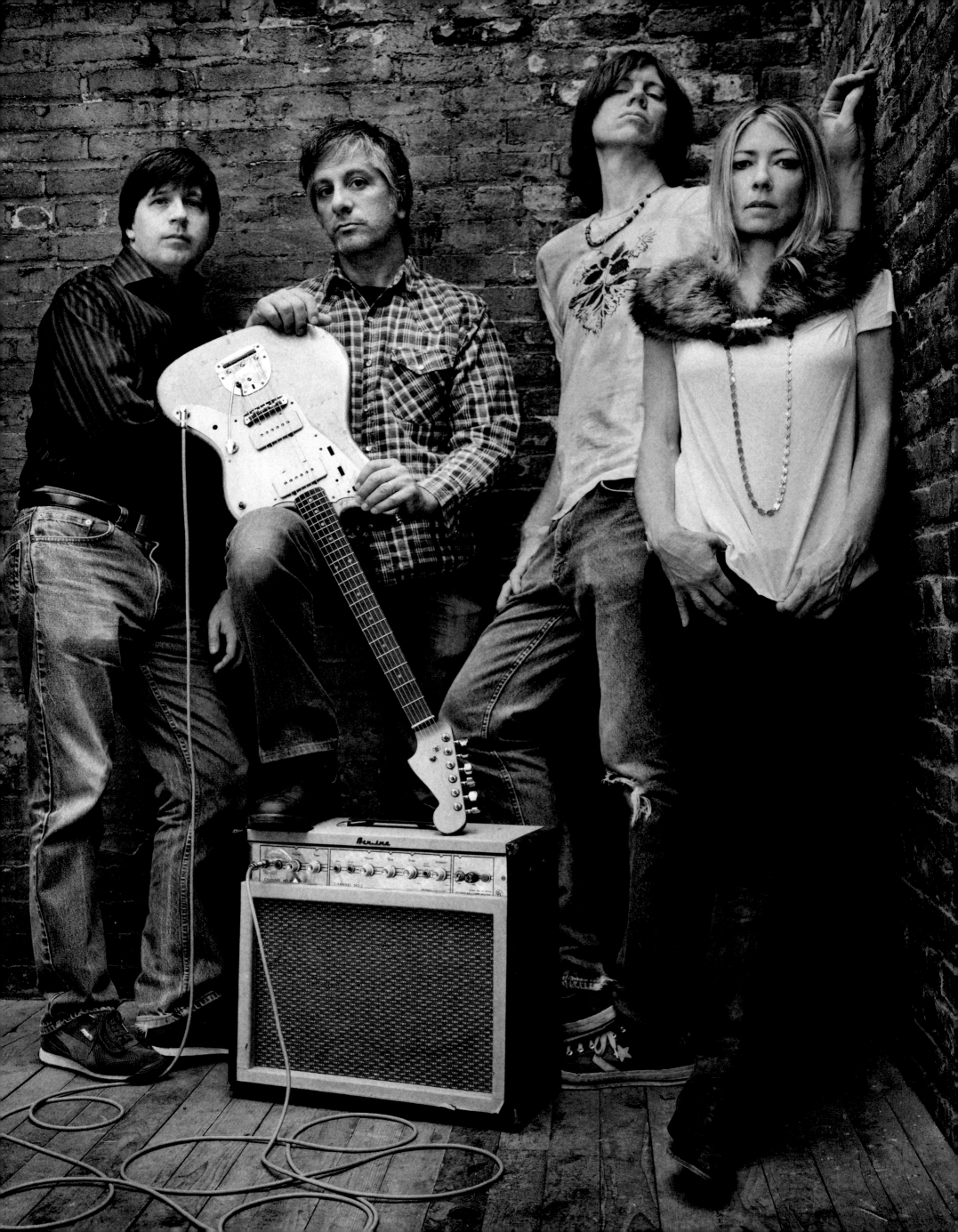

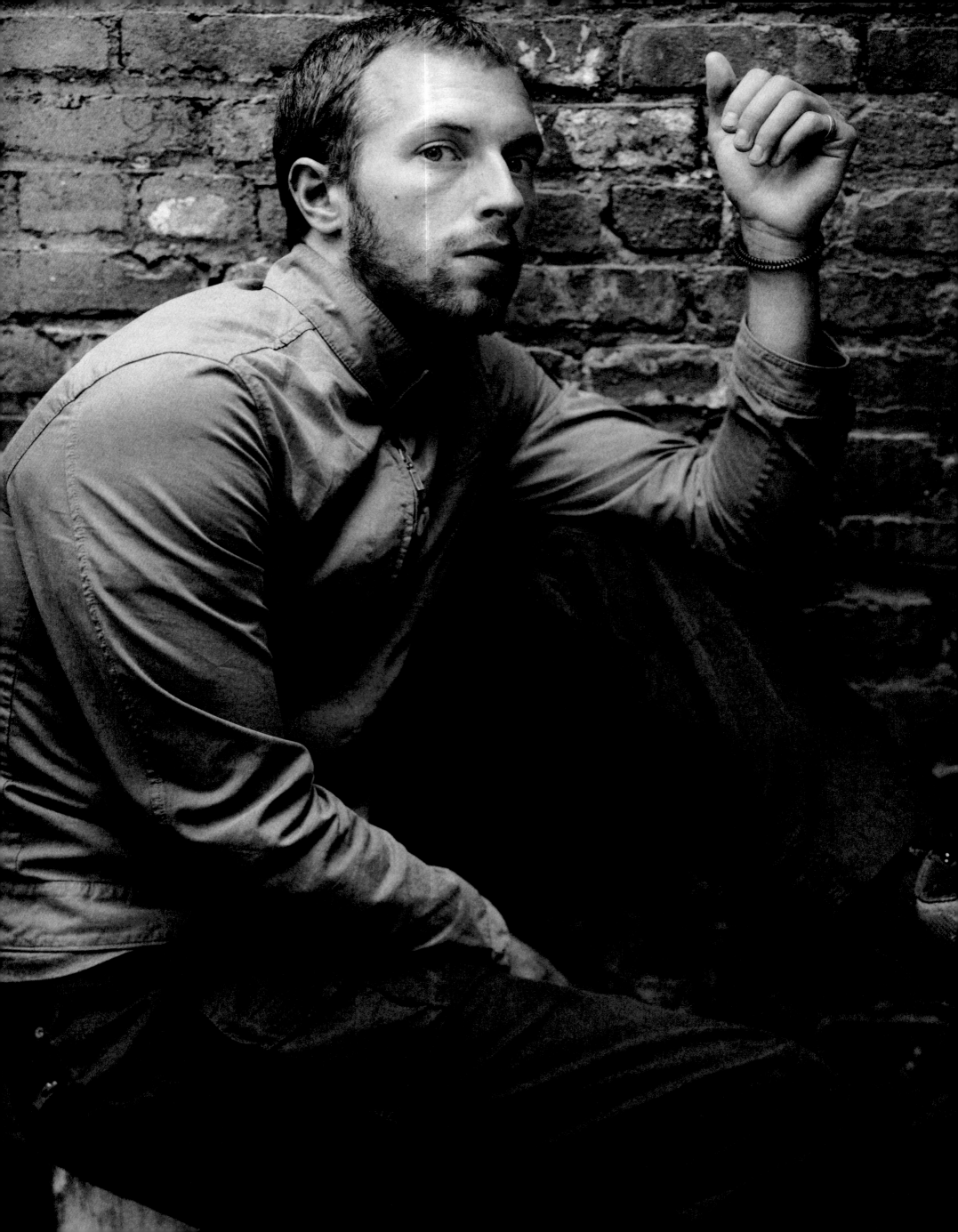

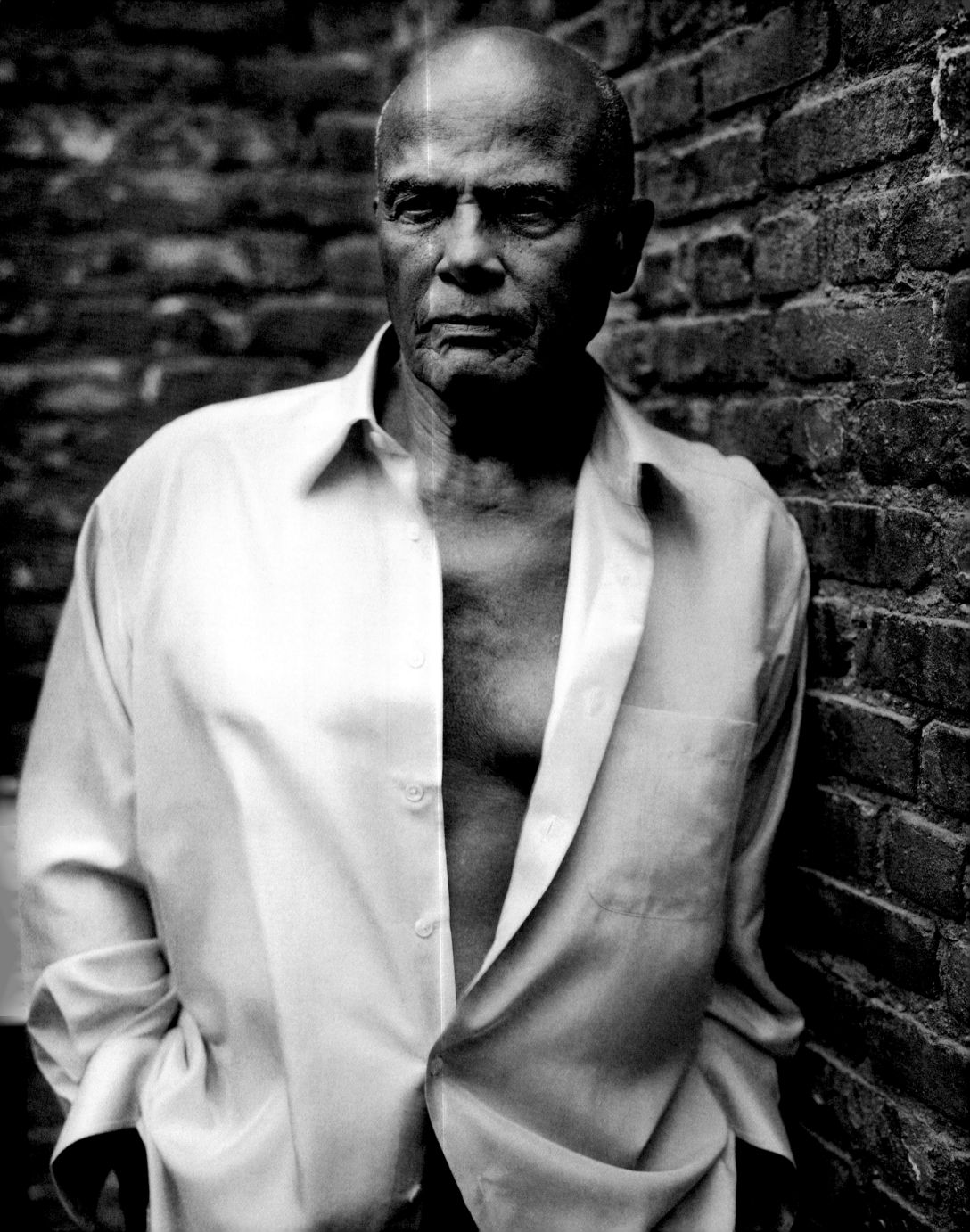

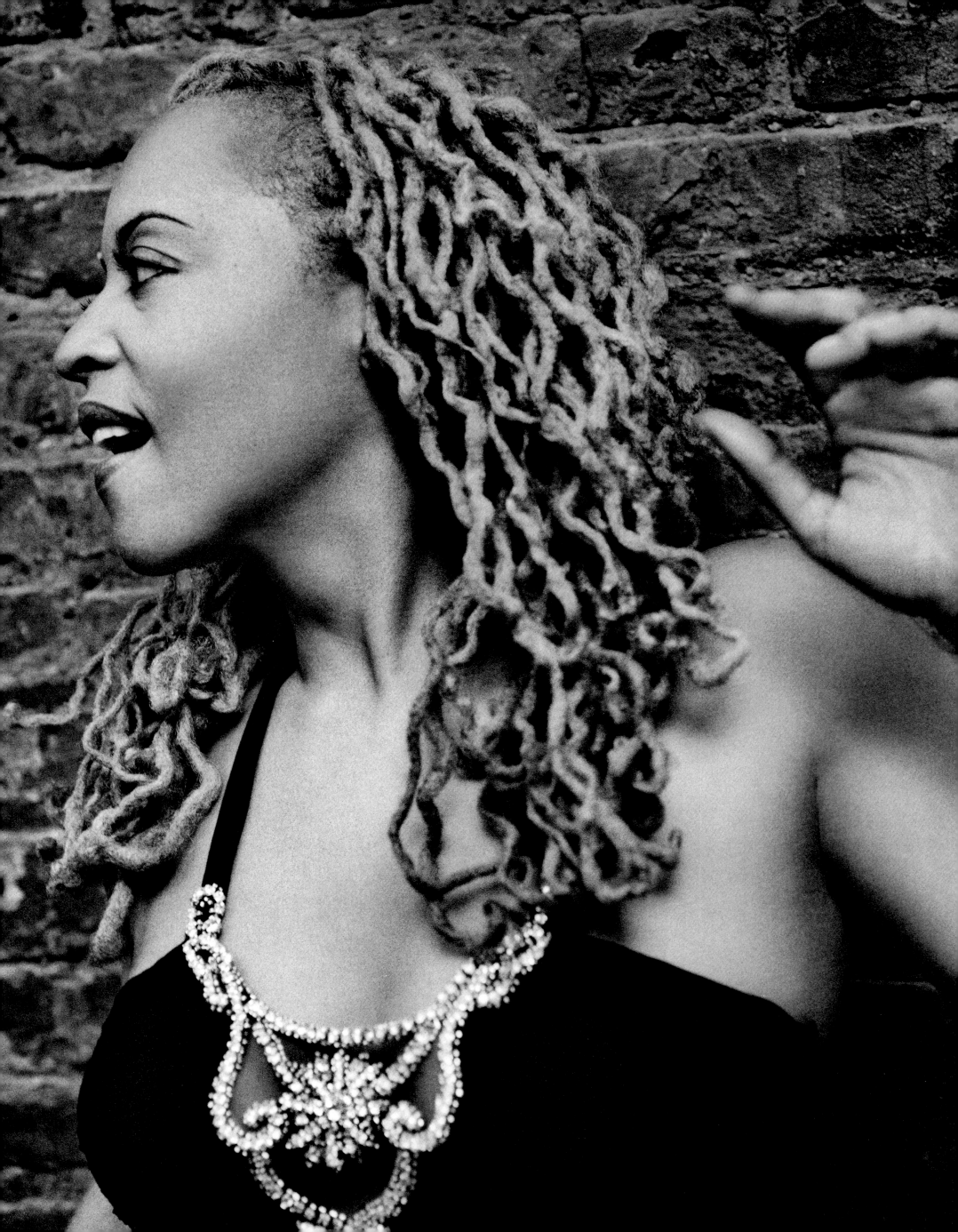

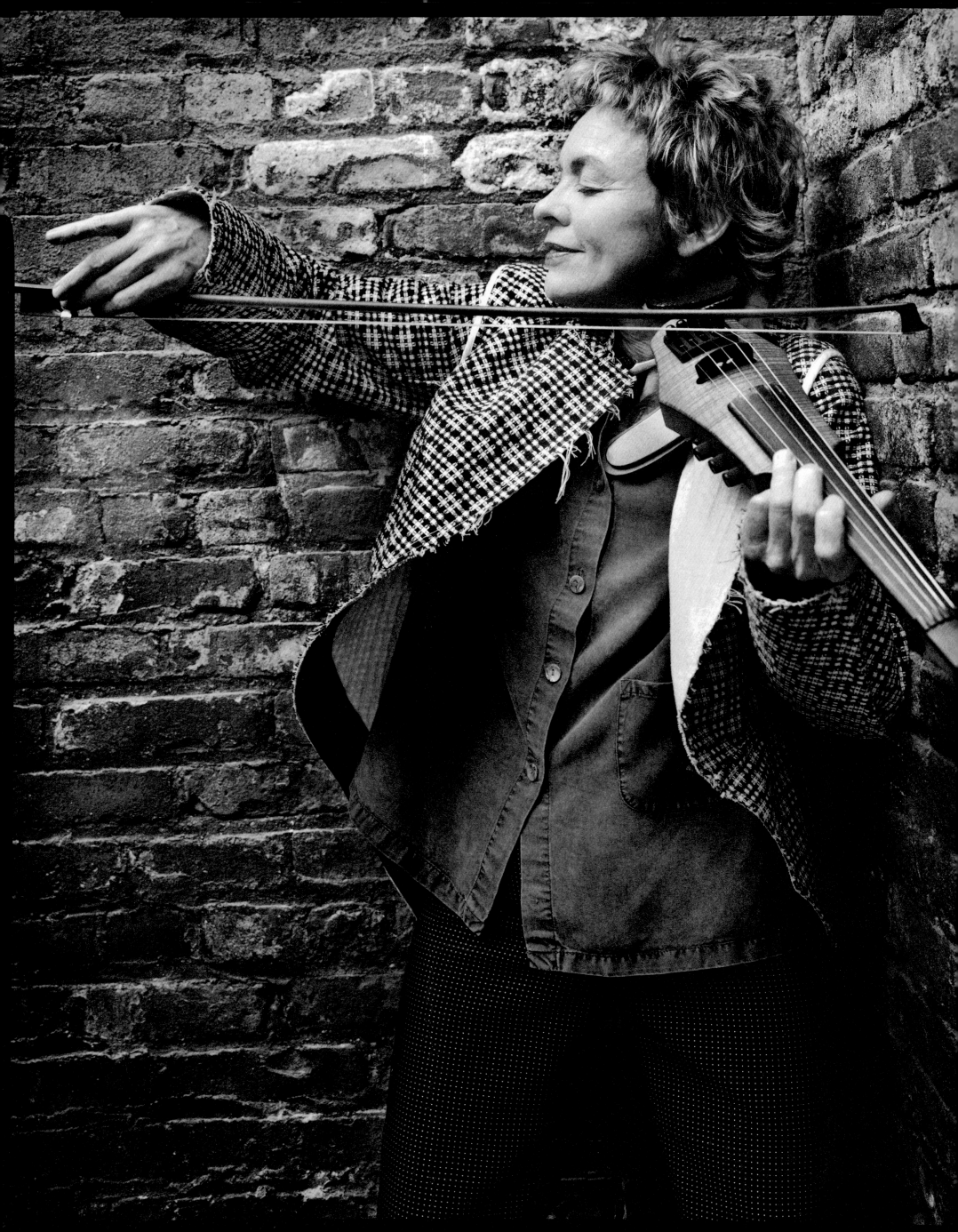

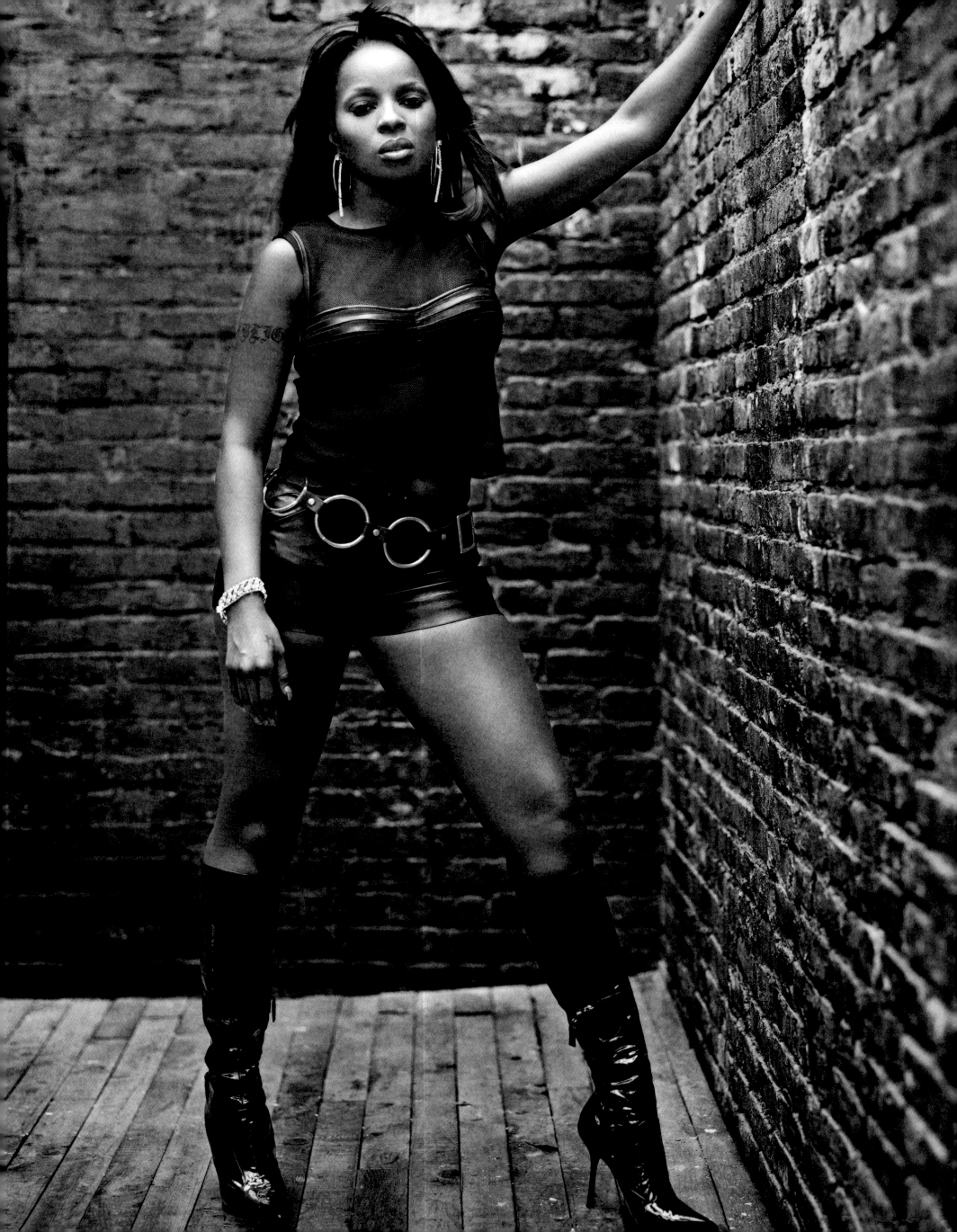

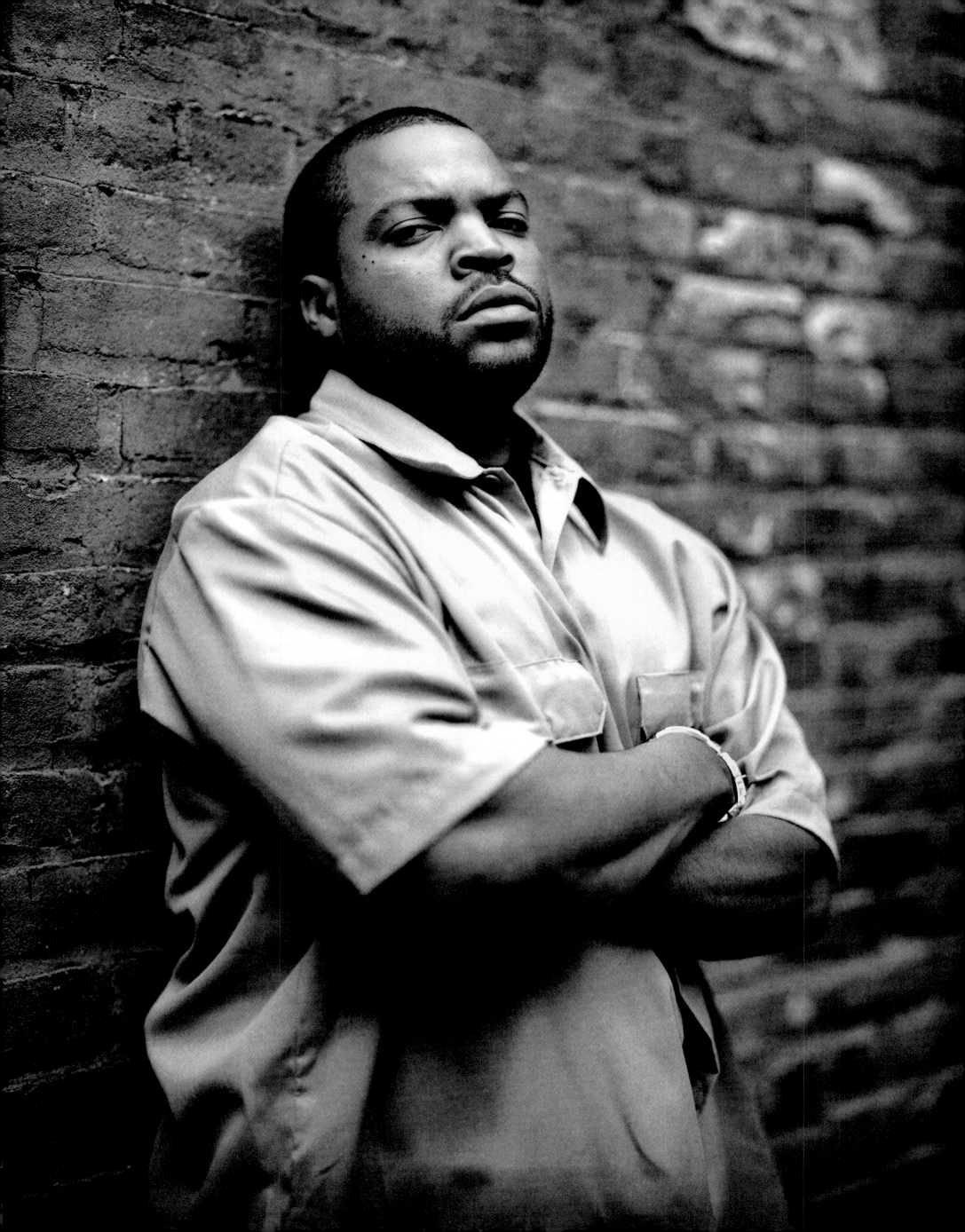

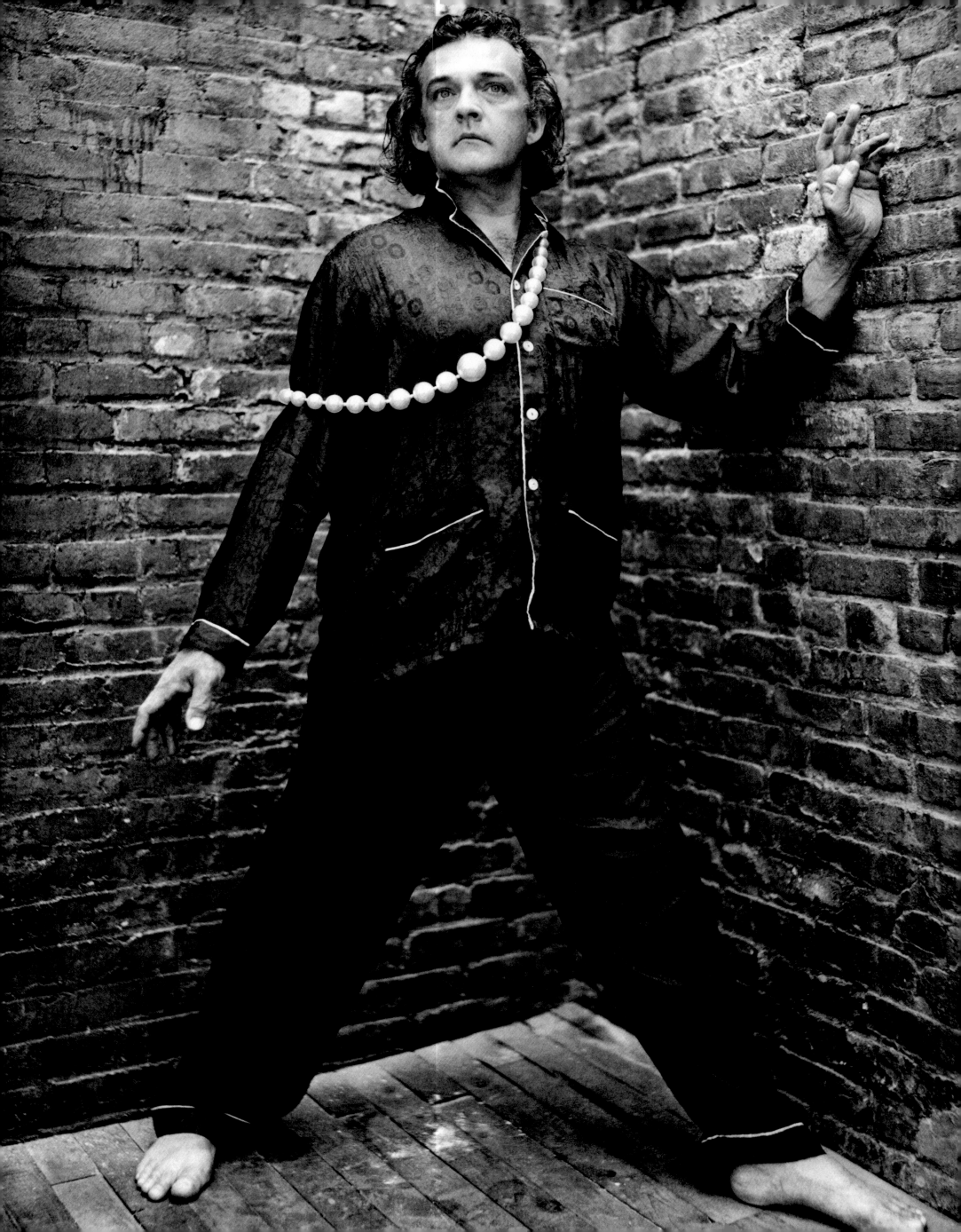

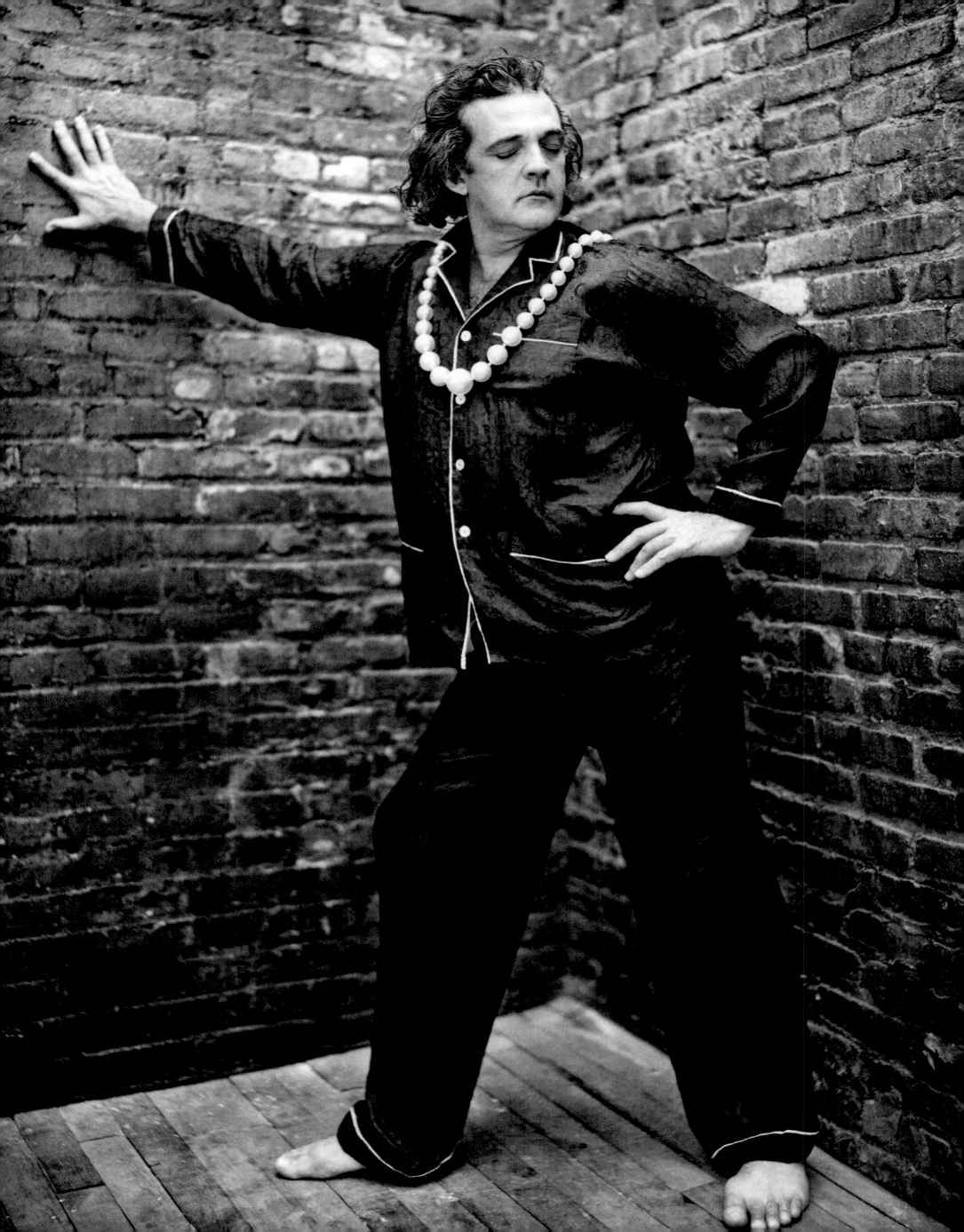

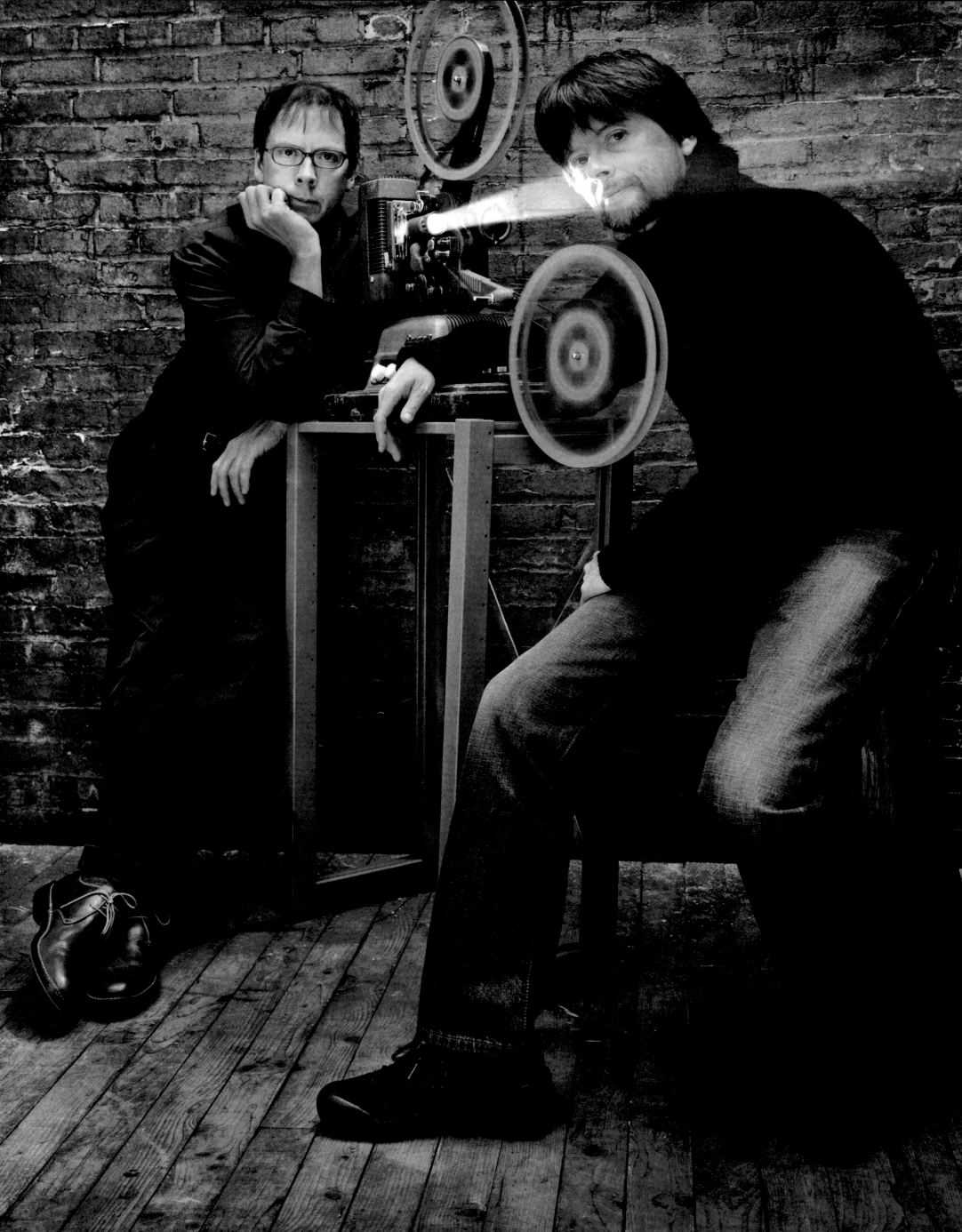

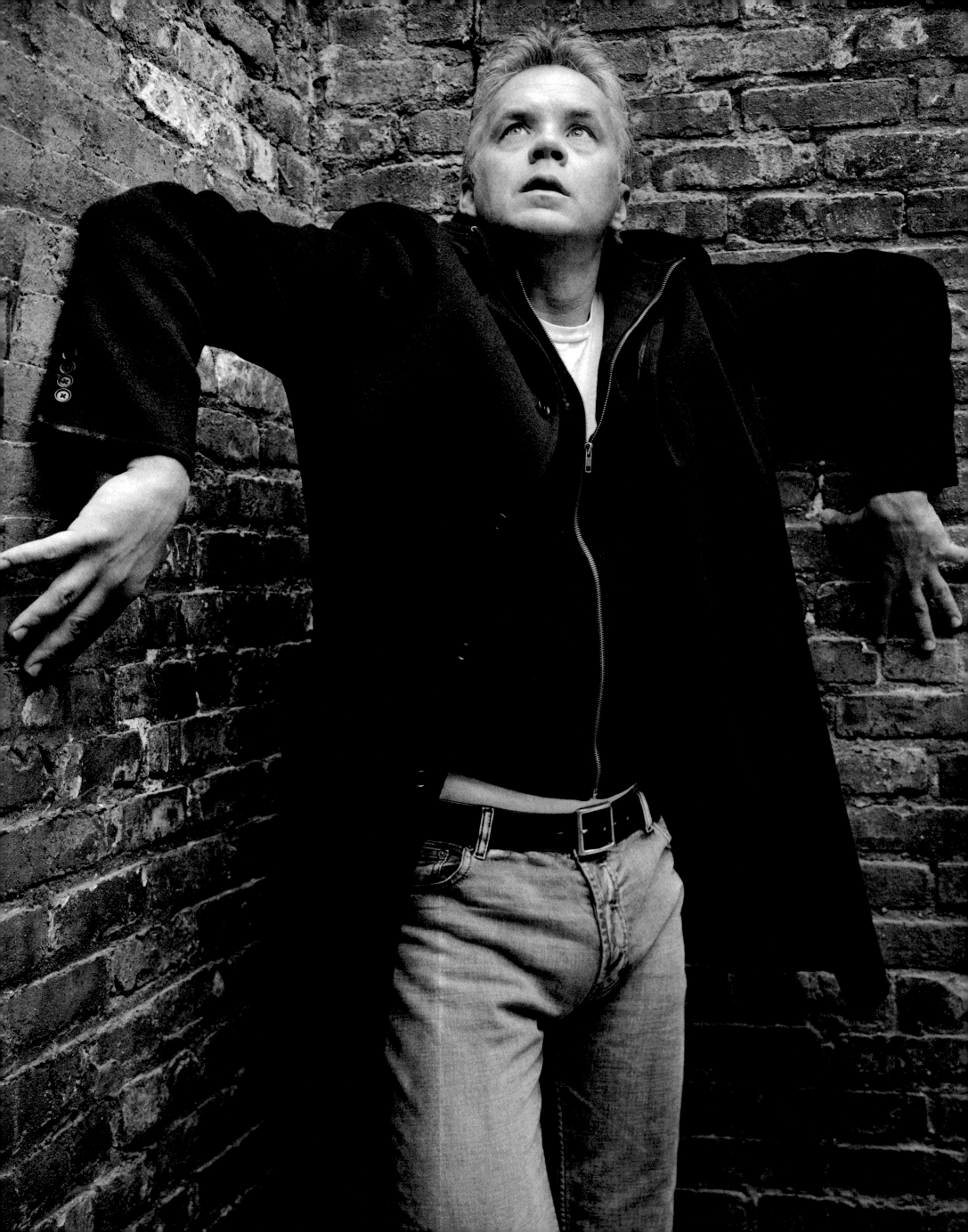

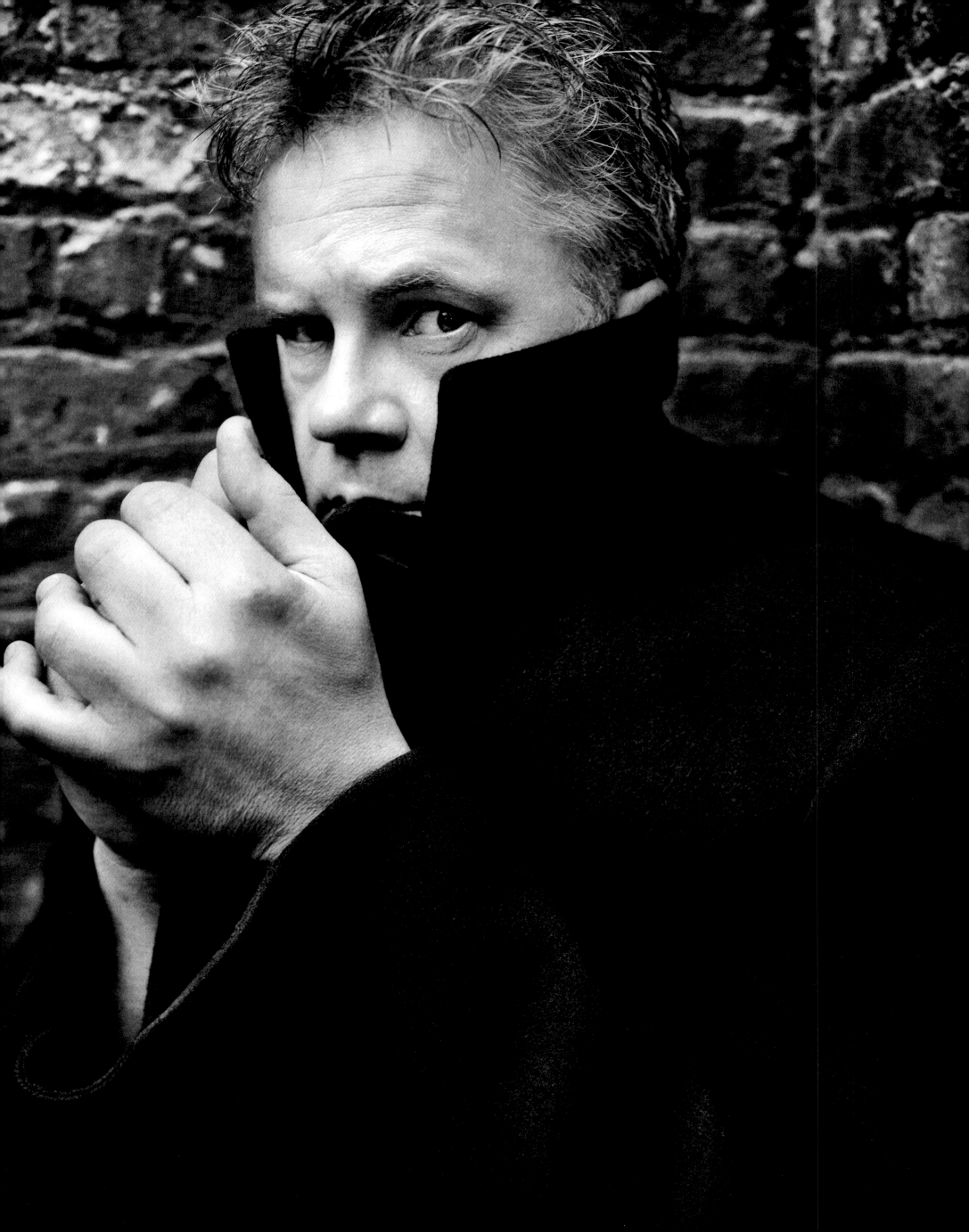

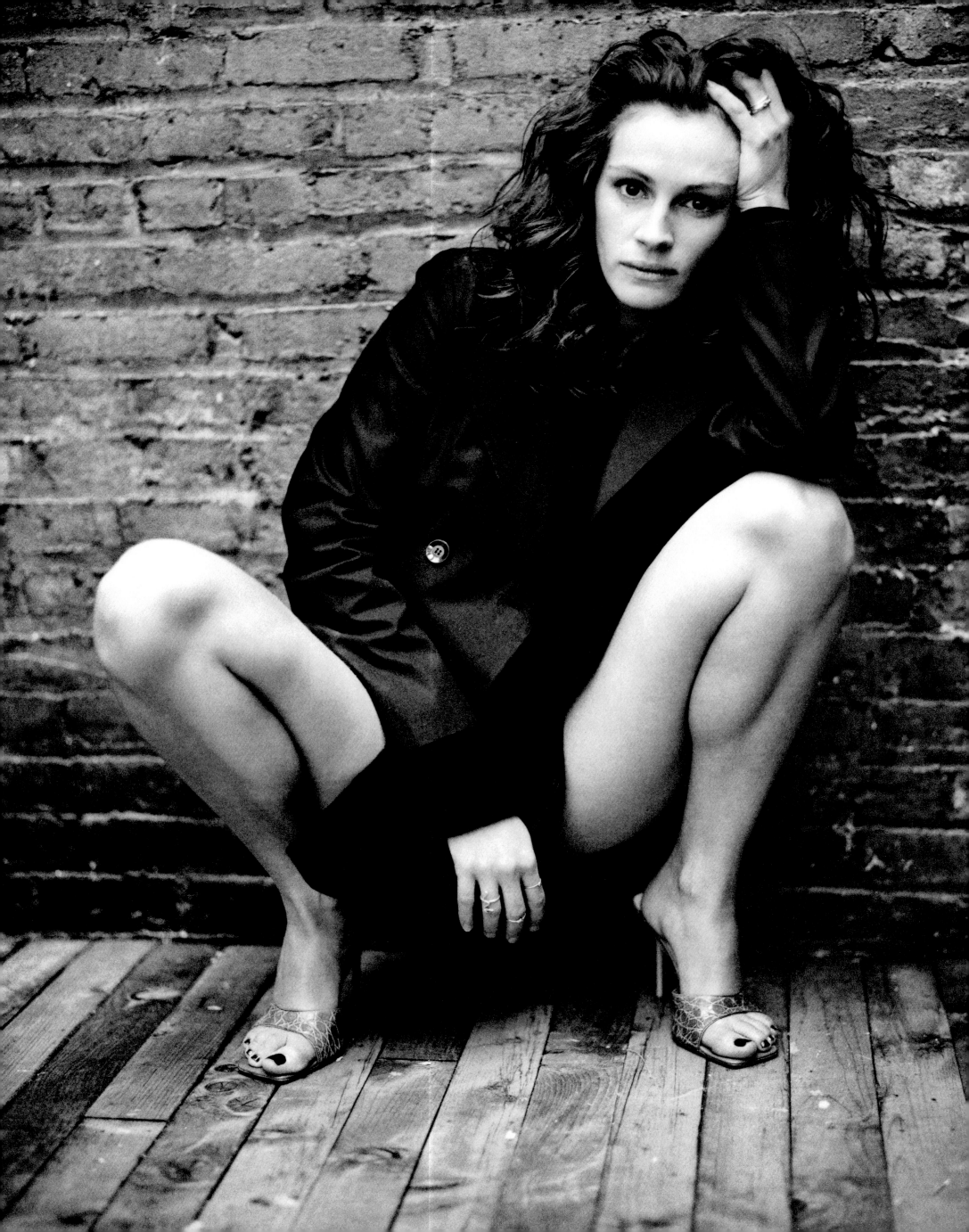

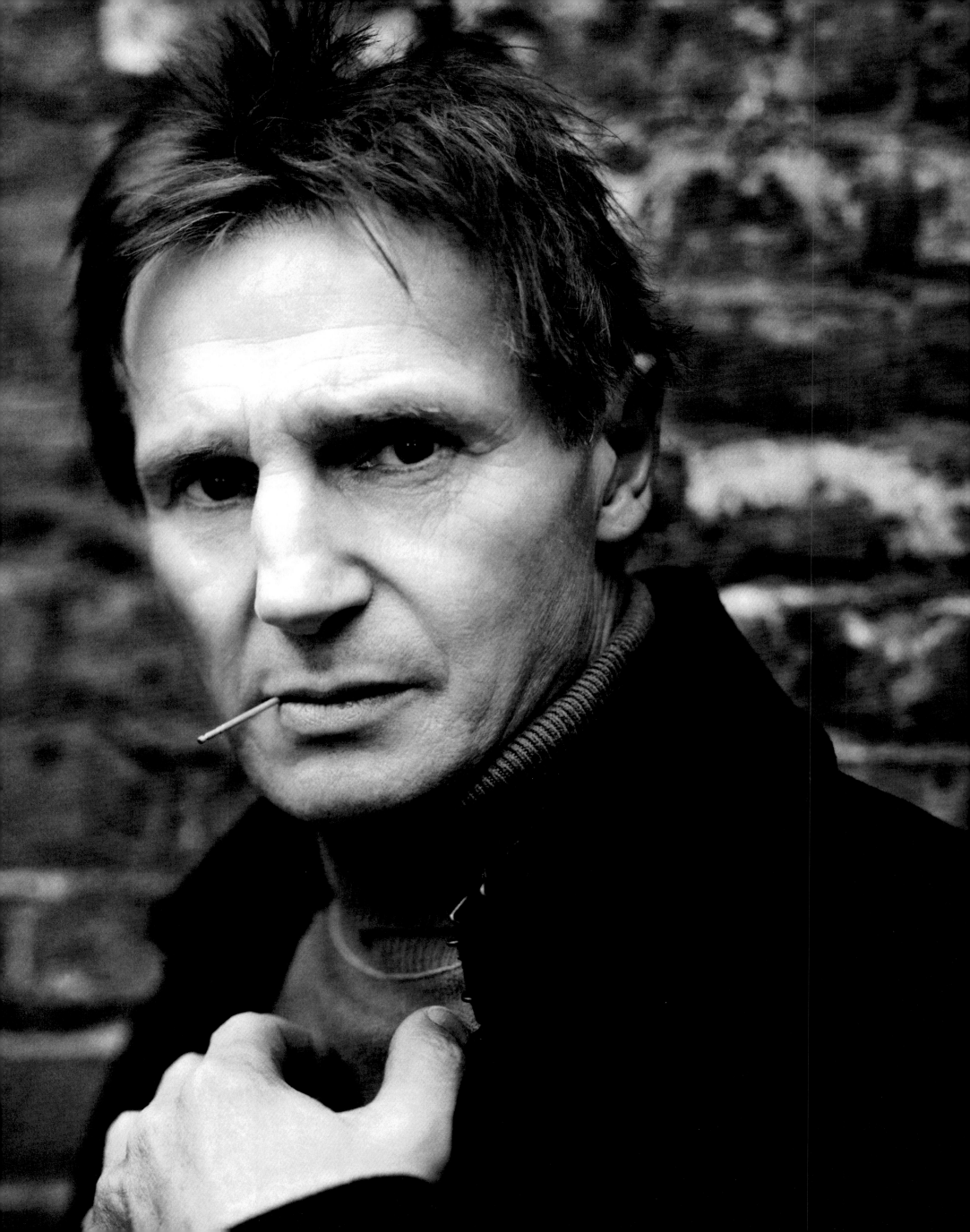

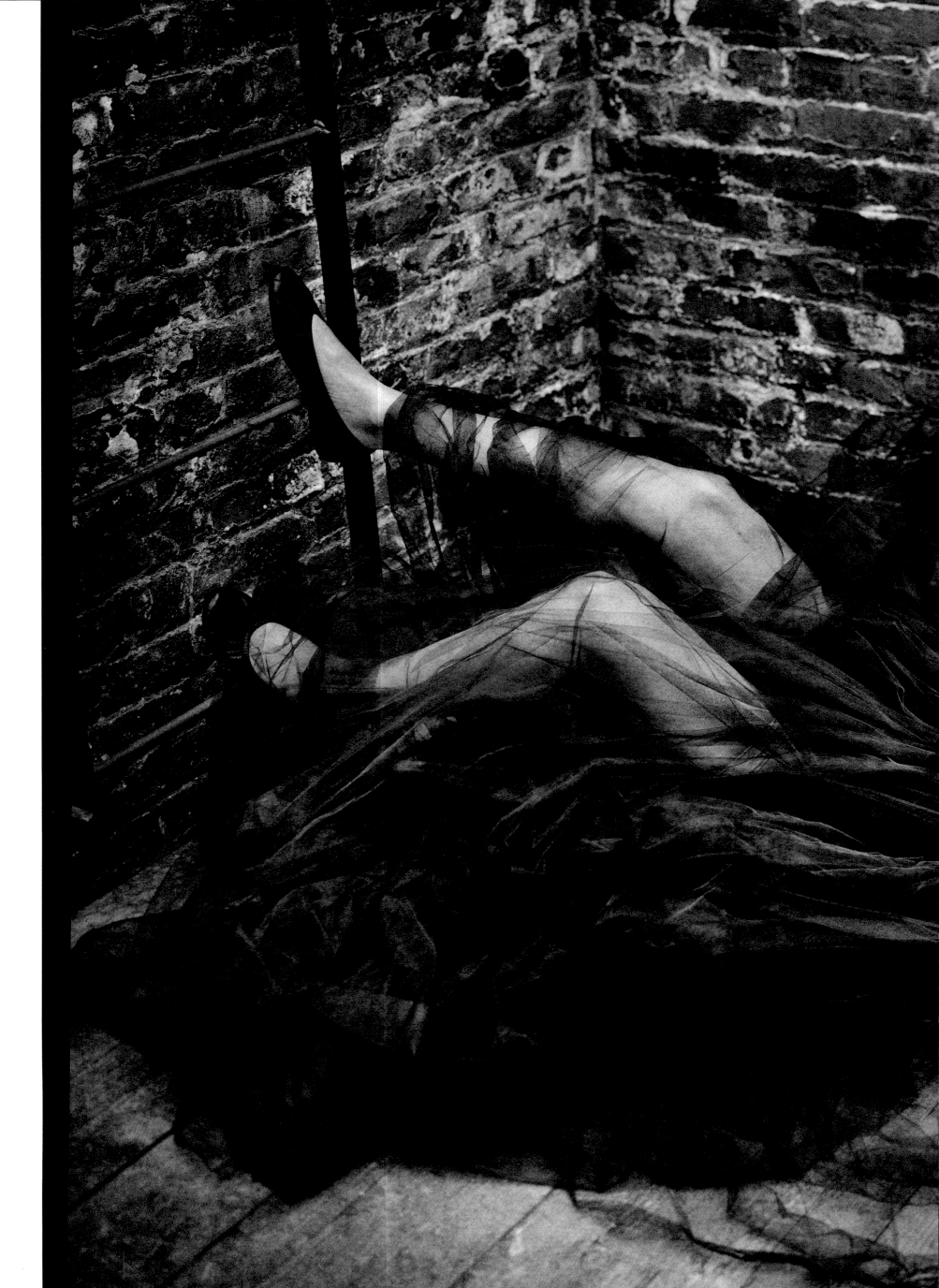

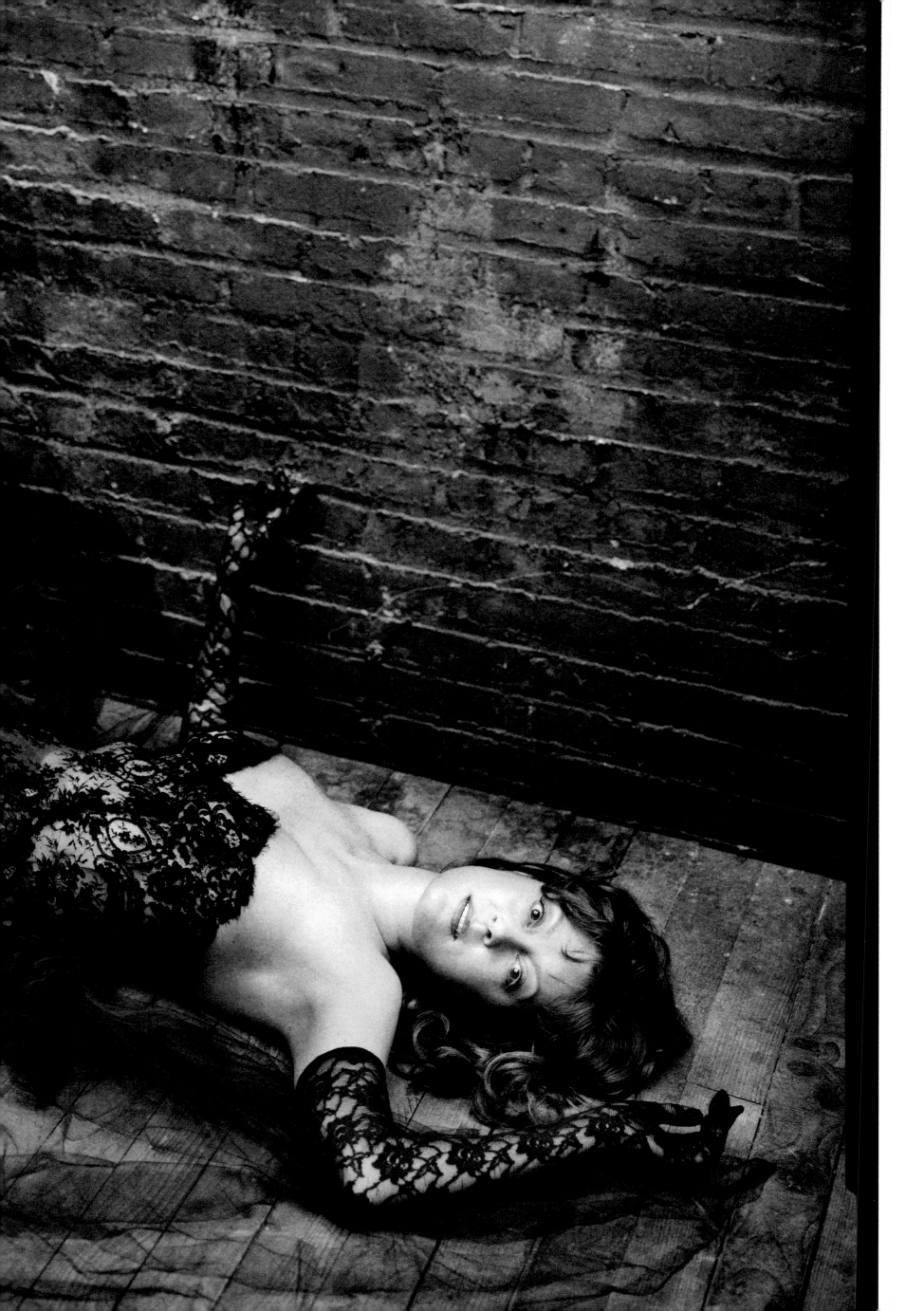

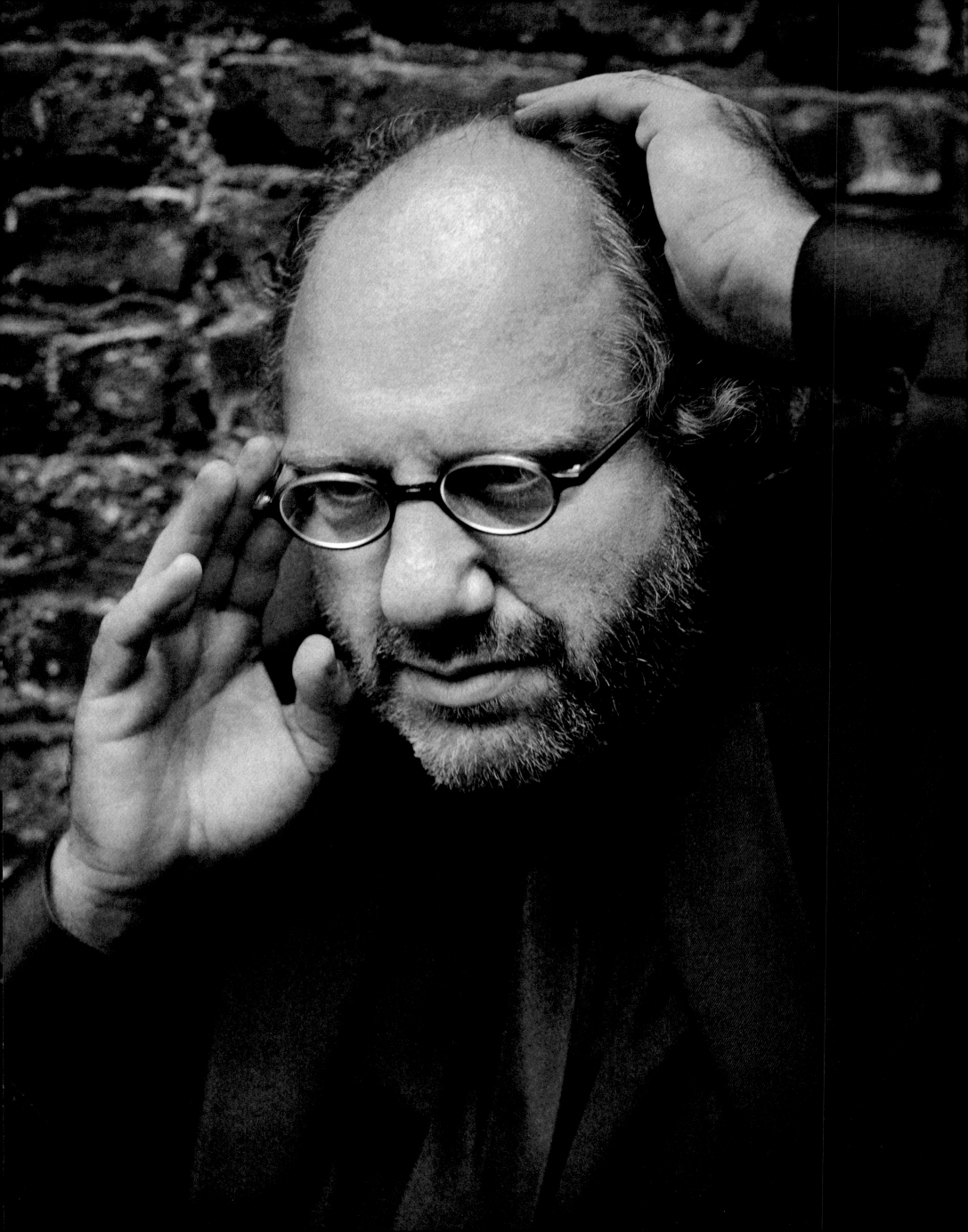

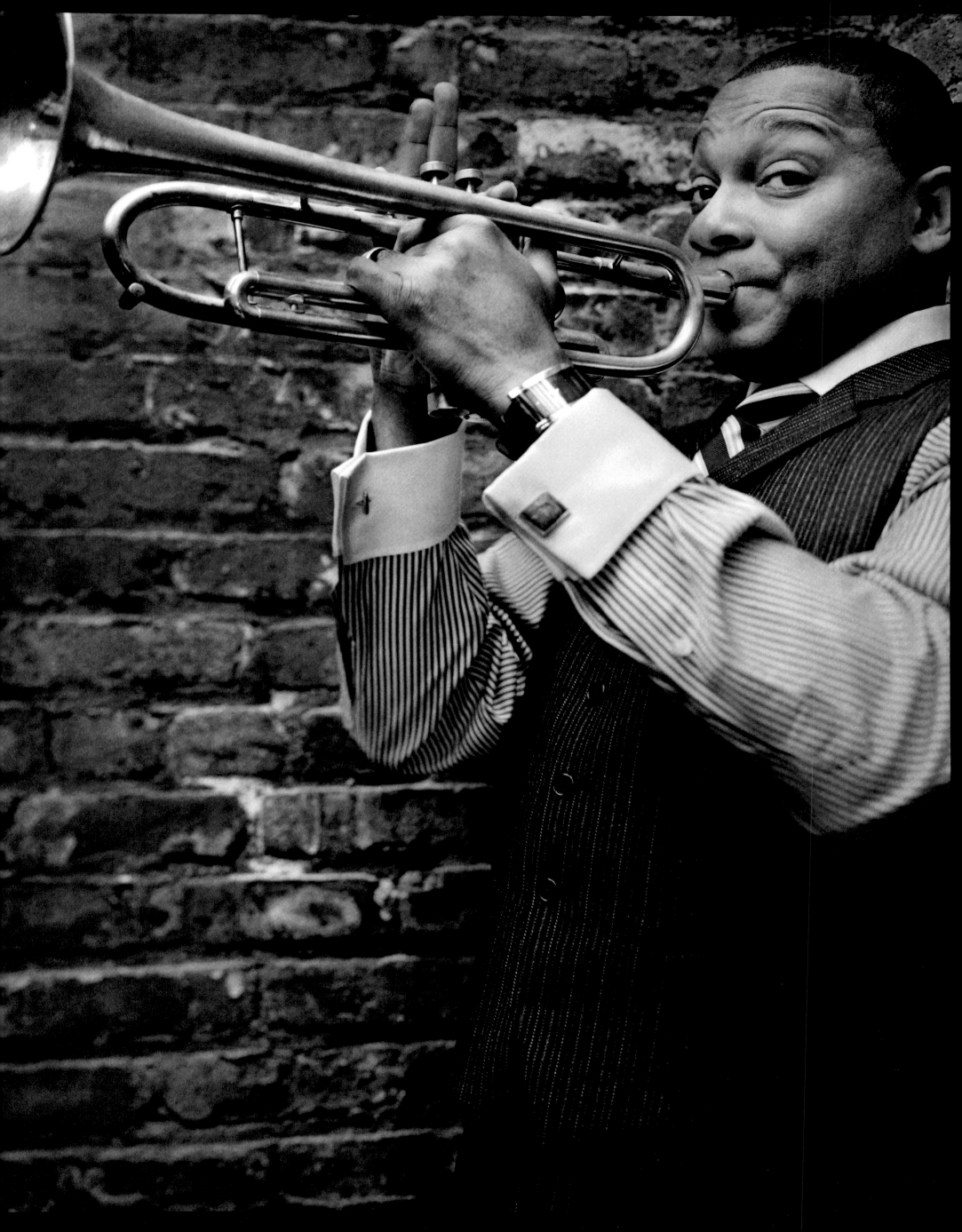

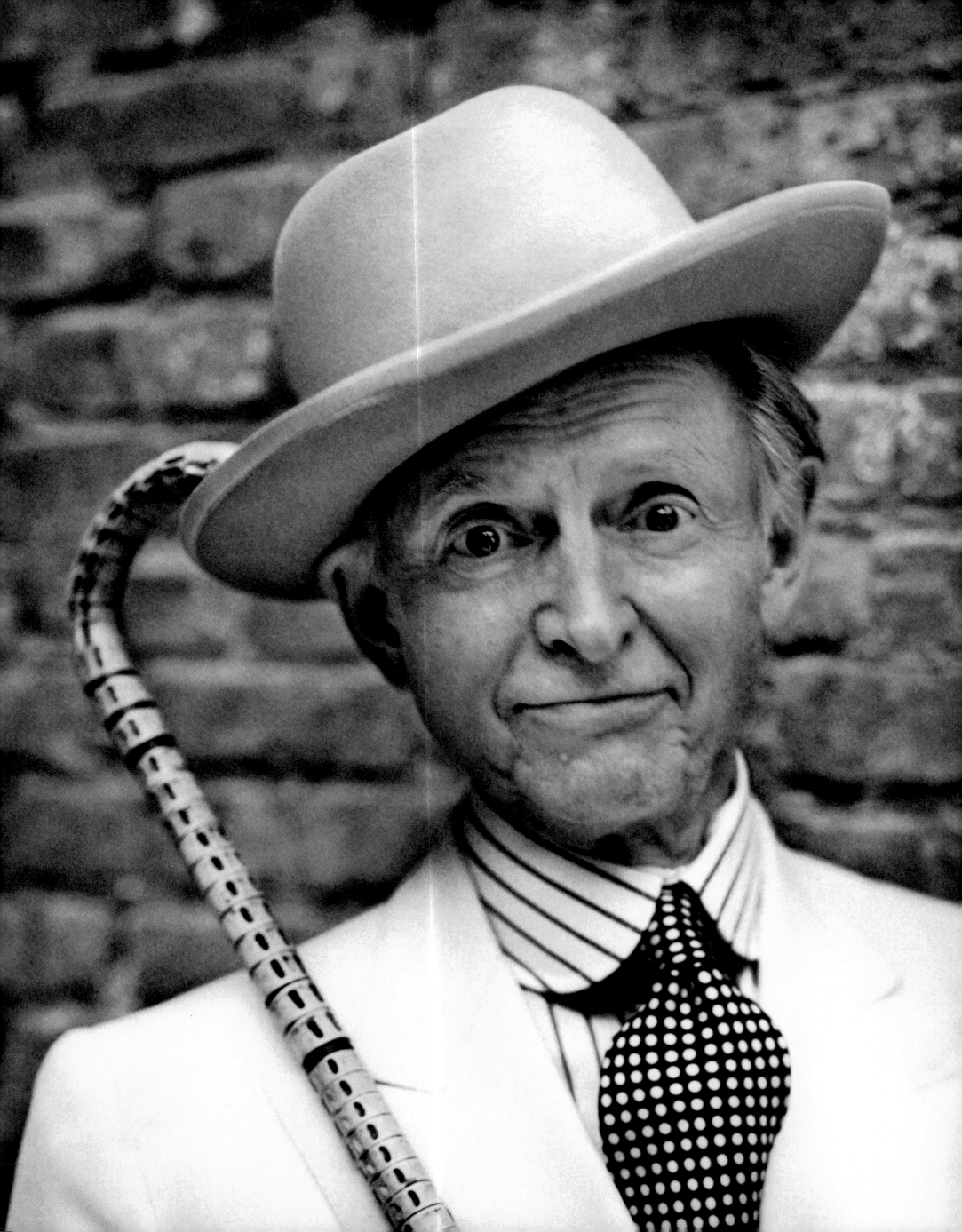

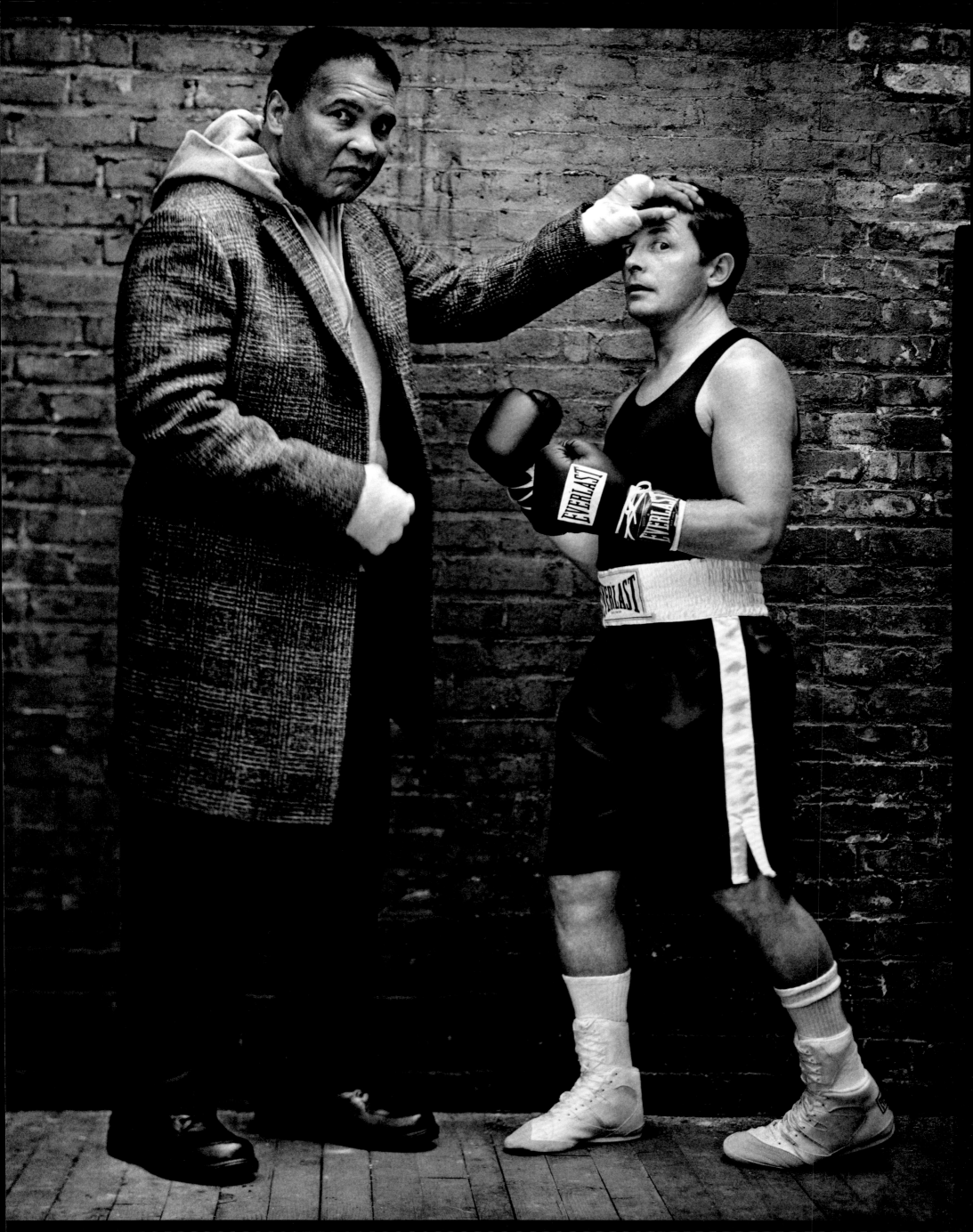

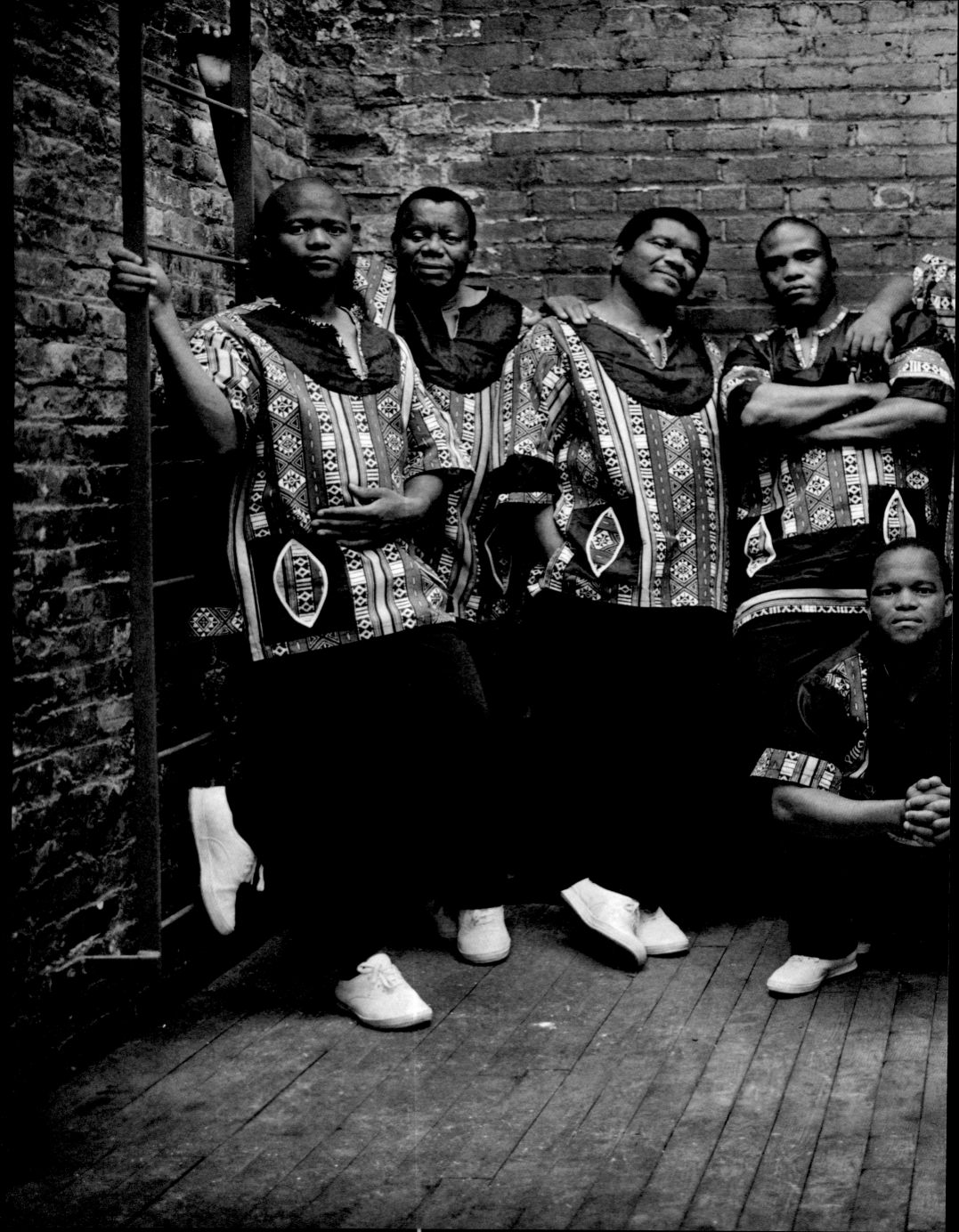

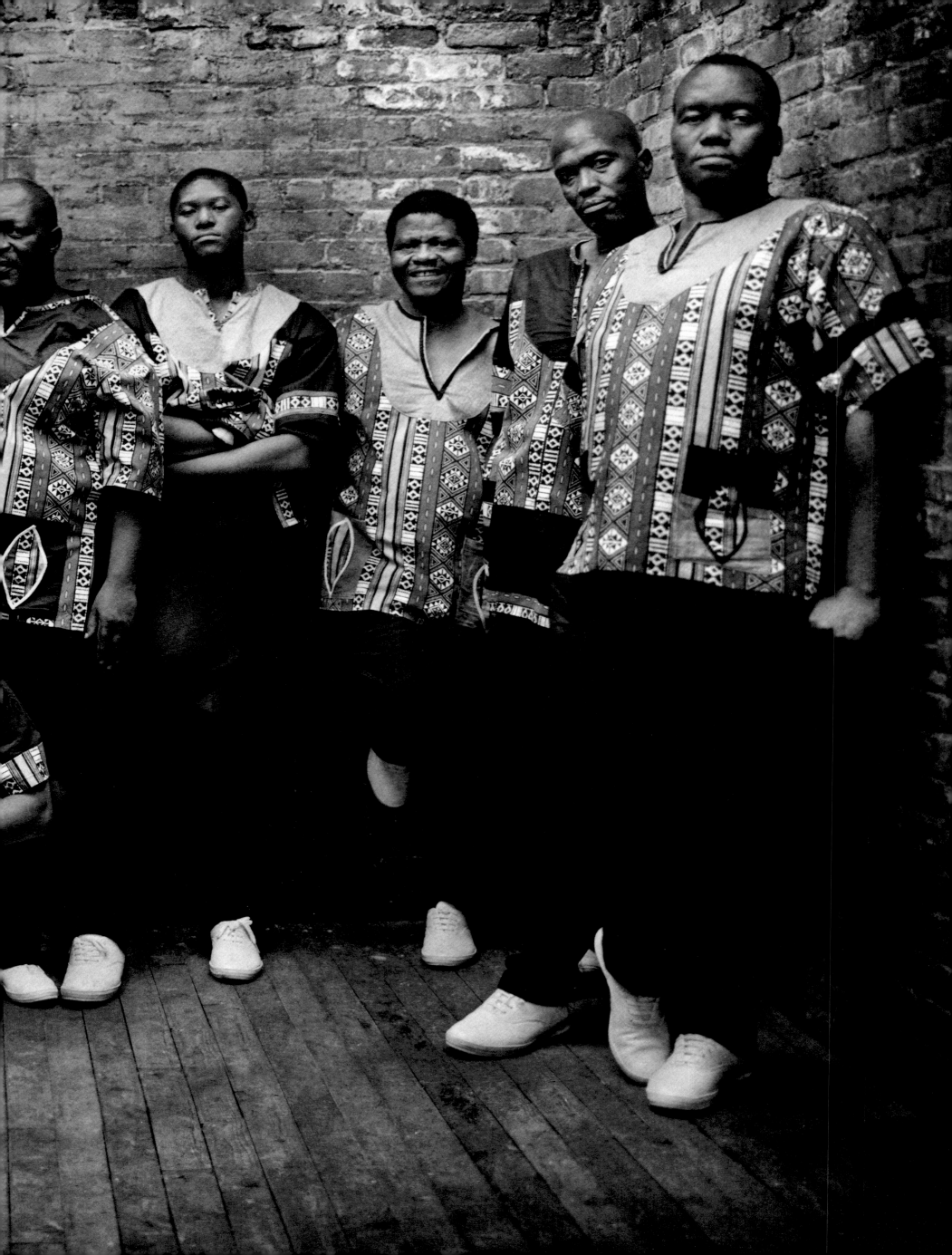

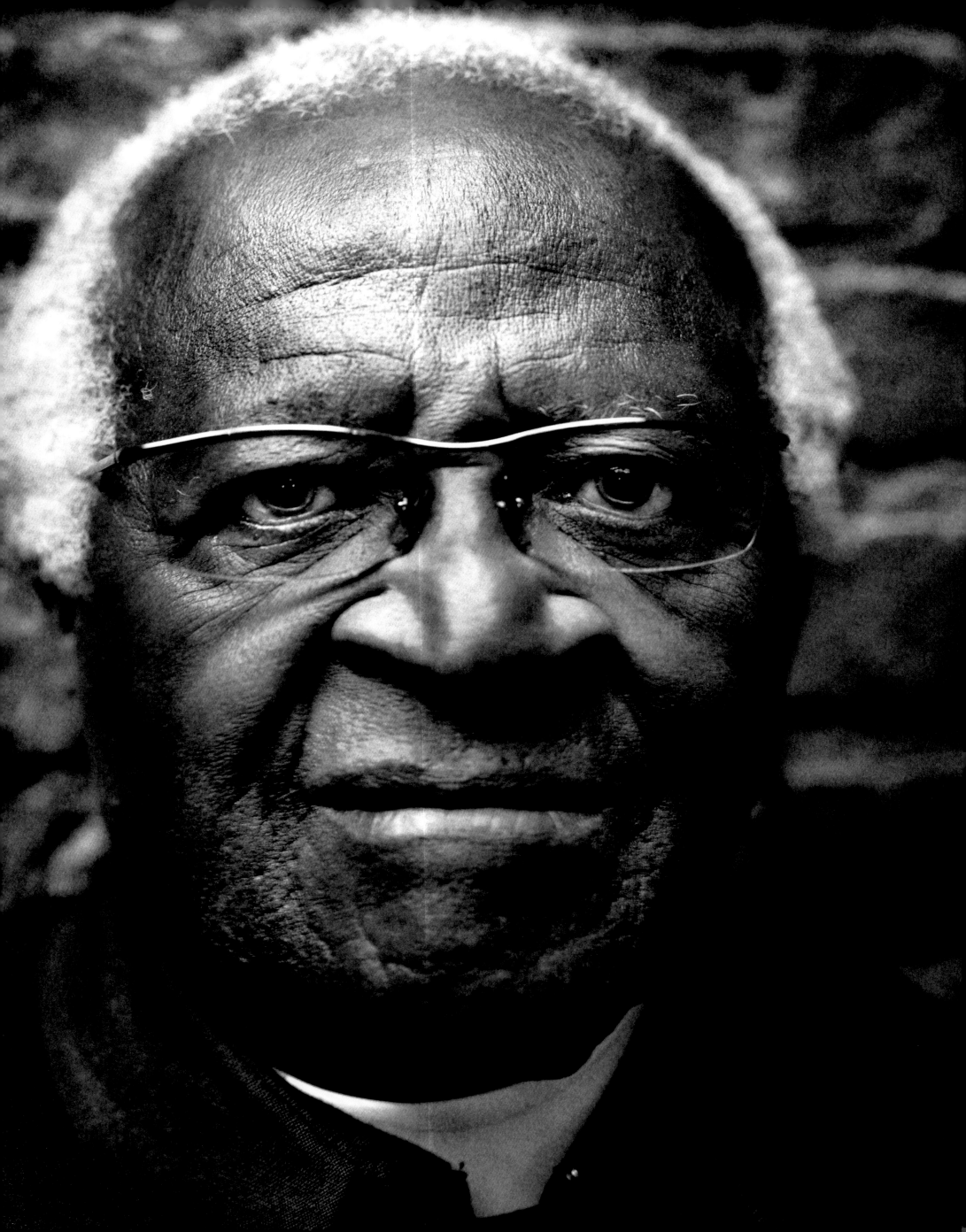

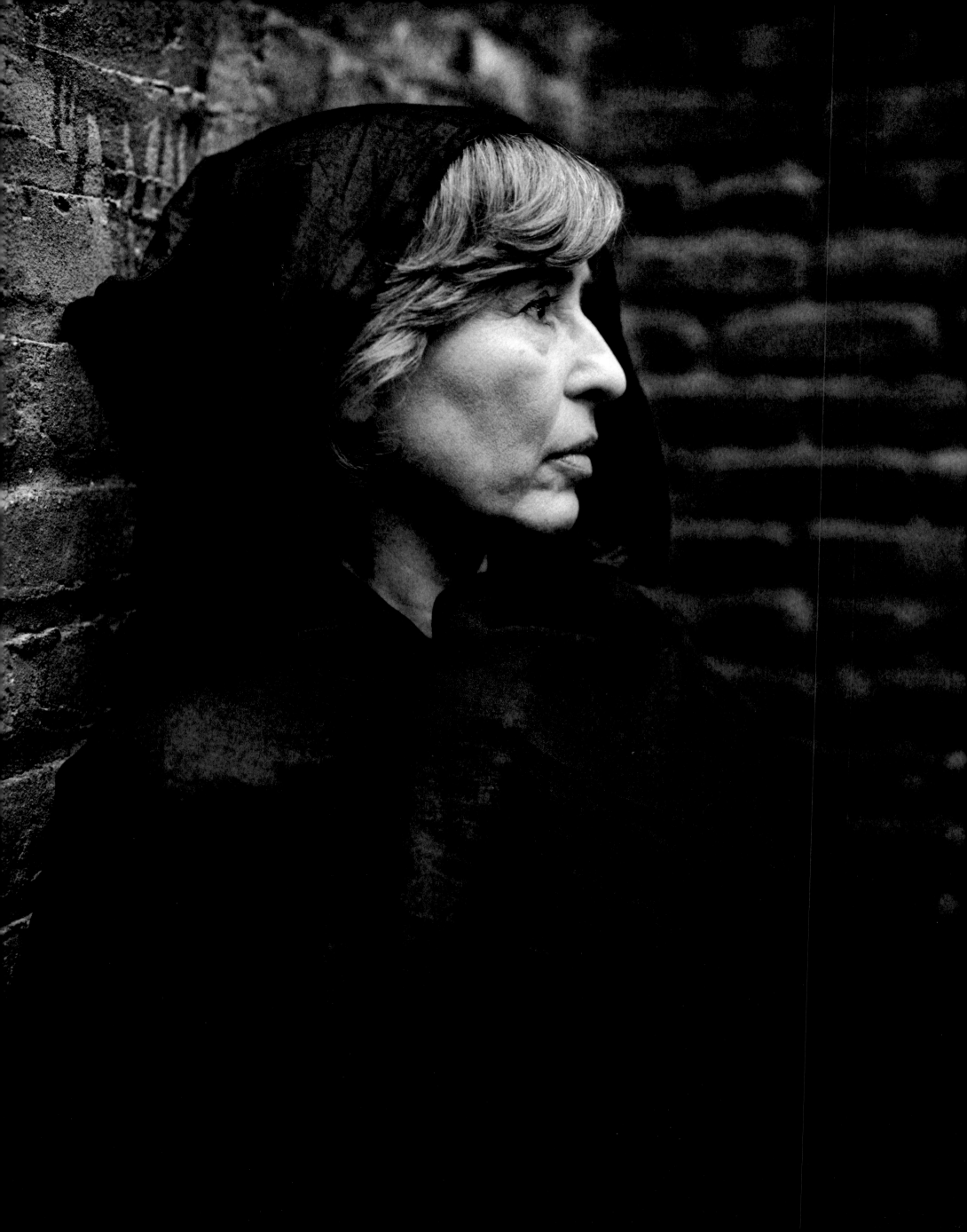

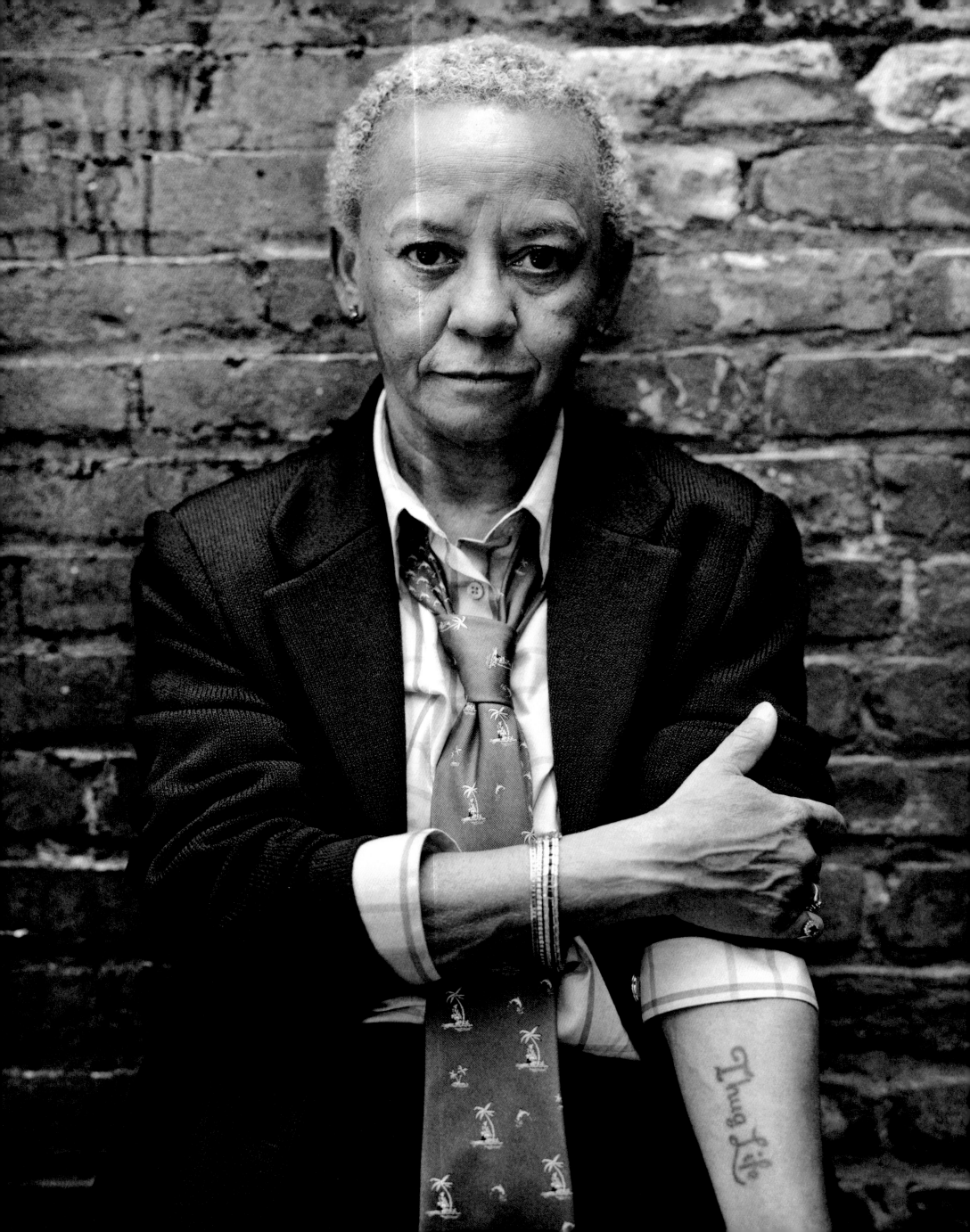

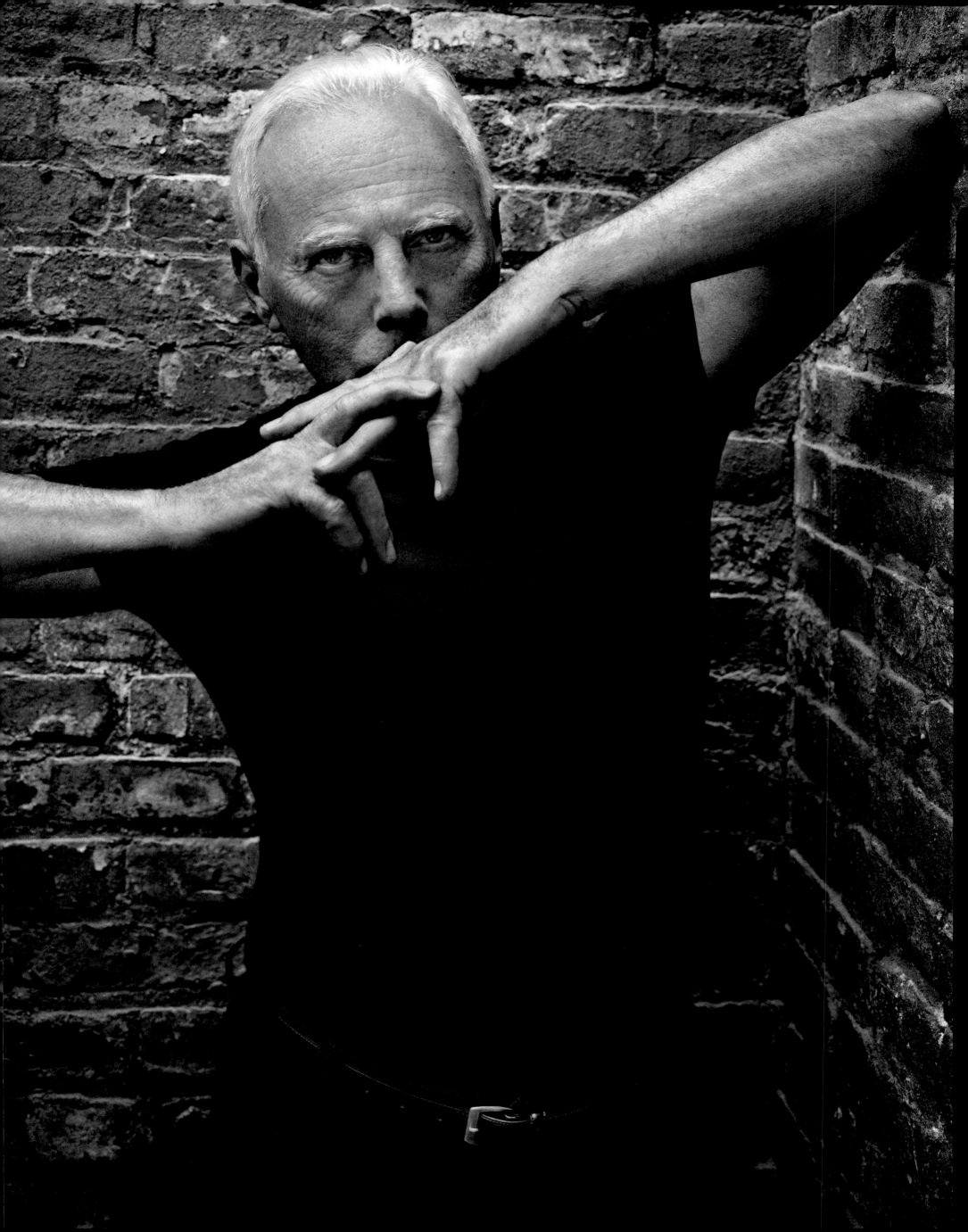

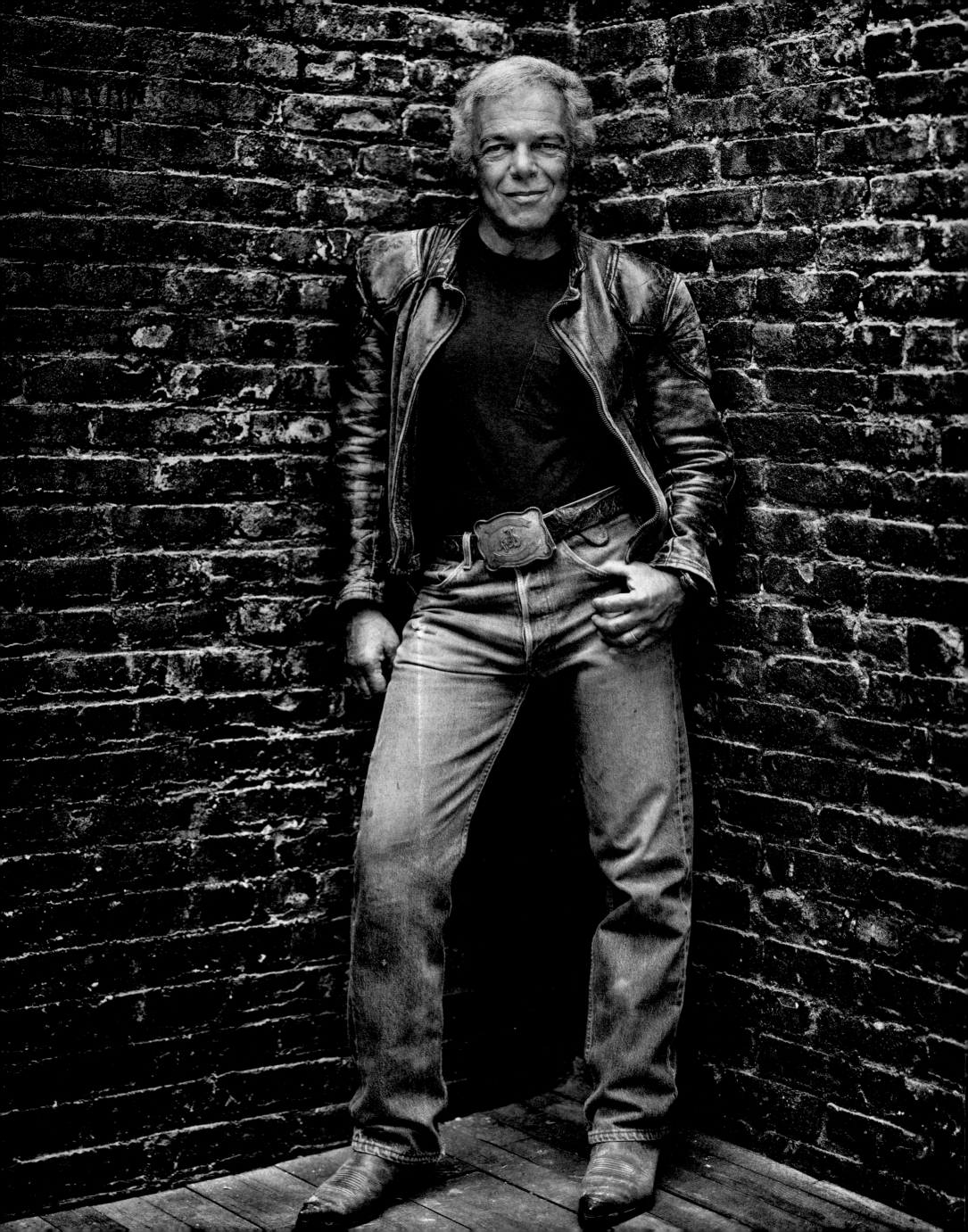

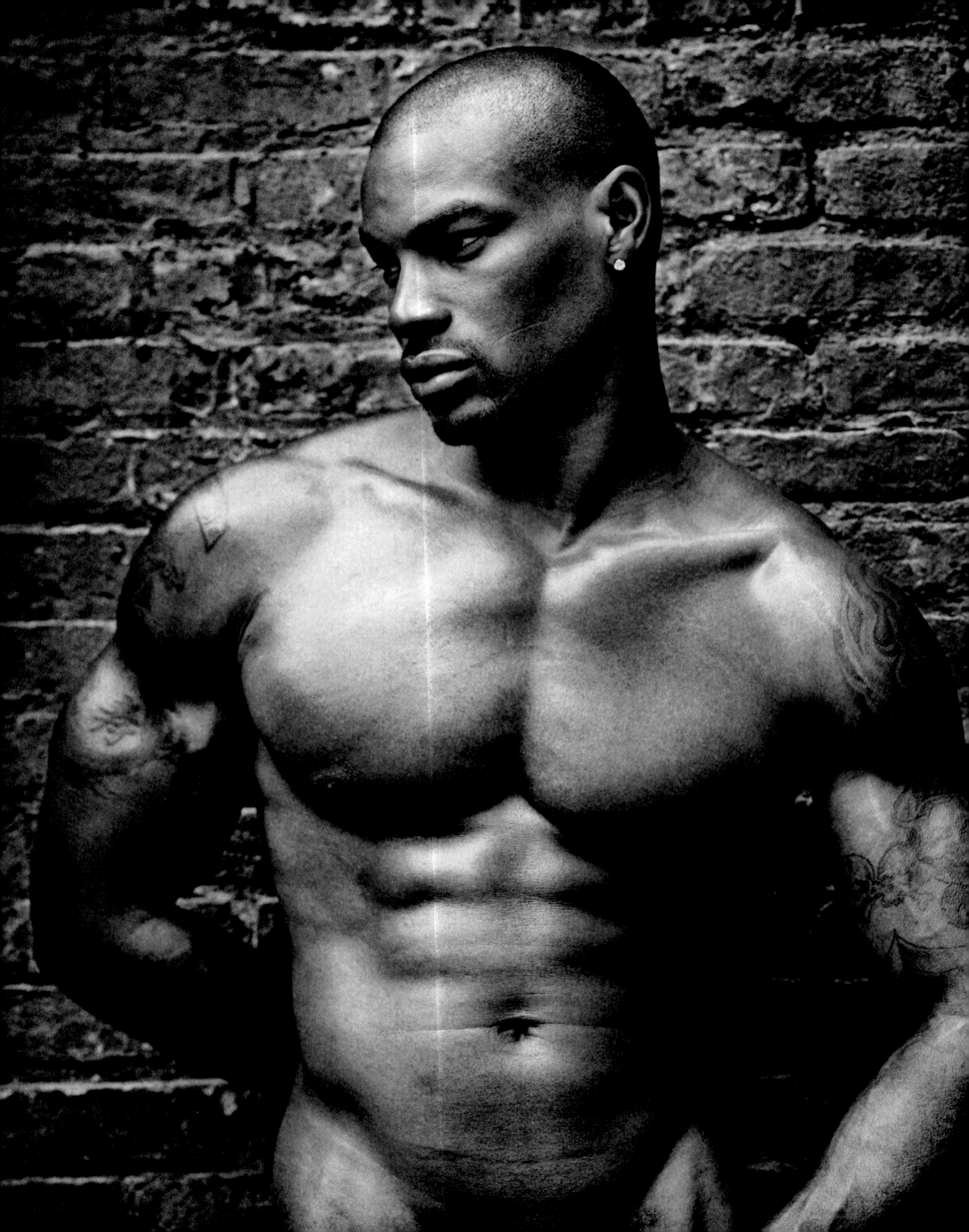

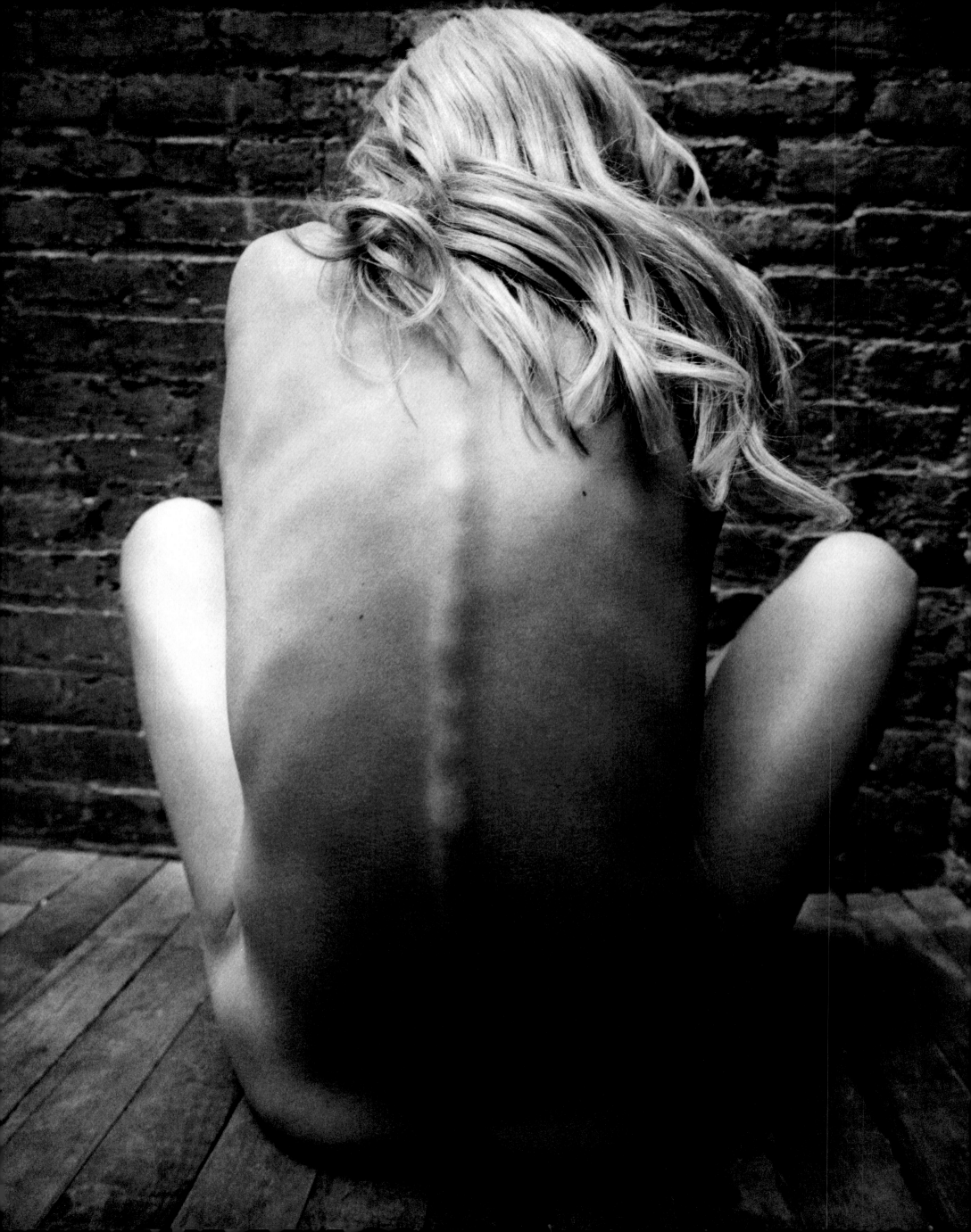

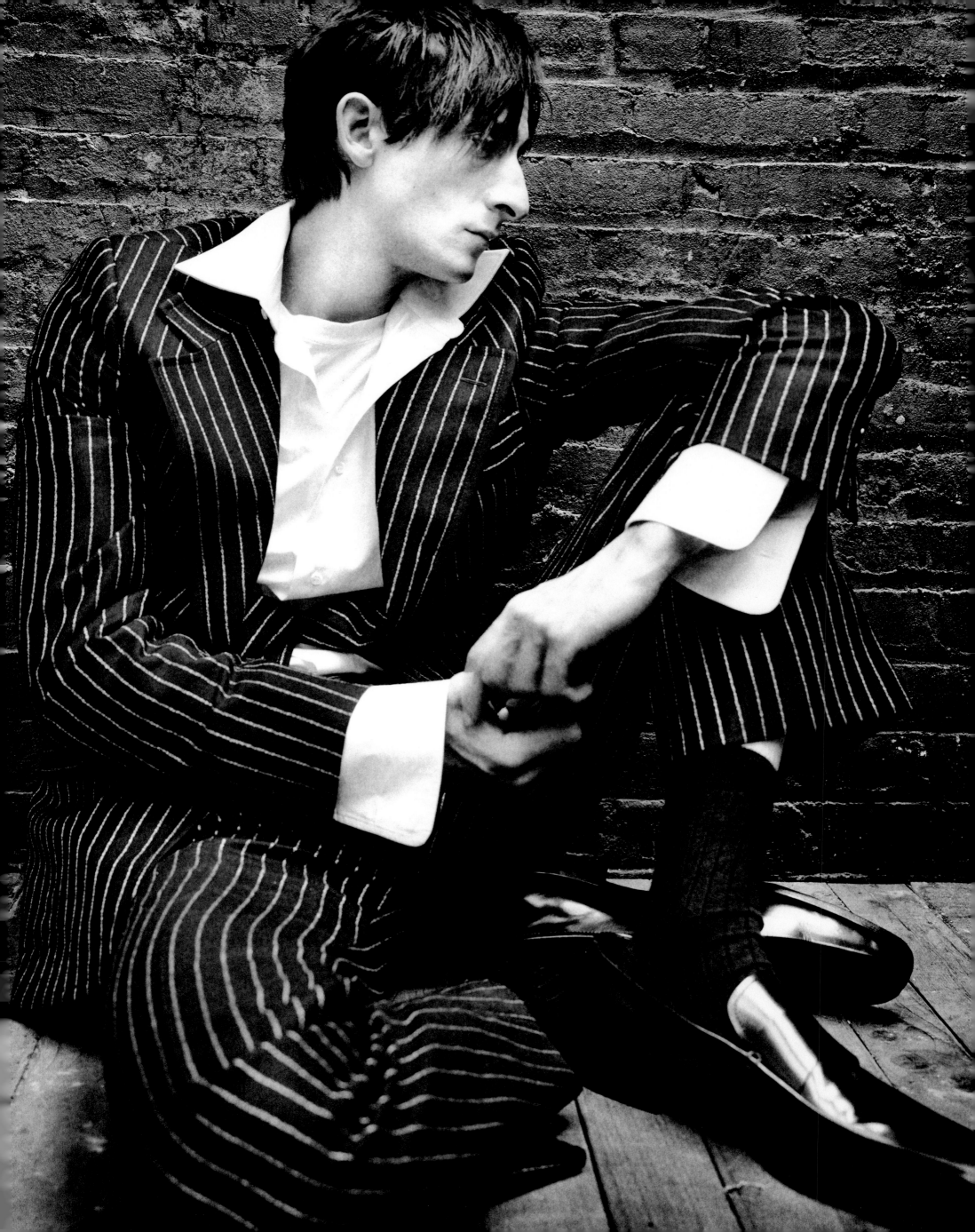

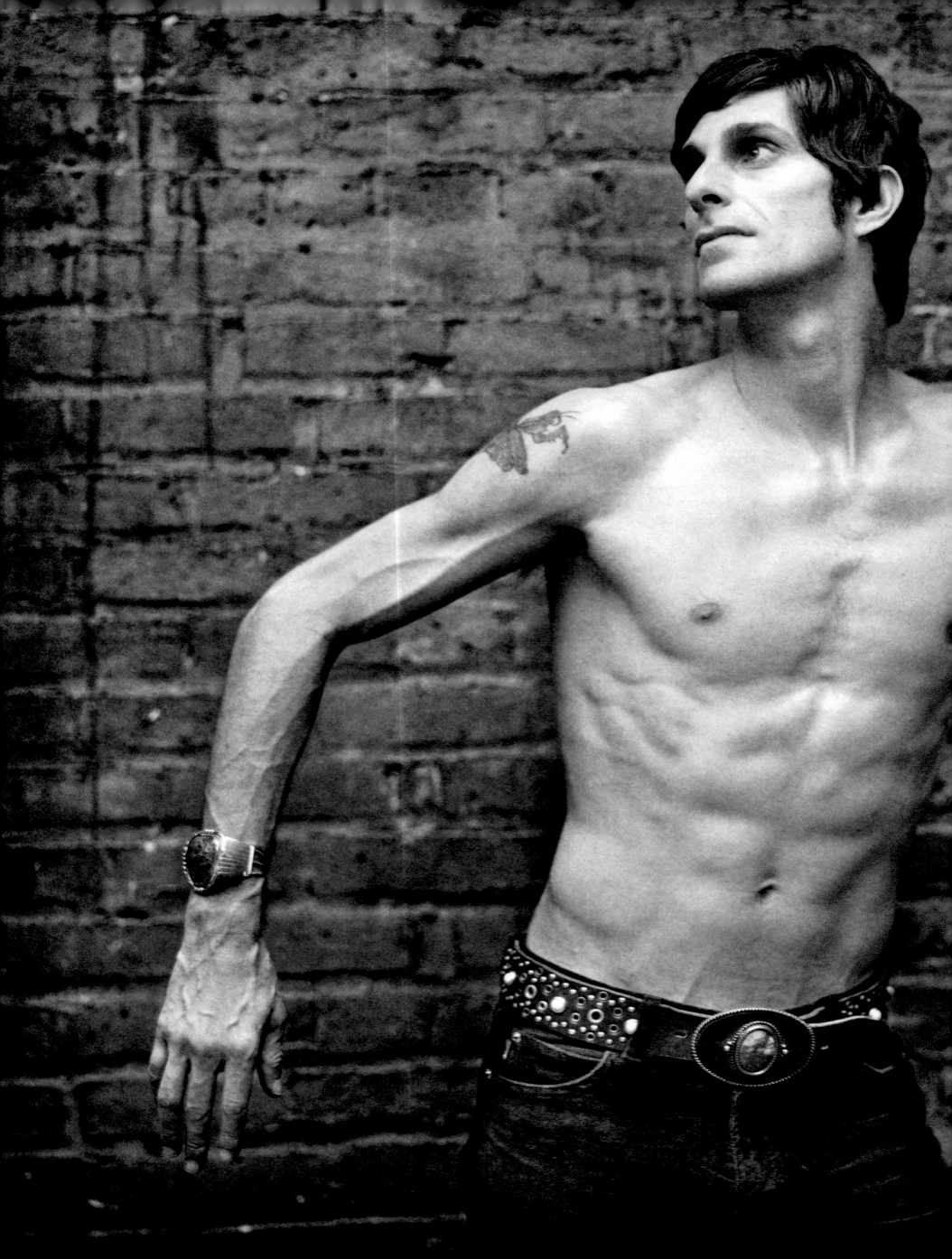

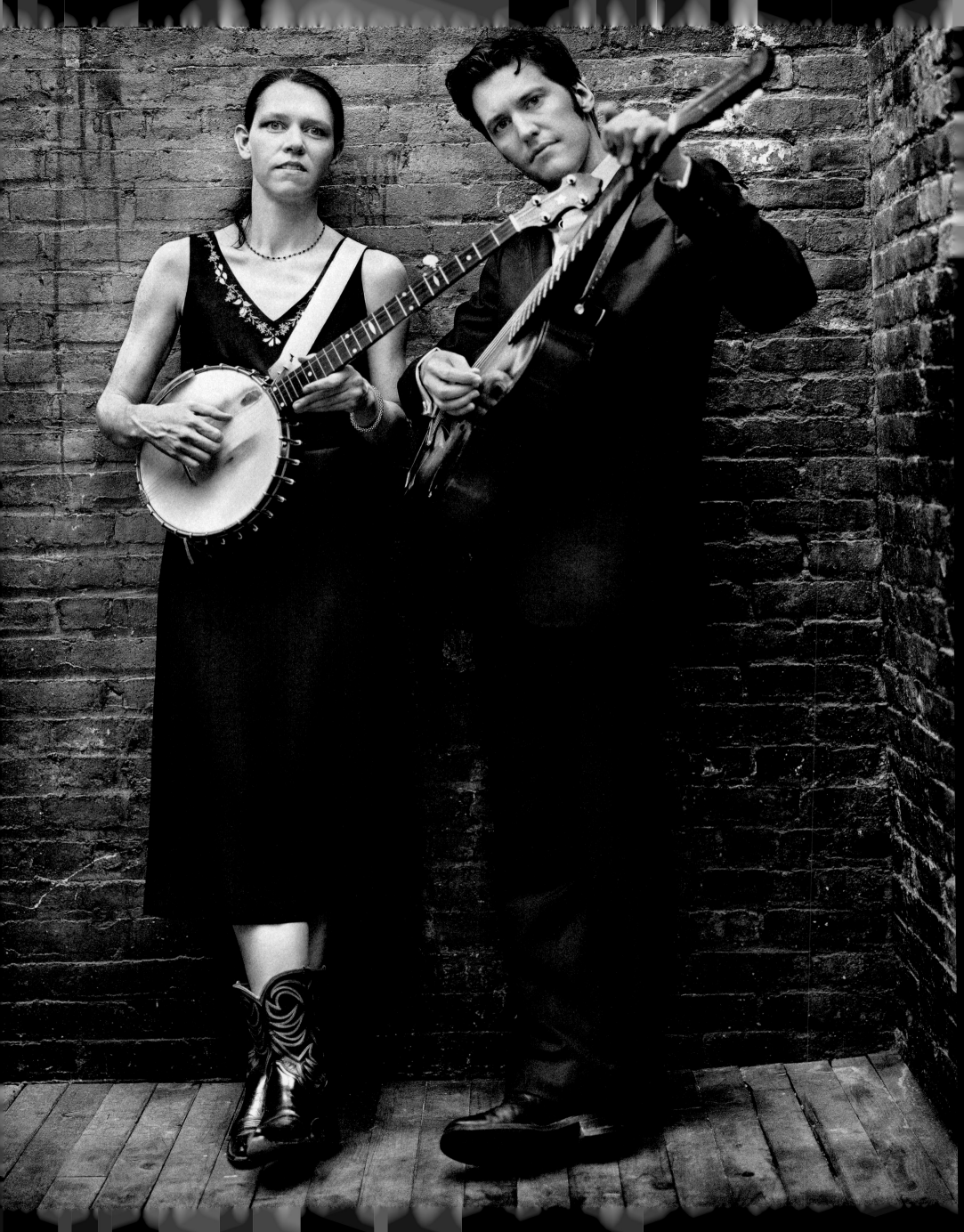

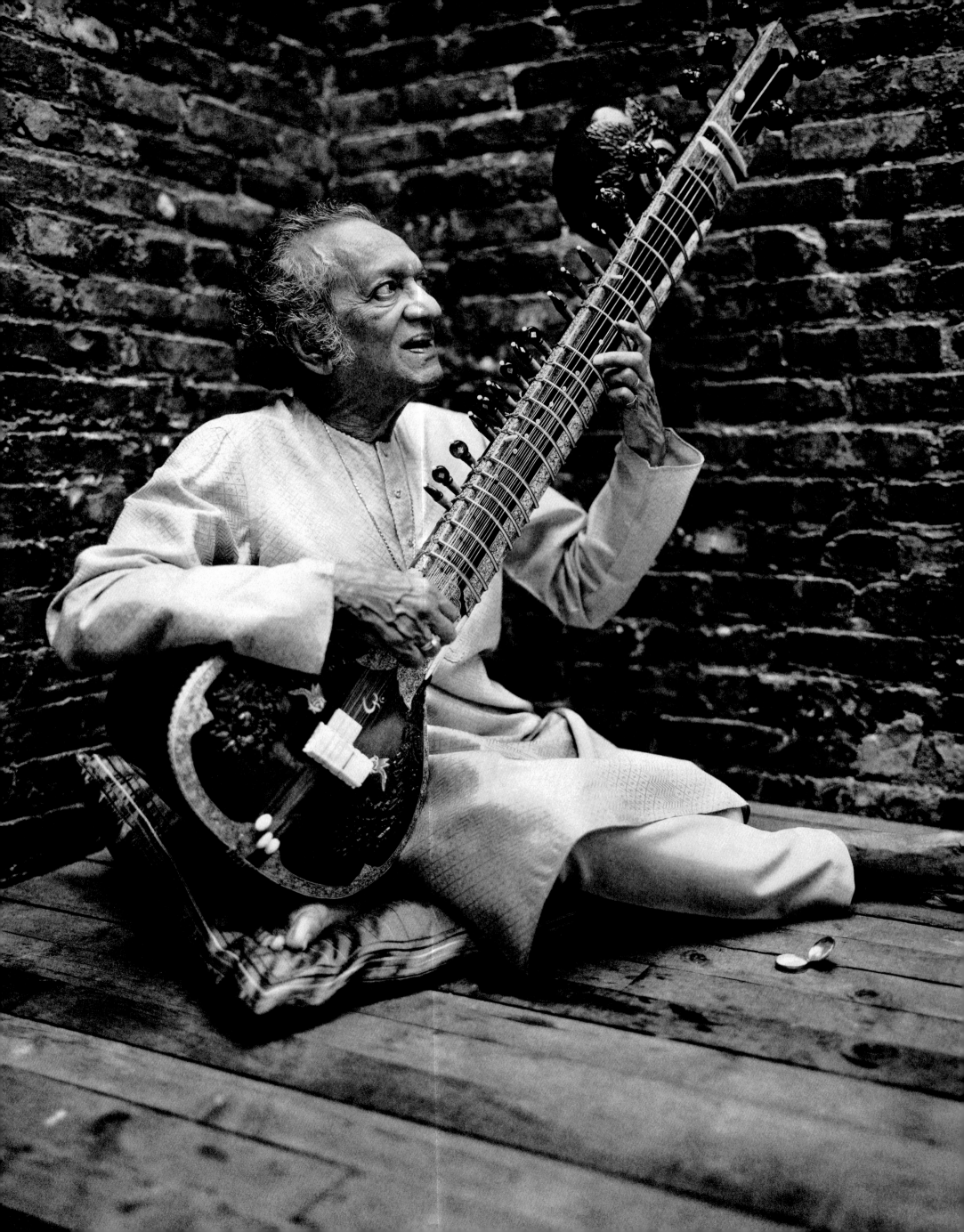

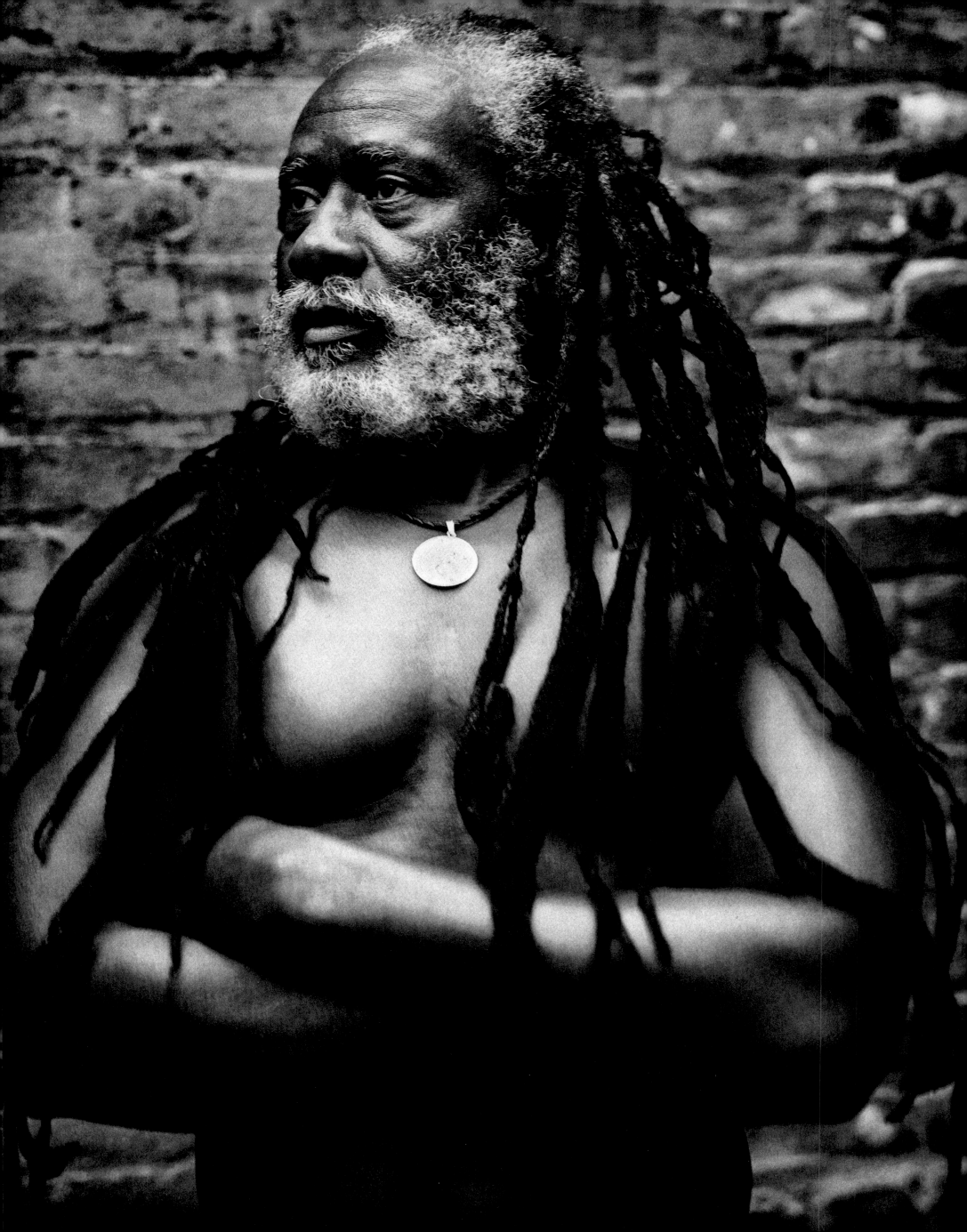

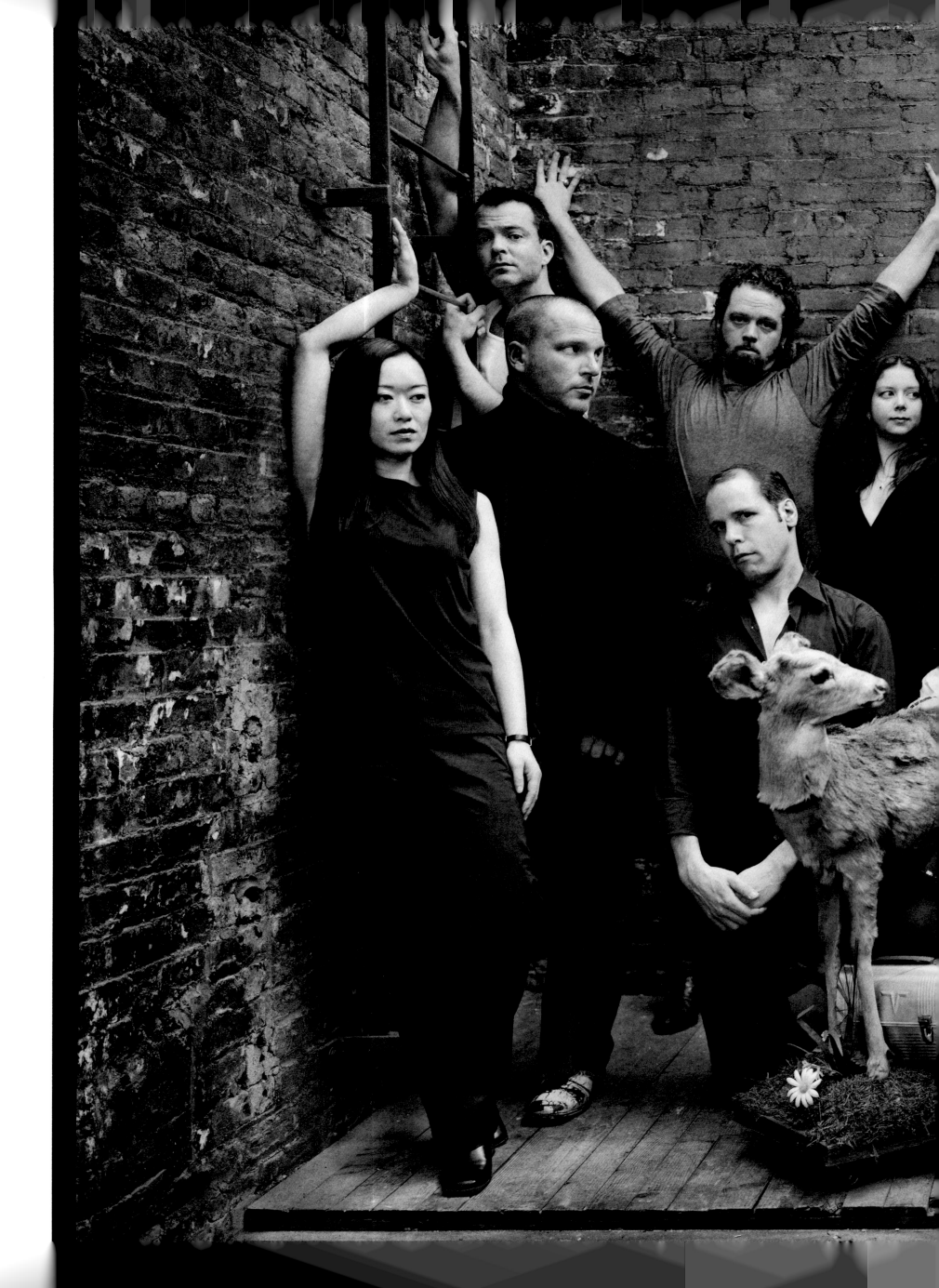

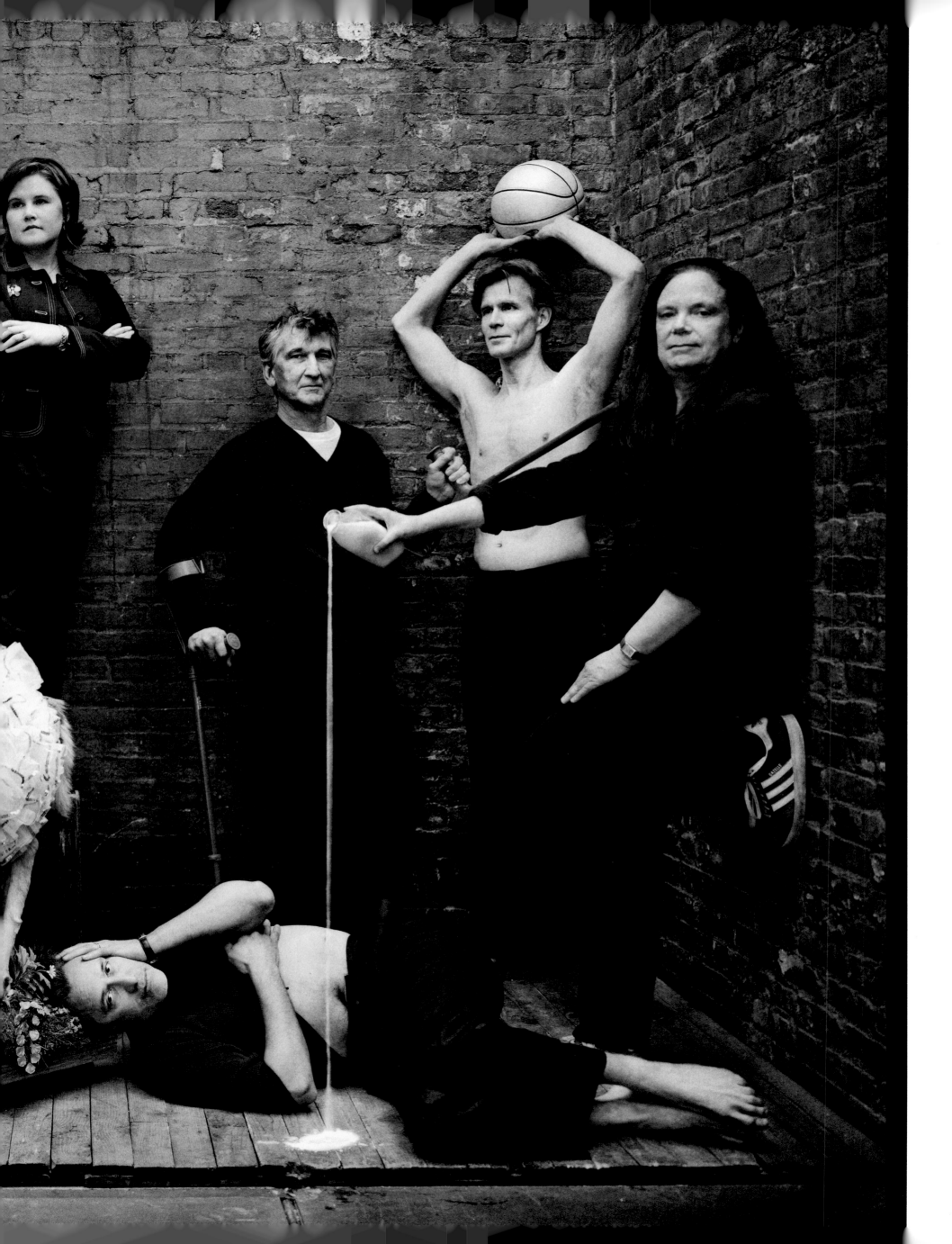

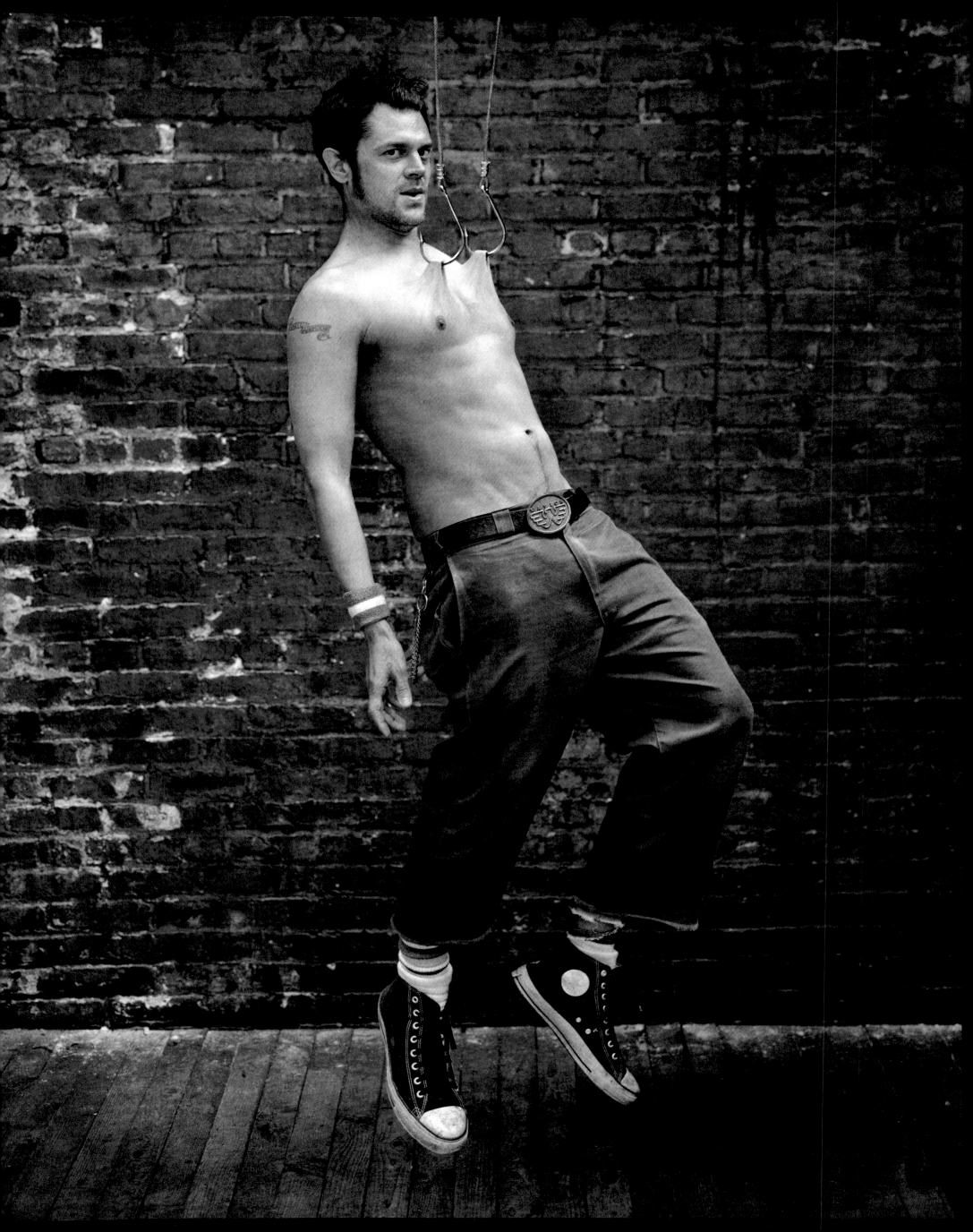

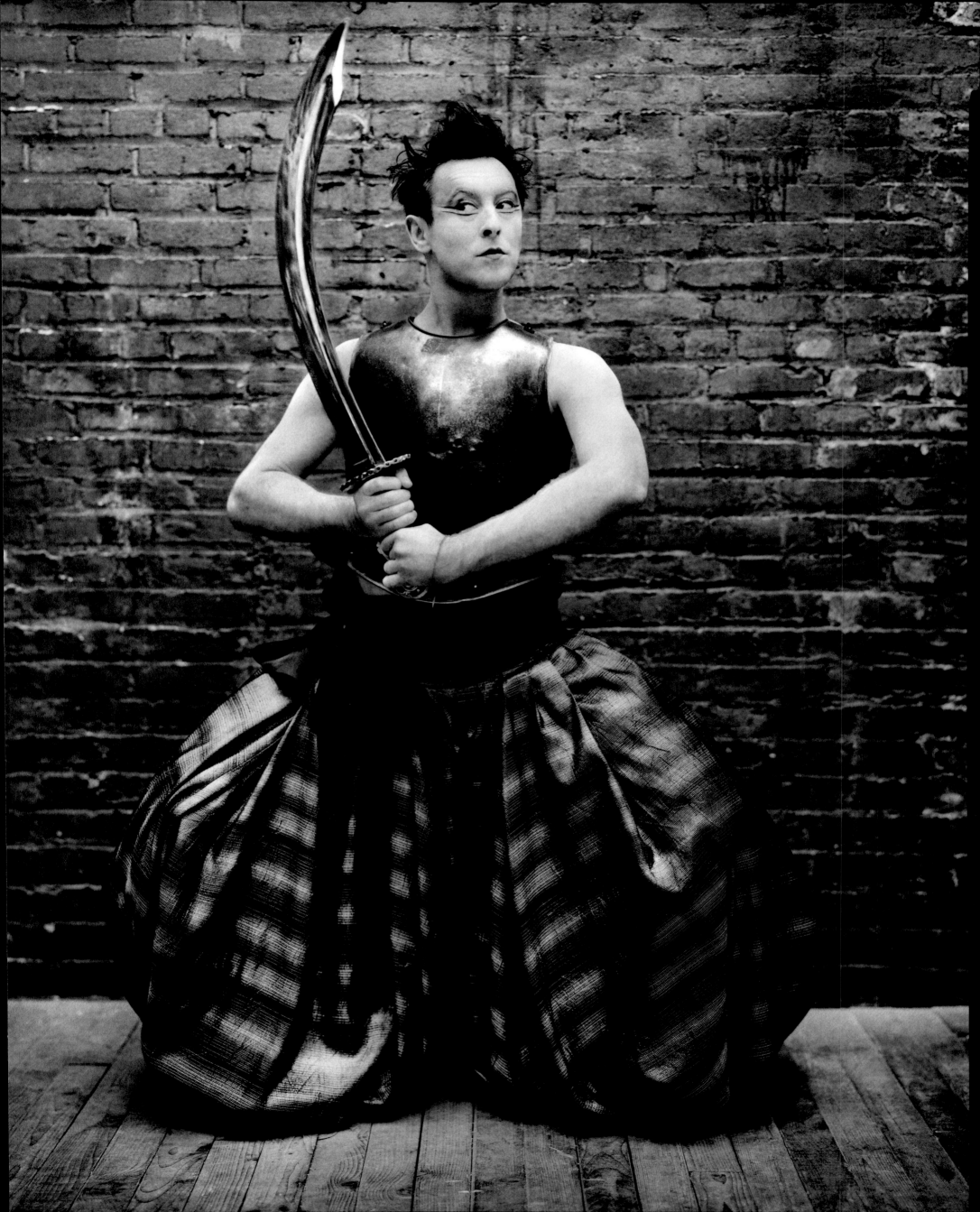

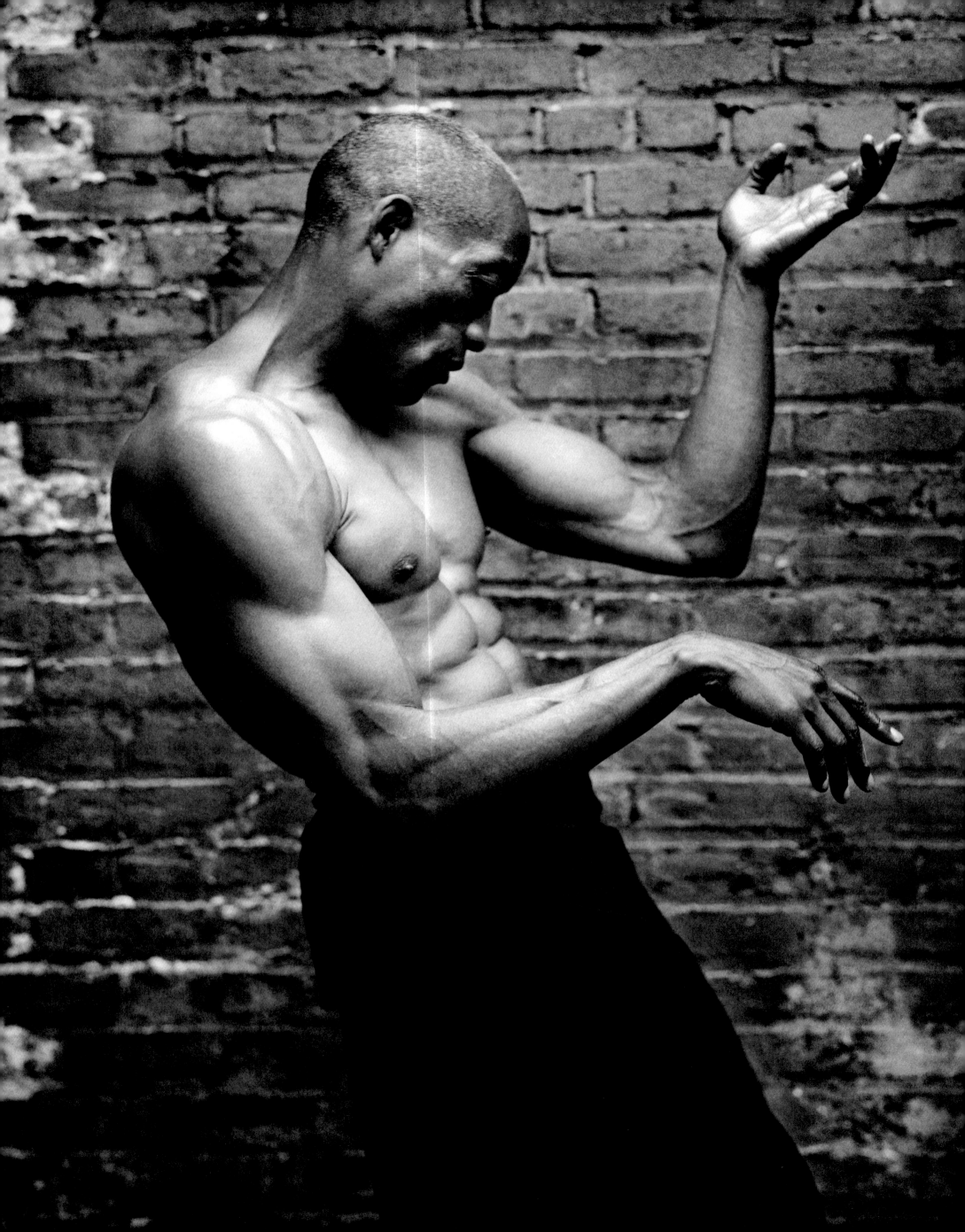

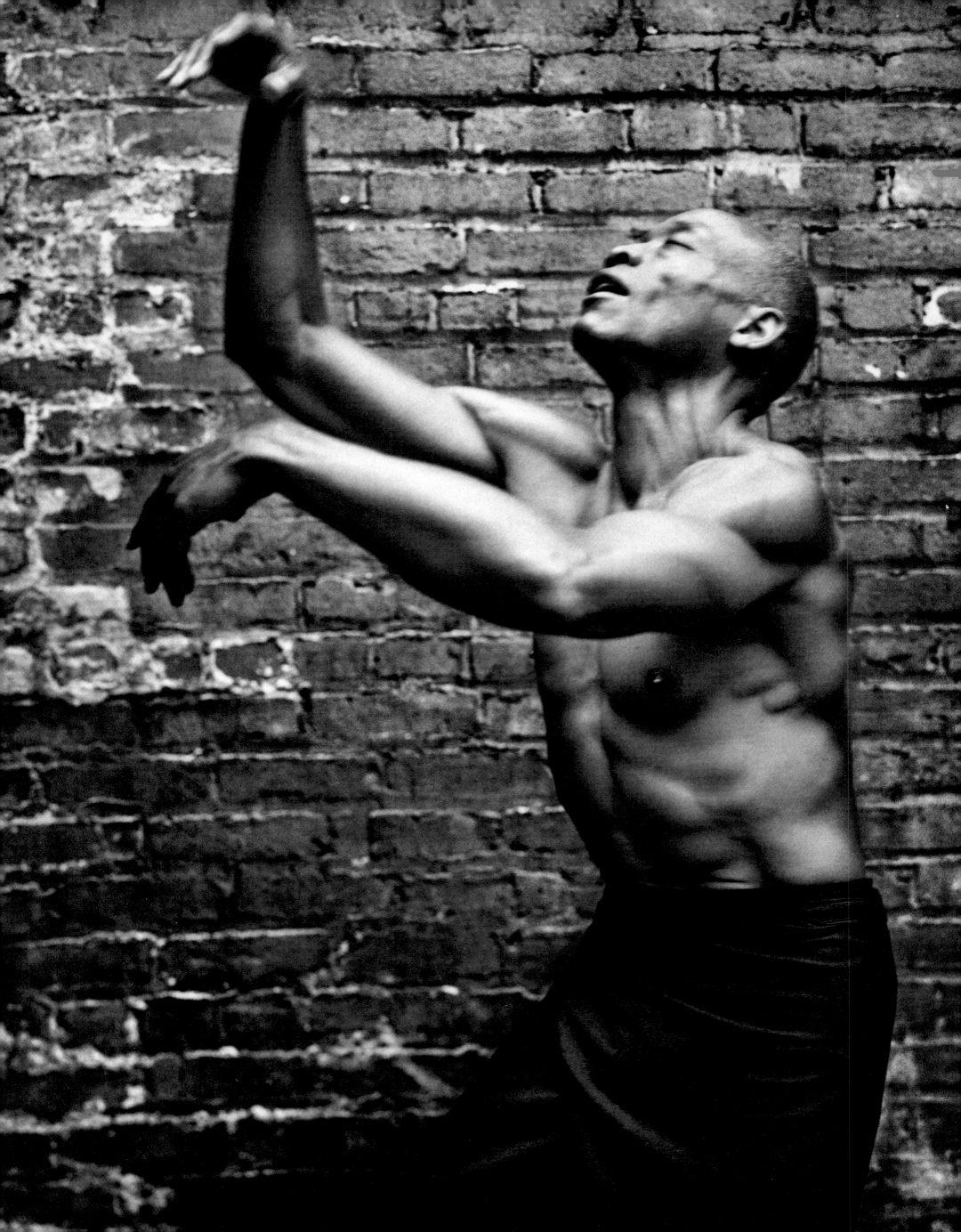

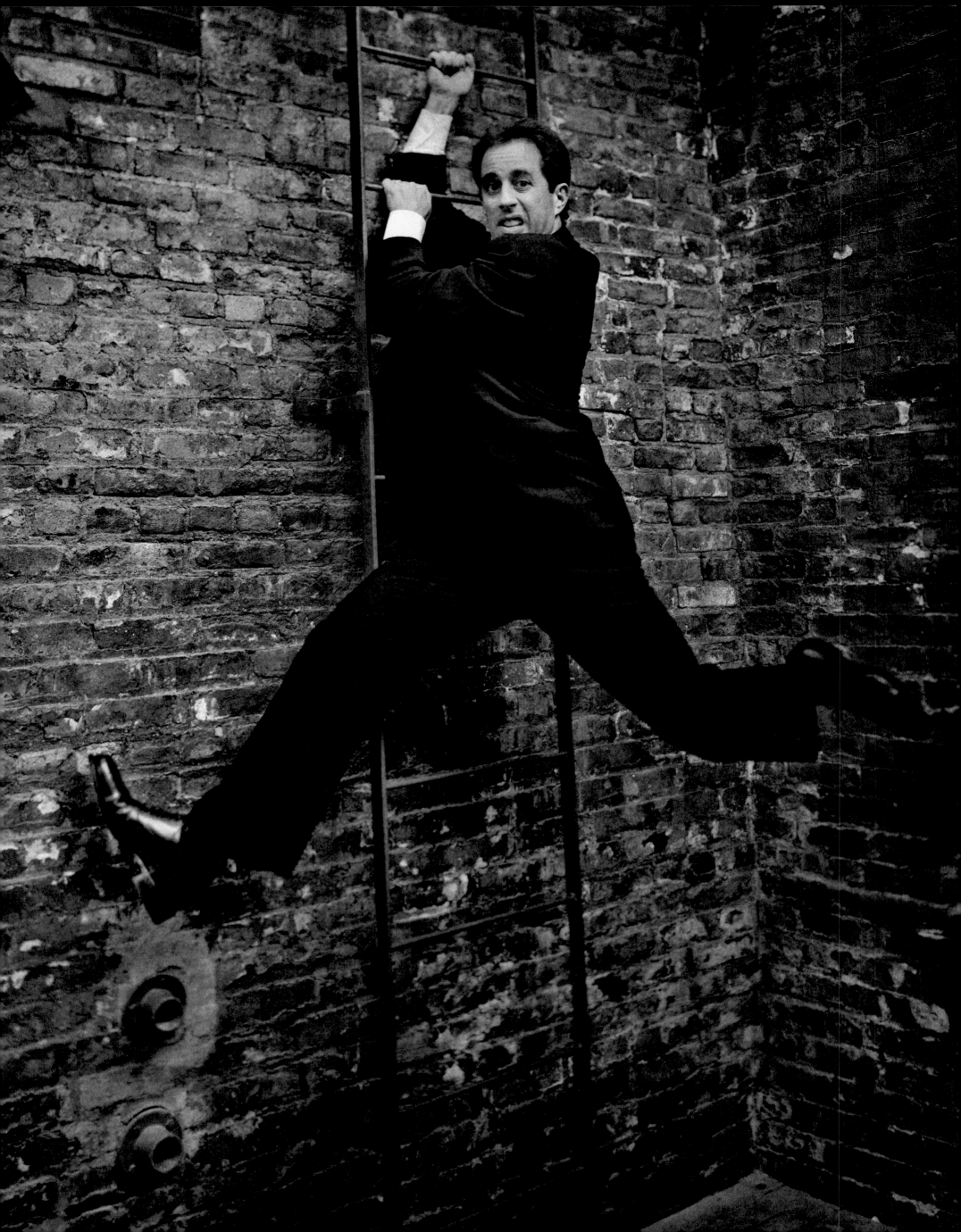

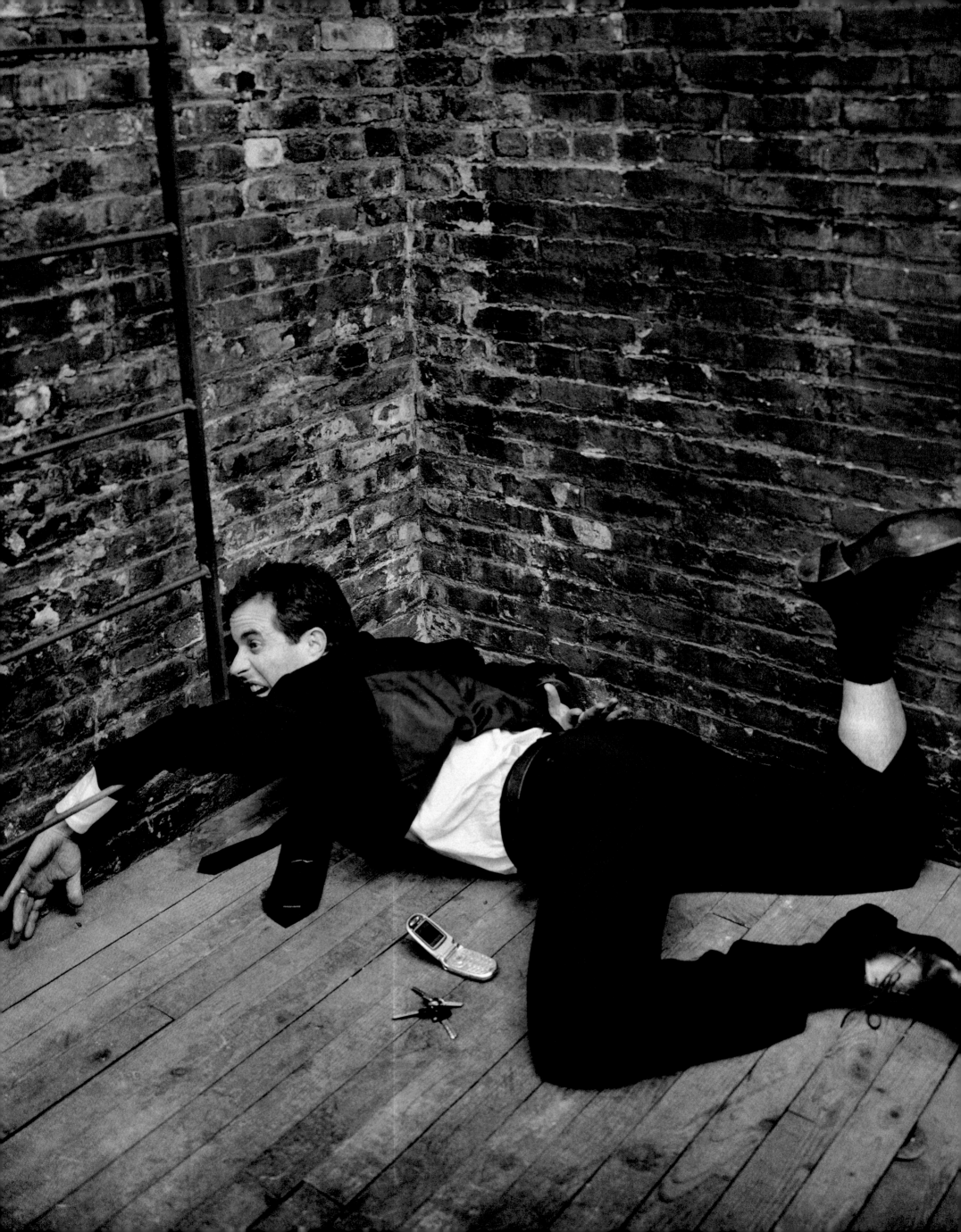

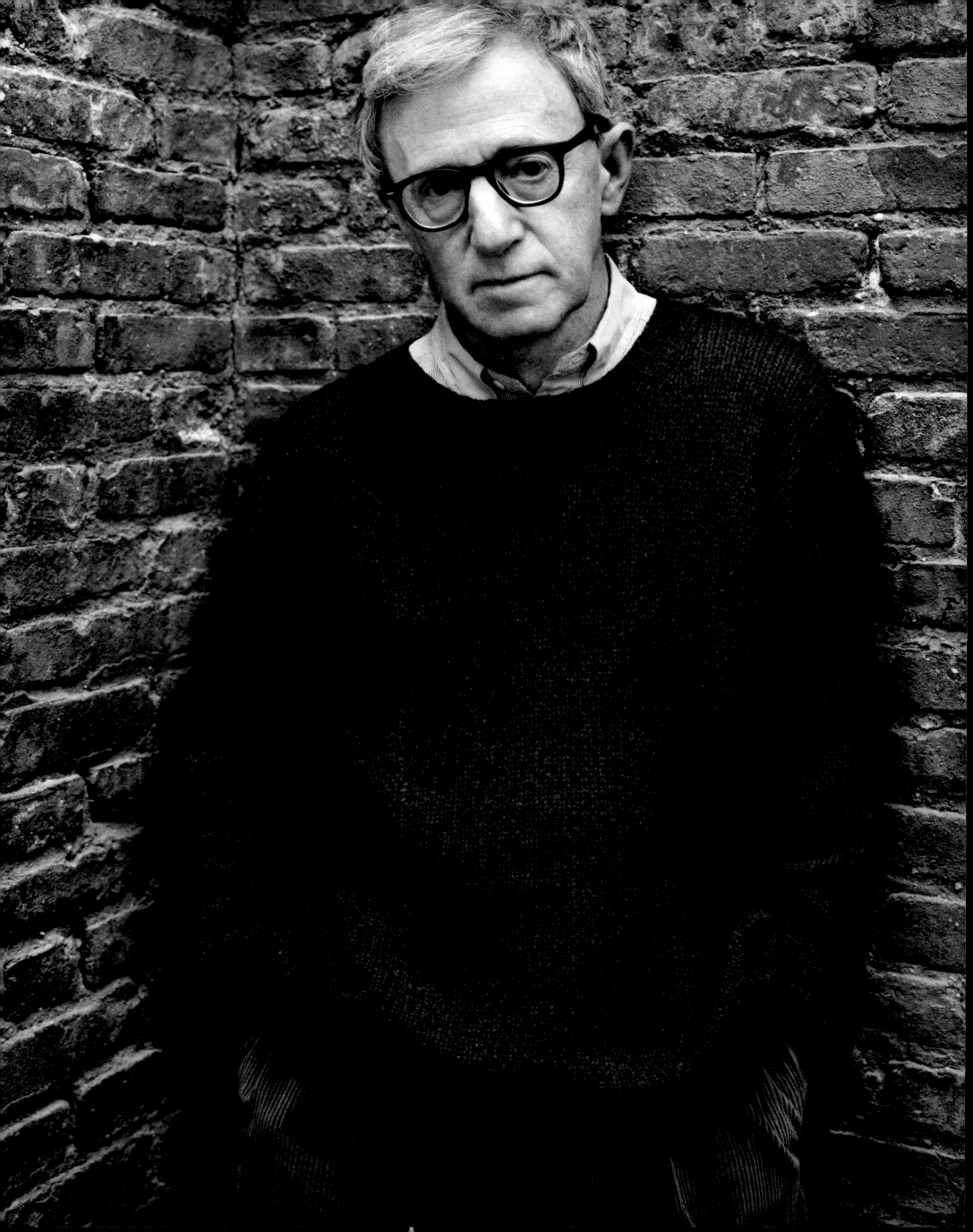

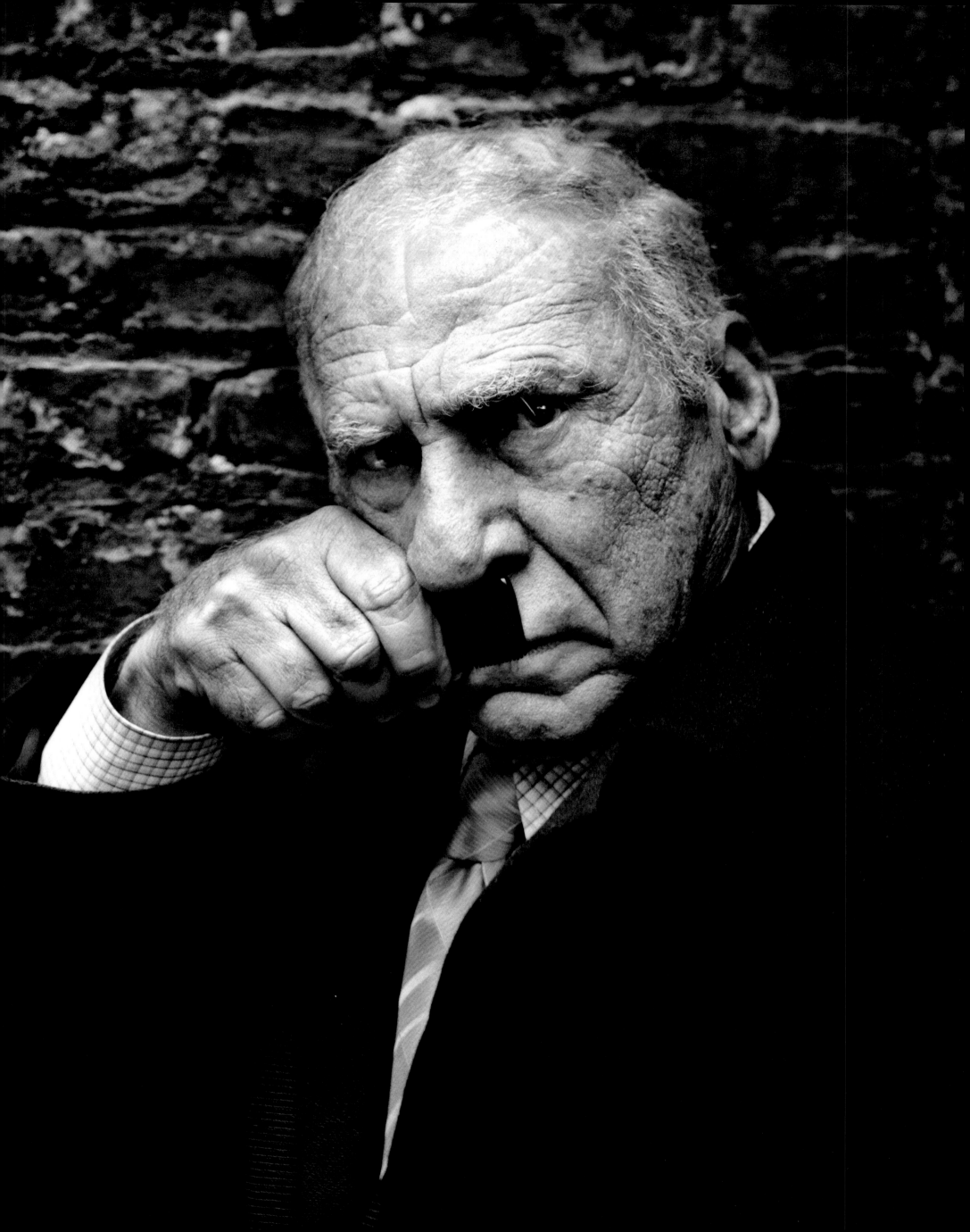

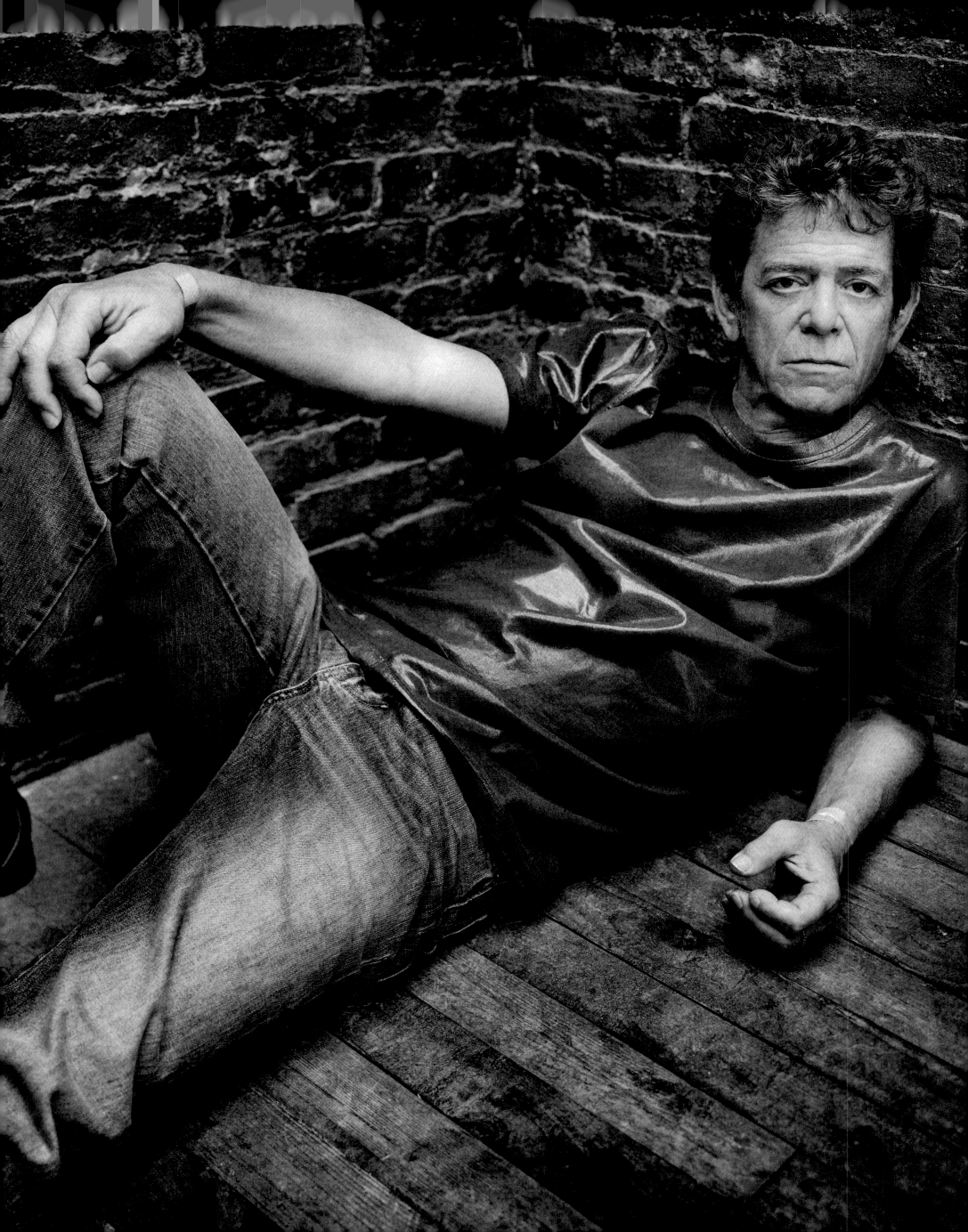

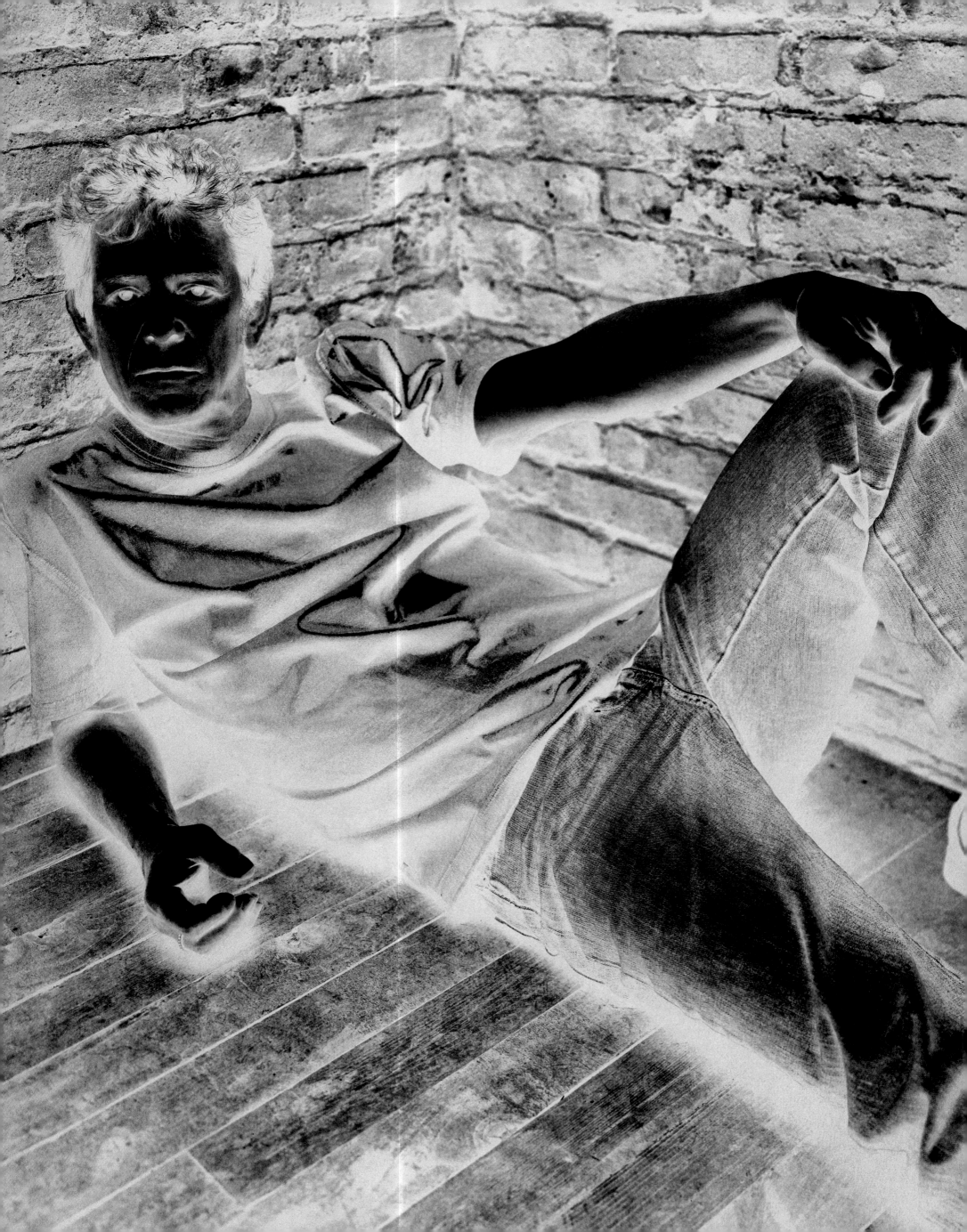

Lou Reed

TECH TALK:
A CONVERSATION BETWEEN
LOU REED AND MARK SELIGER

I was so impressed with Mark Seliger's Stairwell Project, his views of some of the finest artists of our generation, all posed in the same surrounding, the stairwell . . . a dilapidated brick staircase—large intact and old that he had refurbished in his loft warehouse overlooking the Hudson River. I've seen other photos of artists by other artists and I was interested in the thought that lay behind these photos. What was the goal, what thought was intended to differentiate them from the other photos of many of these same people? After all, an icon is an icon—on the beach or on a stair. Of course this is a large collection done by someone who has made his career in celebrity photography for the major magazines. What did Mark hope to get from this besides the satisfaction of doing it? What was the intent that would separate them from those done by the other notables in his field? When I was at his studio I lusted after his equipment . . . ah, a tech head I thought . . . a place close to my heart. The studio is like a large castle from another time, a speakeasy perhaps . . . the perfect place for a photographer. Lenses and dials . . . a man who does his own setup. . . . I thought, this is a man who knows what he wants. As I dabble in the art as well I was interested in the equipment—the whys, the lighting, the hows. Mark is a particularly nice fellow and seemed happy to explain things to me. It was an invaluable lesson in mastery of technique.

. . .

LOU REED:
Why the Stairwell?

MARK SELIGER: When I first saw the stairwell, it struck me as a blank canvas—nondescript and stripped of any concept. Somewhere around the turn of the century, the building operated as a horse stable for a women's correctional facility and had never really been renovated past the point of laying down plywood to cover the stable floors and some pseudo-walls to divide a room here or there. I bought the building in 1996 and had to gut the entire thing in order to bring it up to code. It was during the demolition that I discovered the stairwell, which used to be an elevator shaft and, above it, a skylight that was critical—it dictated the lighting. No artificial lighting was used in any of the portraits and even late afternoon sessions were hopeful with pushing film. Given the fact that I was dealing with available light, I had to depend on extremely long exposures to achieve the proper depth of field. Particularly on cloudy days or late afternoons some of the exposures were up to four seconds long which isn't much fun for your subjects unless they're sleeping or meditating. Matthew Barney's comment to me was, "It forces you to slow things down." Regarding the project as a whole, as the viewer becomes more involved in the book, the stairwell becomes the common denominator and as a background, it's never distracting.

Which came first: the idea or the assignment? Did you always have a collection in mind with a unifying theme? Was this something you were aiming to do at some point anyway . . . a natural outgrowth?

Not at all, not at first, anyway. It was ancillary, at best.
Technically, the first photo was taken before the demolition was even finished, of the band D-Generation. I dragged them into the raw construction site and took some portraits. Next came the photos of David Bowie, Willie Nelson, and Julia Roberts, which were taken as an afterthought while I was shooting other projects at my studio. I began to realize the stairwell was one of the most honest places in which I had ever photographed. Subjects had the freedom to become whatever they wanted and everything that happened was equally relevant.

When did it go from taking straight portraits to becoming a stage? Did you direct the subjects?

It was really Bill Irwin, who put on this incredible theatrical performance and made me realize that the potential of the

< D-GENERATION 9.3.96

stairwell was infinite—that I could manipulate the space and that was what encouraged me to think of it in terms of a stage. Directing was key—it always is—but while I would suggest things and have ideas for compositions, it was a collaborative effort that really hinged upon capturing subtle characteristics in the subjects during a session.

What went into the choice of cameras? What determined your mode of printing? I see you have a beautiful large-format camera but that would not be appropriate for many of the situations.

I didn't know you were such a techie, Lou. I normally don't disclose this kind of information but . . . I chose Tri-X black and white film, the uncertainty and surprise of looking through the contact sheets was part of an intuitive journey. Daniel Belknap (photographer/friend who learned palladium printing from Irving Penn) and I met with the photographer Kenro Izu who knows platinum like nobody else, and he guided us through the very complicated and meticulous process of printing with platinum and palladium. The printmaking was a very tactile and gratifying experience. I used a large-format camera because of its detail in the shadows and overall resolution and a 300mm on 8x10 and 210mm on 4x5 lens. However, there was always that moment of a wide-angle lens that really made it possible to connect with the subject. Of course, with the ten members of Ladysmith Black Mambazo, I didn't really have a choice. With a normal lens, I would have had to scale the building across the street and shoot from there if I wanted to fit them all in!

The breadth and depth of the project is remarkable. You were dealing with some of the true icons of our generation. What criteria did you use in deciding whom you would include?

I wanted to create an eclectic mix of people that would be timeless. I immediately thought of the Brooklyn Academy of Music, which seemed like the perfect fit with this series. I wasn't interested in who is mainstream or "cool," but rather I was interested in creating a collection of images that would help preserve artists who have made a contribution of incredible magnitude. With the help of my producer, Jennifer Hutz, I created a setting for individuals considered iconic in their fields—people who have truly succeeded in becoming artistic mainstays.

And finally one question for me: What's your favorite lens?

That response would have to be off the record, Lou.

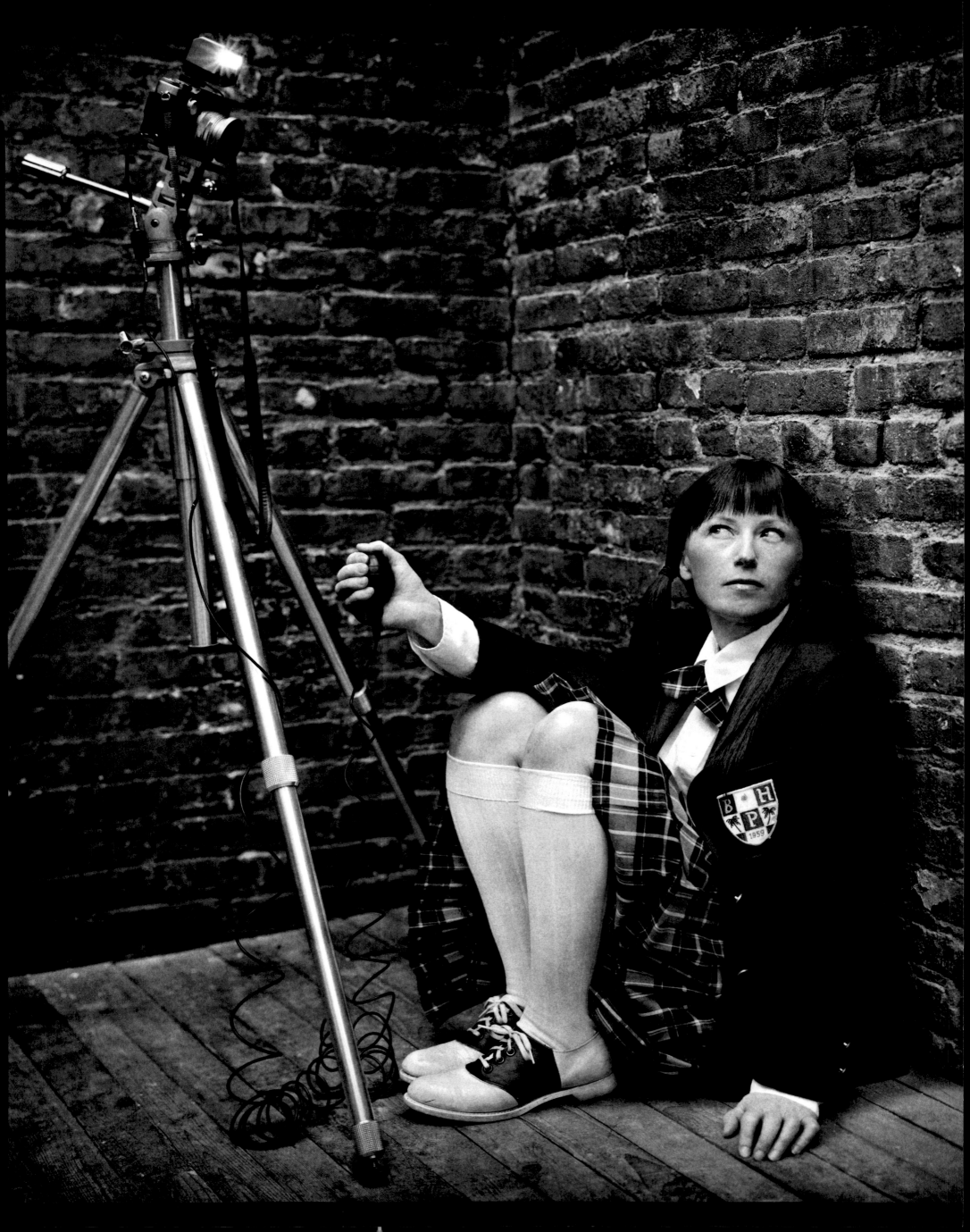

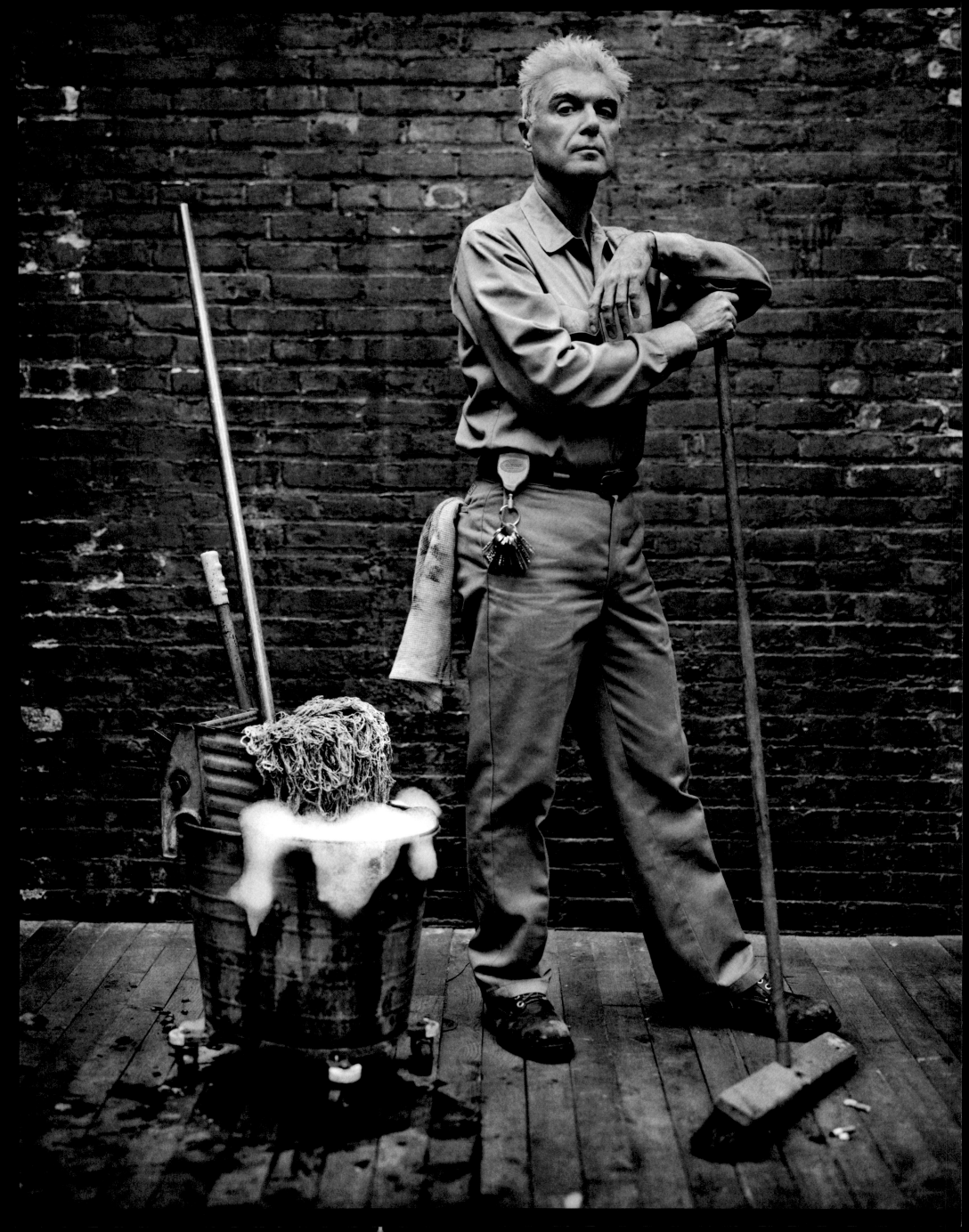

01 . MICK JAGGER
> b . 1943
> *Musician*

KEITH RICHARDS
> b . 1943
> *Musician*

If you look up the term "rock 'n' roll" in the dictionary, you'll find a photograph of the Rolling Stones. At the core of the "world's greatest rock 'n' roll band" are the "glimmer twins," Mick Jagger and Keith Richards, who met at Darford Maypole County Primary School when they were five years old. With their Warhol-designed lips-and-tongue logo and bold sexual image, The Stones have been dominating charts and stadiums since their first performance at the Marquee Club in London in 1962. Inducted into the Rock and Roll Hall of Fame in 1989, The Stones are the longest-lived, continuously active group in rock and roll history.
> *Visited the stairwell*
> 5.11.05

. . .

02 . PAUL McCARTNEY
> b . 1942
> *Musician*

One of music's four knights in shining armor and half of one of the world's greatest writing team, Sir Paul McCartney with The Beatles destroyed every rule and every record in music history. Singer, songwriter, bass player, Ed Sullivan was right: this guy is terrific. Before they conquered the rest of the world, The Beatles invaded Britain with chart-topping albums and took live music to a whole new level. In addition to being one of the Fab Four, McCartney is the person who bridged the melodies of Motown with Buddy Holly, introduced bass guitar as a melody, and got up in the middle of the night to pen "Yesterday," the world's most recorded track. He was inducted into the Rock and Roll Hall of Fame as a solo artist in 1999. Paul McCartney really *is* the walrus.
> *Visited the stairwell*
> 10.12.01

03 . BRUCE SPRINGSTEEN
> b . 1949
> *Musician*

A guitar-wielding John Steinbeck, musical poet laureate, political activist and, of course, The Boss, Bruce Springsteen burst out onto the scene with the E Street Band. His purely acoustic *Nebraska* paid homage to despair and darkness. His albums *Born to Run* (1975) and *Darkness on the Edge of Town* (1978) put him in the center stage of musical stardom. And his most famous release, *Born in the U.S.A*, came out in 1984 and has sold twenty million copies. He won a Grammy as well as an Oscar for Best Song for his "Streets of Philadelphia," and in 1999 he was inducted into the Rock and Roll Hall of Fame. Springsteen is a member of World Hunger Year, an organization that fights against hunger and poverty. It should be noted that Springsteen is single handedly responsible for making being from New Jersey cool.
> *Visited the stairwell*
> 4.6.05

. . .

04 . DAVID BOWIE
> b . 1947
> *Musician*

It's not easy being a space oddity or a rock god, and David Bowie has had a very busy career. He took rock to glam, made androgyny another gender, and became the spokesperson for the changing of an era. Bowie has always been one step ahead of everyone else. His first hit single was "Space Oddity" (1969), but he became a star with the space-rock Ziggy Stardust tour in 1972. A few years later he released *Young Americans*, which produced "Fame," his first No. 1 hit in the U.S. He followed that with another No. 1 hit, *Let's Dance* (1983). He has collaborated with everyone from Tony Visconti to John Lennon to Philip Glass, been in innumerable films, and in addition to being one of the most influential songwriters of all time, he is a painter. Bowie continues to reinvent himself, record, tour, and act.
In 1996 he was inducted into the Rock and Roll Hall of Fame.
> *Visited the stairwell*
> 8.5.99

05 . IMAN
> *Née Iman Abdulmajid*
> b . 1955
> *Supermodel*

Iman is multilingual, the CEO of two beauty companies, and is actively involved in many charities including Mothers' Voices, Action Against Hunger, The Children's Defense Fund, and the For All Kids Foundation. Oh, and she is drop-dead gorgeous. Born in Mogadishu, Somalia, Iman was twenty years old and busy studying political science at the University of Nairobi when she was "discovered" by Peter Beard. Her success was imminent and she soon became a muse for designers like Yves St. Laurent, Versace, Calvin Klein, and Donna Karan. In that, she had a large hand in redefining beauty in the western world. In 1979 Iman made history as the first African (or African-American) woman to appear on the cover of *Vogue*. She looks as good today as she did in the 1970s (if not better) . Her autobiography, *I Am Iman*, was released in 2001.
> *Visited the stairwell*
> 12.7.01

. . .

06 . BEN HARPER
> b . 1969
> *Musician*

Get a touch of funk, a little bit of soul, and some blues. Add some R&B and folk. Then mix in some reggae and gospel, and you'll have Ben Harper. And what you have, in Ben Harper, is a troubadour and an artist, who, above all else, is devoted to speaking out for the oppressed through his music. Harper began playing guitar at age six and had his first gig when he was twelve. In 1992 he signed a deal with Virgin Records and released his first album, *Welcome to the Cruel World*, two years later. Other albums include *The Will to Live* (1997), *Diamonds on the Inside* (2003), and the Grammy-winning *There Will Be a Light* (2004) . Harper is known for his collaborations with artists like Beth Orton, John Lee Hooker, and the Blind Boys of Alabama, about whom, he says, "They see what we won't, they see what we don't, and they see what we can't. It is an honor to be in their presence."
> *Visited the stairwell*
> 10.13.04

07 . ELLEN GALLAGHER
> b . 1965
> *Artist*

Ellen Gallagher is to culture and identity politics what plastic surgeons are to Beverly Hills. She lasers and layers, sculpts and paints, embellishes and transforms. And in so doing, she begs the question: Who speaks for whom? Gallagher revisits stereotypical black advertising and parodies the idea of self-improvement. Her trademark bulging eyeballs and the makeover she performs on dated ads from mid-century African-American magazines like *Ebony* and *Sepia* challenge conventional assumptions about beauty, color, and art itself. Gallagher received accolades for her work at the Whitney Biennial in 1995, had her first solo show in a Soho gallery in 1996, and in 2005 the Whitney Museum of American Art debuted her show, "DeLuxe."
> *Visited the stairwell*
> 1.14.05

. . .

08 . RICHARD SERRA
> b . 1939
> *Sculptor*

Richard Serra's work is on permanent collection in museums around the world. He began his career working in steel mills and shipyards to pay his way through UC Berkeley. He is known for his mammoth-sized metal sculptures: *Torqued Ellipses* is made of gigantic plates of bowed and curved soaring steel. *Charlie Brown*, which Serra named in honor of Charles Schulz's comic strip character, is 60 feet tall. *Tilted Arc* is a 120-foot long, 12-foot high curving steel wall that was installed in the Federal Plaza in New York City and caused great controversy. A public hearing was held: 122 people testified in favor of keeping it, and 58 in favor of removing it. Soon after, in the middle of the night, federal workers cut *Tilted Arc* into three pieces and hauled it off to a scrap-metal yard. Serra had this to say, "I don't think it is the function of art to be pleasing. Art is not democratic."
> *Visited the stairwell*
> 10.14.02

01
02
03
04
05
06
07
08

09 . JEFF KOONS
> b . 1955
> *Artist*

If you want to buy a "puppy" from Jeff Koons, you'd better have really high ceilings, a Swiss bank account, and an irrigation system that rivals that of Jardin des Tuileries. Jeff Koons makes (and makes us reconsider) pop art with no apologies. There may be illicit photos, a 40-foot dog draped with flowers, and stainless-steel bunnies, but it's not all a big show. Koons' work comments on the materialism of contemporary society and he wants his art to make people feel good about who they are; he says, "It's important to accept oneself, one's own history, one's own cultural past. Once an individual does that, then they can eventually go down the path toward acceptance of others." Koons has worked on his elaborate constructions with many of the top scientists in the country including the late Nobel Prize–winning physicist, Richard Feynman.
> *Visited the stairwell*
> 2.15.05

• • •

10 . MATTHEW BARNEY
> b . 1967
> *Artist*

This former football player and native Idahoan makes art, gets dressed up like a satyr, scales the walls of the Guggenheim Museum, and captures it all on tape. His incredible five-film series, *The Cremaster Cycle*, is named for the male cremaster muscle, which represents, among other things, pure potentiality. There are grapes, wrestling mats, race cars, sternal retractors, and truckloads of Vaseline. Constantly on the brink between artistic creation and total destruction, Barney abstracts the linear and subverts everything he gets his hands on. In 2000 he won the prestigious Europa Award at the Venice Biennale. *Cremaster* and the accompanying 2003 cutting-edge show at New York's Guggenheim Museum made it clear, if it wasn't already, that Matthew Barney defines the next generation of art.
> *Visited the stairwell*
> 3.30.04

11 . PETER DINKLAGE
> b . 1969
> *Actor*

Years ago, Peter Dinklage had a role in the Off Broadway play *I Wanna Be Adored*, and now he is. Not only can he play Richard III at Joseph Papp's Public Theater, but he can give any Hollywood leading man a serious run for their money. In 1995 when director Tom DiCillo called and asked him to be in his film, *Living in Oblivion*, Dinklage thought a friend was playing a joke. But it was no joke and neither is Dinklage. He was recognized with a Best Actor nomination in the 2004 Independent Spirit Awards and has appeared in numerous films including *Bullet* (1996), *13 Moons* (2002), *Just a Kiss* (2002), *Elf* (2003), and *The Station Agent* (2003), in which he plays a train-obsessed recluse. One reviewer wrote of Dinklage, "He's kind of awesome, actually." Yes, he is.
> Visited the stairwell
> 1.18.05

• • •

12 . LUCIANO PAVAROTTI
> b . 1935
> *Opera singer*

When Luciano Pavarotti opens his mouth, people listen. He has appeared on the stages of the most important opera houses in the world and, for forty years, he has used his voice to do everything from perform at New York's Metropolitan Opera House to turn regular people into hard-core opera buffs. He also uses it to heal. Because of donations from his Pavarotti and Friends concerts and CDs with *War Child*, he was able to fund the Pavarotti Music Centre in the Bosnian town of Mostar to benefit children affected by the war. Of the sounds of suffering, he says, "We cannot understand these sounds, yet we must do something to make them easier to bear, and so we will bring music. Surely this is the nature of building peace."
> *Visited the stairwell*
> 2.8.05

13 . BILL IRWIN
> b . 1950
> *Actor, Clown*

Bill Irwin keeps the light on for Charlie Chaplin, Harry Langdon, and Buster Keaton. In other words, he has single-handedly resurrected physical comedy. Then he took it to Broadway. Actor, dancer, writer, choreographer, playwright, director, comic—and, yes, clown—Irwin is the recipient of a prestigious MacArthur Fellowship. His show, *Largely/New York* (1989) was nominated for four Tony awards and he has won two, in 1999 and 2005. He is a member of the International Clown Hall of Fame.
> *Visited the stairwell*
> 7.2.02

• • •

14 . RENÉE FLEMING
> b . 1959
> *Classical singer*

The inspiration for Ann Patchett's award-winning novel *Bel Canto* was mezzo-soprano Renée Fleming, and she doesn't take anything for granted: "I'm very superstitious about gratitude and about humility, because I always feel that this could all disappear tomorrow." But like the recordings she grew up listening to, Fleming is creating her own legacy. Acclaimed by the press as "one of the truly magnificent voices of our time," her repertoire includes world premieres such as: Countess in Corigliano's *The Ghosts of Versailles* at the Metropolitan Opera and Blanche DuBois in André Previn's *A Streetcar Named Desire* at the San Francisco Opera. She has been granted countless awards, including a Grammy for her album *The Beautiful Voice* (1999), and she received an honorary doctorate of music from the Juilliard School.
> *Visited the stairwell*
> 12.16.04

15 . ROBERT WILSON
> b . 1941
> *Designer, Theatrical director*

If reincarnation exists, Robert Wilson must have been René Magritte in his past life. In poignant non sequiturs, Wilson's visual references are very bold, very architectural, very colorful, and very surreal. And this makes perfect sense. After all, before he became the internationally acclaimed avant-garde director of events who merged drama and dance with opera, art, and instrumental music, Wilson studied architecture and painting. He has collaborated with the likes of Philip Glass, Heiner Müller, David Byrne, William Burroughs, Lou Reed, Susan Sontag, and Tom Waits, to name just a few. Among Wilson's classical productions are *Parsifal*, *The Magic Flute*, *Madame Butterfly*, and the complete Wagner Ring cycle. In 1992 he founded the Watermill Center in eastern Long Island, an international facility for new work in the arts.
> *Visited the stairwell*
> 9.27.03

• • •

16 . TONY HAWK
> b . 1968
> *Professional skateboarder*

Tony Hawk thinks Isaac Newton's law of gravitation is nonsense. He also turns the best tricks in the industry. Get your mind out of the gutter— that's skateboard vernacular for being the best skateboarder in the world. Instrumental in turning extreme sports into the alternative Olympics, Hawk has won more medals than any athlete in X Games history. At age thirty-one he retired and launched a kids clothing line, a video game for PlayStation®, and the Boom Boom HuckJam skateboarding tour. In 2002 he started the Tony Hawk Foundation, which helps fund public skate parks in low-income areas. So, if you were wondering whom every teenage boy would choose as his favorite person in this book, you've found him.
> *Visited the stairwell*
> 11.13.02

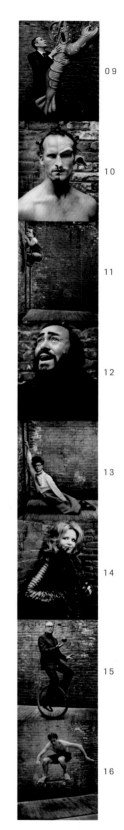

09
10
11
12
13
14
15
16

17
18
19
20
21
22
23

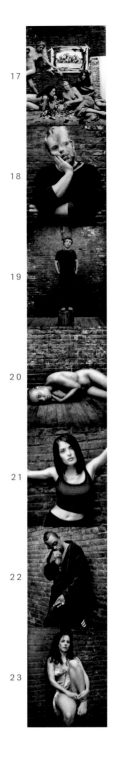

17 . PETER BEARD
> b. 1938
> *Artist*

Buddies with Bacon, Dali, and Warhol, the eternally handsome Peter Beard is not to be typed as a photographer. He is a collagist and his work is like an extravaganza of found goods. Dirt from the ground, newspaper clippings, pig's blood, other people's photographs: everything belongs to him and he completely overtakes any image you are looking at with his collage. Beard has published many books including *The End of the Game* (1965), *Longing for Darkness* (1975), and *From a Dead Man's Wallet* (1993). When he was attacked by an elephant and had its tusk rammed through its leg, he said he deserved it because it was he who invaded its space. When he's not in Africa crusading to end the rampant destruction of wildlife or making art, Peter Beard likes to watch television in his house in Montauk, New York.
> *Visited the stairwell*
> 3.3.05

18 . PHILIP SEYMOUR HOFFMAN
> b. 1968
> *Actor, Director*

Philip Seymour Hoffman is one of those actors who comes along, like, once in a lifetime, and makes being bad feel soo good. Oozing with talent, Hoffman has won awards for most of the films he has been in including *When a Man Loves a Woman* (1994), *Twister* (1996), *Boogie Nights* (1997), *The Big Lebowski* (1998), *Flawless* (1999), *Almost Famous* (2000), and *Cold Mountain* (2003). One of the most respected actors/ directors in the theater world, he directed numerous Off Broadway plays including *In Arabia, We'd All Be Kings* (1998), and won a Tony nomination for his stage performance in *True West* (2000) and for *Long Day's Journey Into Night* (2003). Hoffman is coartistic director of the LAByrinth Theater Company.
> *Visited the stairwell*
> 1.24.05

. . .

19 . ERIC BOGOSIAN
> b. 1953
> *Playwright, Actor*

All you need to know about Eric Bogosian is that he has played the devil at least four times. Well, and that *The New York Times* called his work, "irresistibly watchable." And if that is not compliment enough, the *Daily Texan* says, "Bogosian . . . hadn't simply crossed the line of good taste, he snorted it." Two of his best-known plays, *Talk Radio* and *subUrbia*, have been translated into acclaimed films, and he has created six full-length solos, including the three Obie award-winning *Drinking in America* (1986), *Sex, Drugs, Rock & Roll* (1990), and *Pounding Nails in the Floor with My Forehead* (1994). He is the recipient of a Drama Desk Award and in 2004 a Guggenheim Fellowship. He has worked with some of the greatest directors of our time including Robert Altman, Paul Schrader, Woody Allen, and Oliver Stone. Bogosian really is *to die for.*
> *Visited the stairwell*
> 10.22.04

20 . MESHELL NDEGEOCELLO
> *Née Mary Johnson*
> b. 1969
> *Musician*

Nine-time Grammy award nominee and mother of Neo-Soul, Meshell Ndegeocello is the female Marvin Gaye. She plays the meanest bass around and tackles everything from the politics of race to sex. Her work spans jazz, R&B, soul, and funk, and her interest in music began in the 1970s. As a teenager, Ndegeocello played regularly in the clubs in Washington, D.C., and by 1993, she was one of the first female artists to be signed to Madonna's Maverick label. She has collaborated with everyone from John Mellencamp to Chaka Khan to Cookie. Some of her albums include *Peace Beyond Passion* (1996), *Bitter* (1999), and *Comfort Woman* (2003). Meshell is an innovative, creative, and fierce queen of musical truth.
> *Visited the stairwell*
> 7.28.03

. . .

21 . SALMA HAYEK
> b. 1966
> *Actress*

Salma Hayek knew she wanted to be an actress when she saw *Willy Wonka and the Chocolate Factory* at a theater in her hometown of Coatzacoalcos, Mexico. When she moved to Los Angeles in 1991 she found that Latin actresses were only offered stereotyped bit roles, and Hayek was determined to change that. Director Robert Rodriguez cast her opposite Antonio Banderas in *Desperado* (1995), and again in *From Dusk Till Dawn* (1996), opposite George Clooney. Her next big role was in *Wild Wild West* (1999), but her true acting talent was recognized in *Frida* (2002), the biography of the legendary Mexican painter. Echoing the most powerful Mexican woman to have a voice, in *Frida*, Hayek became the first Latina to ever earn a Best Actress Oscar nomination and the film, which she produced, was nominated for six Oscars. She is also a champion and powerful force in the fight for violence against women.
> *Visited the stairwell*
> 10.5.99

22 . SEAN COMBS AKA PUFF DADDY, P. DIDDY, AND PUFFY
> b. 1970
> *Musician, Entrepreneur*

Sean "P. Diddy" Combs has almost as many names as he does talents. From his rankings on R&B and pop charts to his Bad Boy Entertainment empire, he dominates everything he touches. His multiplatinum debut release *No Way Out* (1997) won two Grammys, and his production of Mary J. Blige's *What's the 411?* (1992) topped the charts. Puff Daddy works hard, plays hard, and is dead serious when he sings, "Can't Nobody Hold Me Down." That song alone was No. 1 in the U.S. for almost eight weeks. In 1997, when the Notorious B.I.G. was shot and killed, Combs recorded "I'll Be Missing You." It went platinum, garnered over $3 million, and Combs donated it all to the family of B.I.G. He also runs a charity called Daddy's House, which gives money to New York City kids for computer camps and trips to Africa.
> *Visited the stairwell*
> 9.15.04

. . .

23 . MARY-LOUISE PARKER
> b. 1964
> *Actress*

Before Mary-Louise Parker went on active duty as a multiaward-winning actress, she was an army brat in South Carolina. She has since appeared in such films as *Fried Green Tomatoes* (1991), *Grand Canyon* (1991), and *The Client* (1994). Her performance in the television miniseries *Angels in America* (2003) earned her a Golden Globe and an Emmy. But she is as versatile as she is talented and as well known for her performances on stage as for those on screen. She has earned a Tony award nomination for her portrayal of a young bride in Craig Lucas's *Prelude to a Kiss* (1990), and won the Tony for Best Actress in 2001 for her performance in *Proof*. In 2004, she returned to Broadway to star in *Reckless*. She's the kind of actress, or, rather, one of the *only* actresses who could have any kind of career she wants.
> *Visited the stairwell*
> 3.27.05

24 . LENNY KRAVITZ
> b. 1964
> *Musician*

With the intellect and sensitivity of a Jewish scholar and the rhythm and soul of an African woman, Lenny Kravitz is a modern day Renaissance man. He plays every instrument you can think of, produces his own records, and still finds the time to design interiors and collect art. The Brooklyn-born brainchild of Sy Kravitz and Roxie Roker (from the 1970s television show, *The Jeffersons*), Lenny grew up surrounded by musical giants such as Duke Ellington, Sarah Vaughan, and Miles Davis. He broke the mold with his first album, *Let Love Rule* (1989), and his second, *Mama Said* (1991), went platinum. But it was *Are You Gonna Go My Way* (1993) that catapulted him into superstardom and turned him into a household name. In 1999 he received a Grammy for Best Male Rock Vocal Performance for the song "Fly Away." Like Lenny himself, his music is a defiant blend of retro, rock 'n roll, soul, funk, and hip-hop—in other words, 100% original.
> *Visited the stairwell*
> 7.3.01

. . .

25 . PALOMA HERRERA
> b. 1975
> *Ballet dancer*

Principal dancer of the world-renowned American Ballet Theatre, Herrera has been called everything from Prima Ballerina to Ballet's Angel. And she always knew she would be: "I couldn't understand my sister, why she didn't know what she wanted to do in life. I was seven, and I just knew!" The seven-year-old Herrera stood out as a star when she started ballet in Buenos Aires, Argentina. By the time she was nine, she had already won first prize at the Latino American Ballet Contest, and when she was fifteen, she moved to New York. At nineteen her dream came true: the role of Juliet in *Romeo and Juliet*. She has performed on stages across the globe and was named by *The New York Times Magazine* one of the thirty artists "most likely to change the culture for the next thirty years." But Herrera is more than an artist—she is a piece of art come to life.
> *Visited the stairwell*
> 12.13.04

26 . MIKHAIL BARYSHNIKOV
> b. 1948
> *Dancer*

Mikhail Baryshnikov should be exhausted. The trek from his native Latvia to the U.S. alone is a distance further than most people travel in a lifetime. But Mikhail Baryshnikov isn't most people. Heralded the greatest living dancer of all time by *Time* magazine in the 1980s, Misha continues to be the definition of grace. His mesmerizing stage presence and technical prowess landed him an Oscar nomination for his role as a dancer in the film, *The Turning Point* (1977). In 1990 he cofounded the White Oak Dance Project with acclaimed dancer Mark Morris, which was born of Misha's desire "to be a driving force in the production of art." Among his awards are the Kennedy Center Award and the National Medal of Honor. Watching him dance leaves audiences around the globe in absolute awe.
> *Visited the stairwell*
> 3.3.05

. . .

27 . FIONA SHAW
> *Née Fiona Mary Wilson*
> b. 1958
> *Actress*

Irish-born Fiona Shaw does what any leading classicist should do: she raises T. S. Eliot from the dead (*The Waste Land*), lobs off chunks of her own hair on stage (*The Taming of the Shrew*), crosses gender lines (*Richard II*), and kills babies (*Medea*). She has received three Laurence Olivier Theatre awards, two London Critics' Circle Theatre Awards, a New York Drama Critics Circle Award, and in 2001, she became an Honorary Commander of the Order of the British Empire. She has also appeared in numerous films including the Harry Potter series, *Jane Eyre* (1996), and *My Left Foot* (1989).
> *Visited the stairwell*
> 6.6.03

28 . WILL KEMP
> b. 1977
> *Dancer, Actor*

Will Kemp is the James Dean of Ballet. After all, it takes a legend to be the lead swan in *Swan Lake* (1995–2000). One of the principal dancers for Matthew Bourne's cutting-edge dance company, Adventures in Motion Pictures (AMP), British-born Kemp began dancing at age nine. Bourne continued to involve Kemp in his works, including *Spitfire*, *The Car Man*, and *Play Without Words*. He was nominated for a Los Angeles Critics Drama Award for Outstanding Featured Performer for his role in *Cinderella* (1997–1999), and in 2004 leapt from the stage to the big screen with the role of Prince Velkan in Stephen Sommer's *Van Helsing*. He then played an FBI trainee in Renny Harlin's *Mindhunters* and has strutted his stuff not only as dancer and actor but also as a model.
> *Visited the stairwell*
> 11.5.98

. . .

29 . MERCE CUNNINGHAM
> b. 1919
> *Dancer,*
> *Choreographer*

In the words of the godfather of modern dance: "There's no thinking involved in my choreography. . . . I don't work through images or ideas. I work through the body. . . . If the dancer dances—which is not the same as having theories about dancing or wishing to dance or trying to dance—everything is there. When I dance, it means: this is what I am doing." Cunningham founded his own dance company at Black Mountain College in 1953 and his style is like no others: his dancers learn and rehearse their pieces in silence, often not hearing the music until dress rehearsal or opening night. His collaboration with composer John Cage began in 1942 and ended only with Cage's death five decades later. Cunningham was inducted into the National Museum of Dance Hall Fame in 1993.
> *Visited the stairwell*
> 7.3.02

30 . ELVIS COSTELLO
> b. 1954
> *Musician*

DIANA KRALL
> b. 1964
> *Musician*

Elvis Costello is the angry young man with Buddy Holly glasses who bridged the gap between new wave and punk . . . and he did everything else you thought couldn't be done, too. Heralded "the most innovative, influential and best songwriter since Bob Dylan," Costello has been nominated for ten Grammys and won one (*Painted from Memory*, 1998). So it's fitting that he's married to the Canadian Queen of Jazz who also did everything you thought couldn't be done—from Diana Krall's five Grammy nominations to her two Grammy awards (*When I Look in Your Eyes*, 1999). Her multiplatinum and gold albums have broken every rule in the jazz book and turned her into the top-selling jazz vocalist. When the daughter of a jazz-loving stride pianist and son of a British bandleader collaborate, it's like attitude meets sensitivity. The duo has raised nearly a million dollars for the leukemia program at Vancouver General Hospital.
> *Visited the stairwell*
> 5.5.03

24

25

26

27

28

29

30

31 . EIKO AND KOMA OTAKE
> Eiko b. 1952, Koma b. 1948
> *Postmodern, Post-Hiroshima Dancers*

Eiko and Koma are wife and husband, two separate dancers who often seem to become one during their highly emotional, minimalist performances. Originally law and political science students in Japan, the two began studying dance with the Tatsumi Hijikata company in 1971. They quickly became exclusive partners, choreographing and performing their own works. They moved to the U.S. in 1976, staging their first American performance, *White Dance*, that same year. Their postmodern style of dance (often performed with little or no clothing) has earned them many honors, including a John Simon Guggenheim Memorial Fellowship (1984), a MacArthur Fellowship (1996), and a Samuel H. Scripps American Dance Festival Award for lifetime achievement in modern dance (2004). They say, "Through dance we present archaic landscapes, eons older than the world we all occupy in which we can rediscover our essential selves."
> *Visited the stairwell*
> 10.5.04

32 . WILLIE NELSON
> b. 1933
> *Musician*

Fifty percent wiseman and fifty percent wiseass, Willie Nelson is to Texas what Frank Sinatra is to New York. A radical in the truest sense of the word, Willie is where hippie and redneck collide. He is the brains behind Farm Aid, spends 290 days a year in his tour bus, and recently became an energy company executive for Willie Nelson's Biodiesel, a company that markets fuel made from vegetable oils to truck stops. His 1975 album, *Red Headed Stranger*, is the top-selling country music album in history. In 1993 he was inducted into the Country Music Hall of Fame thus cementing himself as the Jesus Christ of country music.
> *Visited the stairwell*
> 7.23.01

. . .

33 . TONY BENNETT
> *Né Anthony Dominick Benedetto*
> b. 1926
> *Singer*

The United Nations honored Tony Bennett with its Citizen of the World award for a reason. To name a few: fifty million albums sold worldwide, platinum and gold albums, ten Grammy Awards, and the Grammy Lifetime Achievement Award. After Bennett's appearance on MTV with the Red Hot Chili Peppers, *The New York Times* said, "Tony Bennett has not just bridged the generation gap, he has demolished it." In 1963 Bennett accompanied Dr. Martin Luther King, Jr. on his freedom marches. After the march, authorities denied Bennett a permit for a stage, so he and Harry Belafonte performed on a stack of unused coffins. Bennett has performed for the British royal family and continues to perform at sold-out venues all over the world. Bennett is also an avid painter, has raised millions of dollars for Juvenile diabetes, and now, in his seventies, he says: "I need two lifetimes. I'll never get it finished. I have that many creative ideas about what I'd like to do and what I'd like to learn."
> *Visited the stairwell*
> 5.14.01

34 . SUSAN STROMAN
> b. 1954
> *Choreographer, Director*

Susan Stroman is so intense and focused that if she was a laser beam she would destroy everything in her path. Or, anyway, that's what Mel Brooks says. She began taking jazz, tap, and ballet lessons at age five, and studied theater at the University of Delaware, moving to New York City after graduation. Stroman choreographed the Off-Broadway cult hit *Flora, the Red Menace* (1987) and won the first of five Tony awards for her choreography work on *Crazy for You* in 1992. More big shows followed, including *Show Boat* (1994), *Contact* (2000), and *The Music Man* (2000). *The Producers* won a record twelve Tony awards in 2001, including two for Stroman's direction and choreography. She followed up with hits like *Oklahoma!* (2002) and *The Frogs* (2004). Susan says if she had not become a choreographer, "With these visions . . . I'd be in big trouble. . . . I'd probably be in jail!"
> *Visited the stairwell*
> 1.30.05

. . .

35 . PHILIP GLASS
> b. 1937
> *Musician, Composer*

A modern day Mozart on an adrenaline rush, Philip Glass is frenetic, filmic, and one of a kind. In homage to Eadweard Muybridge, Glass wrote the music-drama, *The Photographer*. In 1968 he founded his own performing group, the Philip Glass Ensemble, because he couldn't find groups to perform his unusual works correctly. Known for his minimalist style with musical influences from all over he world, Glass has written everything from operas (such as *Einstein on the Beach*, with director Robert Wilson) to concert works for solo instruments and entire orchestras. In 1981 he collaborated with filmmaker Godfrey Reggio and wrote the score for the 87-minute, nonnarrative tale about the decline of mankind, *Koyaanisqatsi* (Hopi for "life out of balance"). It has proved the most influential mating of cinema and music since the 1940 *Fantasia*. The scores for *Kundun* (which earned him an Oscar nomination), *Dracula*, and *The Hours* are other notches on his belt.
> *Visited the stairwell*
> 7.21.03

36 . DENNIS RUSSELL DAVIES
> b. 1944
> *Conductor*

Dennis Russell Davies is the man with the baton, the leather pants, *and* the motorcycle. Considered a champion of contemporary music and among today's most inventive forces in classical, there is nothing conventional about D.R.D. Davies was music director and conductor of the Cabrillo Festival of Contemporary Music in Santa Cruz, California, for seventeen years. Now the chief conductor of the Stuttgart Chamber Orchestra and the Linz Opera, he is also professor of orchestral conducting at the Salzburg Mozarteum. In 2002 he was appointed to a five-year term on the board of directors of the esteemed Fromm Music Foundation at Harvard University. He is revered as a masterful, versatile artist at the forefront of the orchestral, chamber, and operatic worlds.
> *Visited the stairwell*
> 11.6.04

. . .

37 . CHUCK CLOSE
> b. 1940
> *Artist*

Highly renowned as a painter and best known for his large portraits, mostly of himself, family members, and artist friends like Cindy Sherman, Philip Glass, Roy Lichtenstein, and Richard Serra, Close is also a radical printmaker. He has redefined the art of portraiture with his intricate grid system and the tiny, meticulous dotlike elements he employs. In 1988 he was paralyzed by a spinal blood clot, but he began to paint again the next year using a brush strapped to his hand, and achieved enormous success with his new style. If you think his work looks technologically inspired, you're wrong. Close says: "Some people wonder whether what I do is inspired by a computer and whether or not that kind of imaging is a part of what makes this work contemporary. I absolutely hate technology, and I'm computer illiterate."
> *Visited the stairwell*
> 6.18.04

38 . SHARON OLDS
> b . 1942
> *Poet*

From *Grandmother Love Poem*: She'd crack / a joke as sharp as a tin lid / hot from the teeth of the can opener, / and cackle her crack-corn laugh.

Walt Whitman, Allen Ginsberg, Sylvia Plath, Anne Sexton, and now, Sharon Olds. Raised as a "hellfire Calvinist" in Berkeley, California, Olds earned a doctorate in English from Columbia University and vowed to become a poet even if it meant denying everything she had learned. She has since published eight volumes of poetry, including *Satan Says*, *The Father*, and *The Dead and the Living*, which won the Lamont Poetry Prize and the National Book Critics Circle Award. Currently, Olds is a professor at New York University and is the founding chair of its creative writing program at Goldwater Hospital for the severely physically disabled. She was the New York State Poet Laureate from 1998 to 2000.
> *Visited the stairwell*
> 3.31.05

· · ·

39 . KIKI SMITH
> b . 1954
> *Artist*

Don't try to get digital with Kiki Smith, she's 100% analog. One of the most influential sculptors and printmakers of her generation, she can also save your life: the biology-focused sculptor was trained as an Emergency Medical Technician, and the training has become central to her art. Smith was born in Germany and grew up in New Jersey, sculpting at the side of her father, artist Tony Smith. Kiki makes unflinching—sometimes startling—art. Her demandingly investigative work is of and about the body and human anatomy and she uses everything from wax to bronze to paper to silk. Smith participated in the celebrated *Times Square Show* of 1980 and her work has been featured at the Museum of Modern Art and three Whitney Biennials.
> *Visited the stairwell*
> 3.30.04

40 . JOHN CAMERON MITCHELL
> b . 1963
> *Actor, Director*

Born in East Germany, Hedwig is the cutest transsexual ever. She loves military men and candy. The radical who created her is John Cameron Mitchell, and when you remove the wig and the makeup, that is who you will find. Part Plato myth, part autobiography, the visual inspiration for Hedwig in *Hedwig and the Angry Inch* is based on Mitchell's old babysitter who was a German army wife and a prostitute. Created with musician Stephen Trask, the film is a "rock and roll fairy tale" and Hedwig is a "Marlene Dietrich figure with big hair." But beyond the glam, Mitchell is a serious actor, singer, writer, director, and producer, and Hedwig earned him a Best Director Award at the Sundance Film Festival and a Teddy award for Best Gay/ Lesbian Feature. Mitchell is an outspoken proponent of safe sex and AIDS awareness in the GLBT community.
> *Visited the stairwell*
> 7.21.01

· · ·

41 . SONIC YOUTH
> *Formed in 1981*
> *Musicians*
> *Steve Shelley,*
> *Lee Ranaldo,*
> *Thurston Moore,*
> *Kim Gordon*

Sonic Youth set the stage for Indie bands everywhere. They grabbed underground rock by its throat and incorporated the experimental sounds from The Velvet Underground and The Stooges. Inspired by avant-garde, post punk, no wave and hard core, the band redefined the word "noise." In 1985 they released *Bad Moon Rising* to strong reviews. But it was their next three independent albums (in particular *Daydream Nation* in 1989) that got them heavy play on college radios and attention from the mainstream press. Though bassist Kim Gordon says, "We were never really an 'it' band," their albums have repeatedly topped the charts. Noise has never sounded this good.
> *Visited the stairwell*
> 10.10.04

42 . CHRIS MARTIN
> b . 1977
> *Musician*

Even though his band Coldplay's first full album, *Parachutes* (2000), sold five million copies and won a Grammy, and even though each of his other albums have also all won Grammys, the quiet, soulful, socially conscious Chris Martin hardly has a rock star image . . . but that's just part of his appeal. The rest of his appeal is that when Martin's not making music, he's rallying for the cause of Third World farmers impoverished by the World Trade Organization. He collected over four million signatures for Oxfam's fair-trade petition, which he hand-delivered to the head of the WTO. Not your typical rock star—not your typical anything—Martin is the poster boy of good karma.
> *Visited the stairwell*
> 8.27.03

· · ·

43 . HARRY BELAFONTE
> b . 1927
> *Actor, Singer,*
> *Activist*

There is no other way to say this: Harry Belafonte is a renegade. He is also a singer, actor, civil and human rights activist; close friends with Martin Luther King, Jr., Nelson Mandela, and Desmond Tutu; cultural advisor to the Peace Corps; and United Nations worker. Belafonte has spent his entire career breaking grounds. He was the first black American to win an Emmy in 1960. His album, *Calypso*, was the first album to sell over a million copies. And in a world where people remain silent when they shouldn't, Belafonte is one of the few people to consistently speak out against corruption and inequality. For his work he has been honored with such awards as: Nelson Mandela Courage Award, the National Medal for the Arts, a Grammy for lifetime achievement, and he was appointed a UNICEF Goodwill Ambassador.
> *Visited the stairwell*
> 3.8.05

44 . CASSANDRA WILSON
> b . 1955
> *Singer*

Sultry, sensual, and soulful, Cassandra Wilson has been crossing boundaries since she was a little girl in Jackson, Mississippi. She was in ninth grade when her school became desegregated and just two years later, she played Dorothy in the school's rendition of *The Wizard of Oz*. But there really is no place like home and, in 2003, after thirteen albums, Wilson returned to Mississippi to record the Grammy-nominated *Glamoured* (2003). Her *Blue Light 'Til Dawn* was No. 1 on the jazz charts and she received a Grammy for *New Moon Daughter* (1995). She has worked with everyone from Fabrizio Sotti to Wynton Marsalis, and *Time* magazine has heralded her the "the most accomplished jazz vocalist of her time."
> *Visited the stairwell*
> 1.31.05

· · ·

45 . LAURIE ANDERSON
> b . 1947
> *Performance artist*

Agent Provocateur–Anderson can be credited with, among other things, completely reinventing performance art, music, *and* Herman Melville. Known for her spiky hair, devilish smile, and edgy multimedia performances, Anderson has recorded seven albums including *Songs and Stories from Moby Dick* (1999), *Bright Red* (1994), *Strange Angels* (1989), *Mister Heartbreak* (1984), *United States Live* (1984), and the 1981 hit, "O Superman." In 2003 she was named NASA's first artist-in-residence, which inspired her piece, *The End of the Moon*. Her unconventional performances are ripe with costumes, film, acoustic music, and slides, and her visual art has been exhibited everywhere from the Guggenheim Museum in SoHo, New York to the Centre Pompidou in Paris.
> *Visited the stairwell*
> 6.18.04

38
39
40
41
42
43
44
45

46 . **MARY J. BLIGE**
> b . 1971
> *Musician*

Before Mary J. started singing to audiences packed full of millions of fans, she lived in the Schlobam housing projects in Yonkers, New York, and recorded her songs on a karaoke machine in the White Plains Mall. Then Sean "Puffy" Combs got a hold of one of her recordings and helped turn her into the Queen of Hip Hop Soul. But she didn't forget where she came from. Her first album, *What's the 411?* (1992), is ripe with rawness and pain. And now, nearly fifteen years later, she still hasn't forgotten. "A part of me is still there," she says. "That's why my music is well-received, because I haven't left." Blige has been honored for her charity work, and her 1994 album *My Life* was nominated for a Grammy. Aretha Franklin can rest assured that Mary J. is proudly carrying the torch she has been passed.
> *Visited the stairwell*
> 8.30.01

. . .

47 . **ICE CUBE**
> *Né O'Shea Jackson*
> b . 1969
> *Musician*

This bio doesn't come with a Parental Advisory Warning, but it probably should. Raw, raunchy, political and profane, the rapper named Ice Cube is the original Nigga Wit Attitude (N.W.A.). The group's first album, *Straight Outta Compton*, achieved great underground success. Cube, not really one to shy away from controversy, crossed bicoastal lines when he collaborated with New York's Public Enemy. His first solo album, *AmeriKKKa's Most Wanted* (1990), went gold and *Death Certificate* (1991) went platinum. His six solo albums have sold more than ten million copies, and Cube hasn't toned it down even a little bit. He is as fierce and successful as an actor as he is a rap artist. His credits include *Boyz 'n the Hood* (1991) and *Three Kings* (1999), and he wrote, produced, and starred in the cult hit, *Friday* (1995).
> *Visited the stairwell*
> 11.4.03

48 . **MARK MORRIS**
> b . 1956
> *Dancer, Choreographer*

The "Mozart" of modern dance, who was as a teenager, in his own words, "tall and thin and pale," truly did transform into a beautiful swan. Mark Morris has been called every name in the book: from "enfant terrible" to the "bad boy" of modern dance. Now heralded as one of the most important choreographers in America, *New York* magazine has described his choreographic style as "periodic flare-ups that could spook a Buddha." He has created works for the San Francisco Ballet, Paris Opera Ballet, and American Ballet Theatre, and is the Artistic director of the Mark Morris Dance Group. In 1990 he cofounded the White Oak Dance Project with Mikhail Baryshnikov. In 2003 he wrote an essay entitled "I Guess I'm the Establishment Now." Uh, not quite.
> *Visited the stairwell*
> 7.19.03

. . .

49 . **RIC BURNS**
> b . 1955
> *Director, Writer*

KEN BURNS
> b . 1953
> *Director, Writer*

When *The Civil War* premiered on prime-time television in 1990, Ken Burns thought it was going to get "eaten alive." Instead, it became the highest rated series in the history of American public television. The eleven-hour series that the brothers coproduced grossed more than $100 million and won two Emmys. *American Film* magazine declared it "a film Walt Whitman might have dreamed," and George Will announced: "Our Iliad has found its Homer . . . if better use has ever been made of television, I have not seen it." In addition to this beast, Ken received an Oscar nomination for his *Brooklyn Bridge* and has produced numerous other documentaries. For Ric's part, his epic fourteen-hour *New York: A Documentary* (1999) was rewarded with rave reviews and an Emmy.
> *Visited the stairwell*
> 4.29.04

50 . **TIM ROBBINS**
> b . 1958
> *Actor, Director*

Don't tell Tim Robbins what to do or what to say, because he'll just ignore you. And that's why we love him. Robbins became an activist at a very young age—his first performance was a protest song duet with his father, folk-singer Gil Robbins, and he went to Washington and protested the war in Vietnam when he was just twelve years old. Cut to: 1981 when Robbins and several friends formed The Actors' Gang, a politically radical theater group, where he still serves on the Board of Directors. He began accepting roles in movies in order to support the theater. Cut to: a Best Actor Award at the Cannes Film Festival for *The Player* (1992), a nomination for an Oscar for best director for his work on *Dead Man Walking* (1995), and an Oscar for best supporting actor role for his performance in *Mystic River* (2003). He has been in numerous other films, including: *Toy Soldiers* (1984), *Bull Durham* (1988), *Jacob's Ladder* (1990), and *Bob Roberts* (1992).
> *Visited the stairwell*
> 1.5.05

. . .

51 . **JULIA ROBERTS**
> b . 1967
> *Actress*

This is where Old Hollywood style comes to life. With the most arresting smile on all seven continents, Julia Roberts is, well, she's Julia Roberts. And when you're Julia Roberts you don't *have* to be *like* anyone. In fact you don't have to *do* anything. So it's nice that she does. Roberts is on the Board of Directors for Paul Newman's Hole in the Wall Gang Camp, a nonprofit summer camp for children with terminal illnesses, and has made trips to Haiti and other parts of the world to promote goodwill and peace. After September 11, 2001, Roberts participated in the telethon, *America: A Tribute to Heroes*, which has raised close to $30 million. She has earned several Oscar nominations—one for *Steel Magnolias* (1989) and one for *Pretty Woman* (1990)—but won the Oscar for Best Actress for *Erin Brockovich* (2000).
> *Visited the stairwell*
> 2.2.00

52 . **LIAM NEESON**
> b . 1952
> *Actor*

Thanks to a broken nose, a few too many blackouts, and the high school English teacher who cast him in a play, Irishman Liam Neeson didn't become a boxer. With his chiseled good looks and penetrating eyes, at six-feet-four, Neeson is a huge presence. His lead role in *Schindler's List* (1993) earned him an Oscar nomination, a Golden Globe nomination, and made him a star. He was nominated again for a Golden Globe for his role in *Michael Collins* (1996). In 1993 he made his Broadway debut, earning a Tony nomination for his role in Eugene O'Neill's *Anna Christie*, and he has worked with everyone from Martin Scorsese to Steven Spielberg.
> *Visited the stairwell*
> 12.17.04

. . .

53 . **SUSAN SARANDON**
> *Née Susan Abigail Tomalin*
> b . 1946
> *Actress, Activist*

Gloriously sexy and as fierce on screen as she is off, Susan Sarandon attracts as much attention for her work as an activist as for her work as an actress. She has consistently used her fame as a platform to do good, to make people aware, and to take a stand even when it was not popular to do so. Each time she has emerged glorious and triumphant. Throughout the course of her prolific career Sarandon has played roles in films such as: *Rocky Horror Picture Show* (1975), *Atlantic City* (1980), *The Witches of Eastwick* (1987), *Bull Durham* (1988), *Thelma & Louise* (1991), *Lorenzo's Oil* (1992), and *Alfie* (2004). She has been nominated for numerous Academy Awards, and in 1995 she received one for her powerful portrayal of a nun who mentors a death row inmate in *Dead Man Walking*.
> *Visited the stairwell*
> 12.7.04

54 . HAL WILLNER
> b. 1957
> *Composer, Music producer*

Musicologist Hal Willner has more good ideas in a day than most people have in a lifetime. Which is probably why he has worked with every musician in this book . . . and then some. He has also served as music director for *Saturday Night Live* and produced the anthology of Disney music *Stay Awake* (featuring Ringo Starr and Sinéad O'Connor). The list goes on: *Closed on Account of Rabies: Poems and Tales of Edgar Allan Poe* (featuring Iggy Pop, Christopher Walken, and Jeff Buckley), and his tribute to Kurt Weill, *Lost in Stars* (featuring Tom Waits, Marianne Faithfull, Lou Reed, and Todd Rundgren) was reworked entirely for a brilliant television special called *September Songs*. He has assembled musicians to cover everyone from Thelonious Monk to Charles Mingus to Nino Rota and has a solo album called, *Whoops! I'm an Indian* (1998).
> *Visited the stairwell*
> 10.10.04

. . .

55 . WYNTON MARSALIS
> b. 1961
> *Jazz musician, Composer*

Van Gogh had his brush, Jimi Hendrix had his electric guitar, and Wynton Marsalis has his trumpet. But things were not always so clear-cut: When Marsalis was a youngster in New Orleans, he didn't want to practice because he thought the girls wouldn't like him if he had a ring around his lip from playing the trumpet. He eventually changed his mind, and when he did, he resurrected an endangered species. He also proved to the world that America's best offer at creating something universal did not have to begin and end with fast-food chains and shopping malls. In 1987 he cofounded Jazz at Lincoln Center and has, to date, recorded fifty some-odd albums, received nine Grammys, and in 1997 won the Pulitzer Prize for Music for his oratorio *Blood in the Fields*.
> *Visited the stairwell*
> 1.12.05

56 . TOM WOLFE
> b. 1931
> *Writer*

Tom Wolfe breaks all the rules and that includes the one about not wearing white after Labor Day. But even his fashion isn't nearly as groundbreaking as his writing. In 1968, he published two bestsellers on the same day: *The Pump House Gang* and *The Electric Kool-Aid Acid Test*. His work has earned him international acclaim, a huge fan base, and a few enemies. When *The Painted Word* (1975) enraged the art world, Wolfe kept on wearing white. When *The Bonfire of the Vanities* became number-one on the *New York Times* bestseller list and sold over two million copies, Wolfe kept right on wearing white. His novel *I Am Charlotte Simmons* was published in 2004. And Wolfe, as we can see, continues to wear white.
> *Visited the stairwell*
> 6.25.04

. . .

57 . MUHAMMAD ALI
> *Né Cassius Marcellus Clay*
> b. 1942
> *Boxer*

MICHAEL J. FOX
> b. 1961
> *Actor*

A pacifist by nature and known for his lyrical charm, Muhammad Ali is the greatest heavyweight champion of all time. Ali was stripped of his title and boxing license over his refusal to participate in the Vietnam War and was one of the most powerful forces in the Civil Rights movement. In the face of his illness, Ali continues to inspire children to fight the good fight and "float like a butterfly, sting like a bee."

Alex Keaton, from the classic show, *Family Ties*, would have made his father proud. And not just on television. Canadian-born Michael J. Fox, known for his roles on blockbuster films like *Back to the Future* (1985) and *The Secret of My Success* (1987) as well as television's *Spin City*, says that being a dad to his four kids is his best role yet. In 2002 he published the book *Lucky Man* and received a Hollywood Star.

Parkinson's disease affects an estimated one million Americans per year and has no known cause and no known cure. Between the Michael J. Fox Foundation for Parkinson's Research and The Muhammad Ali Parkinson's Research Center, if anyone can find a cure, it will be thanks to our modern day Peter Pan and this national treasure of athleticism.
> *Visited the stairwell*
> 9.23.04

. . .

58 . LADYSMITH BLACK MAMBAZO
> *Founded 1964*
> *A cappella South African Music Group*
> *(left to right) Sibongiseni Shabalala, Jockey Shabalala, Russel Mthembu, Thulani Shabalala, Jabulane Dubazana, Thamsanqa Shabalala, Joseph Shabalala, Albert Mazibuko, Abednego Mazibuko Seated: Msizi Shabalala*

The Isicathamiya music of Ladysmith Black Mambazo is a blend of traditional Zulu music, Christian gospel, township jive, and doo-wop, and was born in the mines of South Africa. Underpaid, overworked, black laborers would spend their long journeys singing and call themselves the "tip-toe" guys in reference to the choreographed steps they created so as not to disturb security guards. These songs became part of their tradition and, in the 1950s, Joseph Shabalala literally dreamt of harmonious music. His dream became a reality with the help of family members and friends. The foot stomping ten-some has managed to "survive, thrive, and even outlive the dark days of South African apartheid." The group has since won two Grammys and has been nominated for nine. They have produced more than forty albums and have performed for everyone from Queen Elizabeth to Pope John Paul II to Nelson Mandela.
> *Visited the stairwell*
> 1.26.04

59 . DESMOND TUTU
> b. 1931
> *Archbishop*

Antiapartheid crusader, champion for peace, freedom fighter . . . it is difficult to put into words the many roles Archbishop Desmond Tutu has played in abolishing apartheid and empowering black South Africans. Born in Klerksdorp, Transvaal, Tutu studied to be a teacher like his father. But he quit teaching in 1957, in protest of new laws passed to limit black education, and began to study theology. Ordained as an Anglican priest, he became the first black General Secretary of the South African Council of Churches in 1978. He used his position to unite the churches in the antiapartheid cause and to capture the world's attention. And he certainly succeeded—in 1984 Tutu received the Nobel Peace Prize for his work.
> *Visited the stairwell*
> 2.22.05

. . .

60 . AZAR NAFISI
> b. 1955
> *Writer, Professor*

What we search for in fiction is not so much reality, but the epiphany of truth." So begins Azar Nafisi's book, *Reading Lolita in Tehran* (2003), which tells the story of how Nafisi and seven of her students secretly gathered in her house to read forbidden works of literature. In her courageous search for the epiphany of truth, Dr. Afisi was exiled from the University of Tehran for refusing to wear the mandatory Islamic veil and defected to America in 1997. She is now a Visiting Fellow at the Foreign Policy Institute of Johns Hopkins University as well as the director of The Dialogue Project, designed to promote the development of democracy and human rights in the Muslim world. Her work has appeared in *The New York Times*, *The Washington Post*, and *The Wall Street Journal*. She once stated, "Lots of times you can feel as an exile in a country that you were born in."
> *Visited the stairwell*
> 3.30.05

54

55

56

57

58

59

60

61 . NIKKI GIOVANNI
> *Née Yolanda Cornelia Giovanni*
> b . 1943
> *Poet*

Poetry ain't for sissies, and on the inside of her left forearm, this distinguished English professor and NAACP Image Award winner for Literature sports a "Thug Life" tattoo immortalizing legendary hip-hop artist/poet, Tupac Shakur. Which is to say that in addition to being one of the most influential poets of our time, Nikki Giovanni is tough. She is also gentle, soulful, and a leading voice for black rights. In 1996 Giovanni received the Langston Hughes Award for Distinguished Contributions to Arts and Letters, and several magazines—*Essence*, *Mademoiselle*, and *Ladies Home Journal*—have named her Woman of the Year. Her many books include *Racism 101* (1994), *Love Poems* (1997), and *The Nikki Giovanni Poetry Collection*, which was a finalist for the 2003 Grammy Award in the spoken word category.
> *Visited the stairwell*
> 5.11.04

. . .

62 . GIORGIO ARMANI
> b . 1934
> *Designer*

Giorgio Armani is like the Emperor of Milan and his empire is like the Vatican of fashion. Italian soldier and medical student cum fashion icon, Armani is as glamorous, sophisticated, and well-defined as his clothes. In 1975 he launched his own company, Giorgio Armani S.p.A., with partner Sergio Galeotti, and his career took off in 1980 when he dressed Richard Gere in the film *American Gigolo*. In 1982 Armani became the first fashion designer after Christian Dior to grace the cover of *Time*. On top of all that, he's good looking and a nice guy: in 1991 he was named one of *People* magazine's Fifty Most Beautiful People, and a year earlier he received an award from PETA (People for the Ethical Treatment of Animals).
> *Visited the stairwell*
> 10.27.04

63 . RALPH LAUREN
> b . 1939
> *Fashion designer*

If it were not for the Crown Prince of American fashion, we would probably all be wearing baseball caps and white leather sneakers. Thank God for Ralph Lauren. America's most renowned designer started out with a line of wide ties that he created to launch Polo in 1968. Thirty-seven years later, he is still the only designer to receive the Council of Fashion Designer's four highest honors—including the Lifetime Achievement Award, and run a $10 billion a year global enterprise. Not bad for a boy from the Bronx. "I have always had a clear vision. I wanted to develop quality products that didn't exist and create a whole world around that. That means taking risks, going with what you feel, but never losing sight of your vision and conviction." In 2000, Polo Ralph Lauren launched the Pink Pony Campaign, a worldwide effort in the fight against cancer. He then went on to establish the Ralph Lauren Center for Cancer Care and Prevention in Harlem.
> *Visited the stairwell*
> 8.22.02

. . .

64 . TYSON BECKFORD
> b . 1971
> *Supermodel*

Ralph Lauren wisely chose Tyson Beckford to help him prove to the world that Polo does not have to be about a bunch of snotty British men riding around on horses. Tyson has been named Model of the Year (at the 1995 VH1 Fashion Awards), has appeared on the covers of major magazines such as *Paper* and *Essence* and in spreads in *Vogue*, *GQ*, and *The New York Times*. But he is so much more than a twenty-first-century Adonis. With a passion for racing and cars, Tyson has his own rim line as well as a signature tire line with Pirelli. He is also very involved with the AIDS charities, Keep a Child Alive and God's Love We Deliver.
> *Visited the stairwell*
> 4.1.05

65 . HEIDI KLUM
> b . 1973
> *Supermodel*

Ubermodel Heidi Klum has the most beautiful back in the world. And her front isn't bad either. She has graced the covers of *Elle*, *GQ*, *Glamour*, *ID*, *Vogue*, *Marie Claire*, and, well, you get the idea. Born in Cologne, Germany, she made her breakthrough as the 1998 cover girl on the highly coveted *Sports Illustrated* swimsuit issue and calendar. In addition to being a model, she is an actress as well as a designer. She has made appearances on *Spin City* and *Sex and the City*, and is the judge and executive producer of *Project Runway*. She also has her own line of Birkenstocks, jewelry, and perfume. Her charity involvements include work on behalf of the American Red Cross and the Elizabeth Glazer Pediatric AIDS Foundation. But the best thing about Heidi is that she is as sweet as she looks.
> *Visited the stairwell*
> 6.21.02

. . .

66 . ADRIEN BRODY
> b . 1973
> *Actor*

With undeniable talent and looks that recall a young and hungry Al Pacino, Adrien Brody is hot. When Adrien was a kid, his mother, the renowned photojournalist Sylvia Plachy, encouraged him to take acting classes and he started off as a magician at children's parties. Although Brody no longer pulls rabbits out of hats, his performances continue to be nothing less than magical. His first big film role was in Steven Soderbergh's critically acclaimed *King of the Hill* (1993). He has subsequently won roles in several films, including *Angels in the Outfield* (1994), *The Last Time I Committed Suicide* (1997), *The Thin Red Line* (1999), and *Summer of Sam* (1999). His wrenching portrayal of a Polish-Jew struggling to survive the Holocaust in *The Pianist* (2002) earned him an Oscar for best actor making him the youngest man ever to receive one.
> *Visited the stairwell*
> 6.5.03

67 . PERRY FARRELL
> *Né Perry Bernstein*
> b . 1959
> *Musician*

No one should look this good after twenty years of being a hard-core rock star, but Perry Farrell really does. In the 1970s a young Bernstein moved to California and wanted to become a surfer, but instead he changed his name and became Perry Farrell. Lead singer for one of the most influential bands of all time (that would be Jane's Addiction) and the mastermind behind Lollapalooza, Farrell invented the word "alternative." In 1988, when Jane's Addiction released their breakthrough album, *Nothing's Shocking*, it was like a volcano erupted in the rock world. Their classic album, *Ritual de lo Habitual* helped pave the way for bands like Red Hot Chili Peppers and Nirvana. Once known for his completely outrageous live performances, Perry Farrell is now a supporter of the "Free Tibet" campaign, Amnesty International, and the Third World "Drop the Debt" campaign. The ordained genius and rock visionary finally turned into the nice Jewish boy every mother hopes for. Well, relatively speaking, at least.
> *Visited the stairwell*
> 7.29.03

. . .

68 . GILLIAN WELCH
> b . 1967
> *Musician*

DAVID RAWLINGS
> b . 1969
> *Musician*

Gillian and David drive around in a thirty-nine-year-old F-100 pickup that sports the original AM radio. That means that one of the only things they can listen to is the Grand Ole Opry. But that's fine, they love the Grand Ole Opry. And the Grand Ole Opry loves them—they perform there regularly. And what's not to love? Welch sings unbearably beautifully, and Rawlings, inspired by the sound of Bob Dylan's harmonica, plays guitar solos that are undeniably the second voice to her lyrics. And that's just for the Gillian Welch band. The two have an alter ego, another band, called The Esquires, in which they swap roles: she plays the bass and he sings. Welch and Rawlings were nominated for four Grammys and won one for their platinum selling soundtrack for the Coen brothers' *O Brother, Where Art Thou?* (2000).
> *Visited the stairwell*
> 7.13.02

69 . RAVI SHANKAR
> b . 1920
> *Sitar player,*
Composer

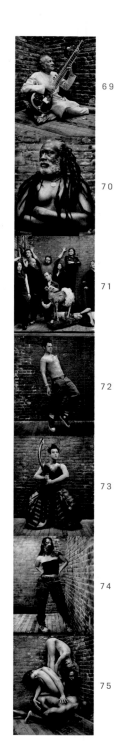

When master sitarist Ravi Shankar wanted to bring Indian music of the East to the West, he hardly set out to become the "godfather of world music." But he did. Shankar has collaborated with everyone from the Beatles' guitarist George Harrison to composer Philip Glass, received two Grammys, eleven honorary doctorates, and the Padma Vibhushan, India's highest civilian award. He has inspired charities and projects around the world. Though a purist in his classical sitar performances, Shankar experiments and pushes boundaries with his compositions. Shankar continues to teach and perform internationally and says, "The only true security that can be found in this world is in the very process of giving love."
> *Visited the stairwell*
> 4.15.02

• • •

70 . BURNING SPEAR
> *Né Winston*
Rodney
> b . 1948
> *Musician*

If you think you get the "burning spear" reference for this Rastafarian, you're wrong. More into fitness than cannabis, Burning Spear chose his name to honor Jomo Kenyatta, a hero of Kenyan independence. The reggae pioneer grew up in the parish of St. Ann's, Jamaica. In 1969 he bumped into Bob Marley who was flanked by a donkey on his way to a farm, and said he would like to get involved in the music business. Bob said, "All right, just check Studio One." And that was how Spear got referred to his first label. Since then, he has released a steady stream of internationally revered albums including *Marcus Garvey* (1975). His *Calling Rastafari* picked up a Grammy in 2000 and racked up nine nominations. His lyrics are filled with his Rasta philosophy, the gospel of Marcus Garvey, and his own spirituality. He is one of the single greatest proponents of self-determination and self-reliance for all African descendants, and his message is based on honesty, peace, and love.
> *Visited the stairwell*
> 1.8.03

71 . ANNE BOGART AND
SITI COMPANY
> b . 1952
> *Theater director*
and company
> *(left to right)*
Akiki Aizawa,
James Schuette,
Barney O'Hanlon,
Stephen Webber,
Brian Scott,
Elizabeth Moreau,
Megan Wanlass
Szalla, J. Ed Araiza,
Charles L. Mee,
Tom Nelis,
Anne Bogart
Not pictured:
Ellen Lauren,
Kelly Maurer,
Susan Hightower,
Neil Patel,
James Bond,
Leon Ingulsrud,
Darren L. West

In 1992 Anne Bogart decided she wanted to revitalize contemporary American theater so she joined forces with Japanese director Tadashi Suzuki and founded Saratoga International Theatre Institute (SITI). SITI is about creating a fellowship of artists from all cultures, emphasizing international collaboration, the creation of new work, and training new artists. Bogart says, "I don't have a vision, I have values." Always the Taoist, she believes that instead of bossing people around she should do what she does best—facilitate. And, in recognition of her outstanding work, Bogart has received numerous awards including several Obie awards, a Guggenheim Fellowship, and the Elliot Norton Award for Outstanding Direction.
> *Visited the stairwell*
> 3.3.05

72 . JOHNNY
KNOXVILLE
> *Né Philip*
John Clapp
> b . 1971
> *Actor*

Johnny Knoxville is a self-proclaimed "jackass," and it has served him well. At age six, he was bitten on the face by his Aunt Phyllis's miniature poodle . . . and he liked it. He is host of one of cable television's highest-rated shows (MTV's, *Jackass*). As a toddler, Knoxville suffered from enuresis. His mother installed a "wee alert" system that went off every time he had an accident and, as a result, Mr. Knoxville now suffers from insomnia. In 1996, he became inspired to shoot himself with pepper spray, a laser, a stun gun, and Jeff Tremaine, editor of *Big Brother* magazine, encouraged him to tape the event. Johnny quickly became a cult hit. He has been featured on the cover of *Rolling Stone*, released several films, and was so hung-over when he visited the stairwell that he threw up seven times.
> *Visited the stairwell*
> 4.11.05

• • •

73 . ALAN CUMMING
> b . 1965
> *Actor*

Pop icon, bon viveur, and sex symbol wrapped up into one, Alan Cumming is totally irresistible. And he knows it. The devilish, dimpled actor, director, and writer grew up in Fassfem, Scotland, and still wears kilts whenever he feels like it. He has starred in numerous films, including *Prague* (1992), *Circle of Friends* (1995), and *Eyes Wide Shut* (1999). His electrifying performance in *Cabaret* earned him a Tony and numerous other awards. He wrote and directed the film *The Anniversary Party* in 2001 and, a year later, published the novel, *Tommy's Tale*. In 2005, he launched his own line of cologne called Cumming.
> *Visited the stairwell*
> 12.12.04

74 . ALICIA KEYS
> *Née Alicia*
Augello Cook
> b . 1981
> *Musician*

Her multiplatinum debut is called *Songs in A Minor* (2001), but there is nothing—nothing—minor about Alicia Keys. And then you check her birth date, and you are like, What? How does that happen? A prodigy housed in the body of a person, Keys is as confident, smart, and focused as her music is profound. The classically trained pianist describes her music as a "fusion" of jazz, blues, R&B, and hip hop. She began studying piano at the ripe age of seven and writing songs at fourteen. She graduated from high school two years earlier than everybody else and briefly attended Columbia University, but her calling proved too strong to deny and ultimately lead her to her manager, Jeff Robinson, and to the desk of music industry heavyweight, Clive Davis. *The Diary of Alicia Keys* (2003) was as much a multiplatinum sensation as her first album, and she has received nine Grammy Awards. She is also the spokesperson for the AIDS charity Keep a Child Alive.
> *Visited the stairwell*
> 9.13.01

• • •

75 . PILOBOLUS
> *Founded 1971*
> *Dance company*
> *(top to bottom)*
Rebecca Anderson-
Darling, Michelle
Curtis, Trebien
Pollard, Gaspard
Louis

They started as a lark, an experiment. Thirty years later, Pilobolus is one of the most innovative dance companies in the world and its dancers are among the strongest, most versatile in the business. So don't try this at home. With four artistic directors and six revolving dancers, Pilobolus refers to themselves as "the dance company for those who don't like to dance . . . and for those who do." Their acrobatic, highly improvisational repertoires are a collaborative effort (to say the least), and they have even developed their own language to describe their moves: one is called the dolphin, another, the deer turn. They have been called "the jazz artists of the dance world" and are recognized as a major American dance company.
> *Visited the stairwell*
> 2.18.02

69
70
71
72
73
74
75

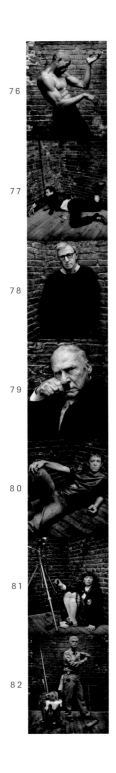

76 . BILL T. JONES
> b . 1 9 5 2
> *Ballet dancer,*
Choreographer

IN THE EARLY 1970s Bill T. Jones, a son of Southern migrant workers, met and fell in love with Arnie Zane, a Jewish/Italian budding photographer from the Bronx. The two created a radical style of dance-theater that confronted racism, religion, class, and sexuality. They also started an artistic and life partnership that lasted seventeen years. Although Zane passed away in 1988, he is memorialized constantly; the Bill T. Jones/Arnie Zane Dance Company, which they formed in 1982, is now one of America's most celebrated and influential. Jones has been the recipient of a MacArthur Fellowship, the Choreographic Fellowship from the National Endowment for the Arts, and his memoir, *Last Night on Earth*, was published in 1995. In the words of Lou Reed, "To see Bill dance is to be thrilled."
> *Visited the stairwell*
> 7.23.03

• • •

77 . JERRY SEINFELD
> b . 1 9 5 4
> *Comedian, Actor*

Jerry is still doing what he does best—making people laugh. Born Jerome Seinfeld, he grew up on Long Island, and was an honors student at Queens College. After graduating in 1976, he performed in New York comedy clubs (often without pay), and his understated style won him a brief role on the television show *Benson* in 1979. He appeared on *The Tonight Show Starring Johnny Carson* two years later, and was such a huge hit that he became a frequent guest. In 1989 Jerry joined his friend Larry David to create *Seinfeld*, a television comedy about "nothing." The hilarious, groundbreaking show became one of NBC's biggest hits, ending at its peak in 1998, after nine seasons. Jerry Seinfeld walked away from his No. 1 television show to go back and do exactly what he was doing when he was trying to make a No. 1 show—stand-up comedy.
> *Visited the stairwell*
> 2.1.05

78 . WOODY ALLEN
> *Né Allen Stewart*
Konigsberg
> b . 1 9 3 5
> *Writer, Director,*
Actor, Producer

The man *The New York Times* has called "the celebrated stand-up Flaubert" got his first big break writing for the show Sid Caesar alongside Mel Brooks. As prolific as he is hysterical, Woody Allen has been releasing a film nearly every year since 1969. He has been nominated for thirteen Academy Awards for writing (more than anyone in the industry) and *Annie Hall* (1977), *Manhattan* (1979), and *Crimes and Misdemeanors* (1989) are to name but a few of his classic films. With passions ranging from the clarinet to the New York Knicks, Allen is as eclectic as he is talented and truly is America's most revered auteur.
> *Visited the stairwell*
> 5.4.05

• • •

79 . MEL BROOKS
> *Né Melvin*
Kaminsky
> b . 1 9 2 6
> *Producer, Writer,*
Director, Comedian

If you told Mel Brooks you admire his work, he'd give you an enormous smile and say, "You have very good taste!" And he'd be right. As a former World War II combat engineer and one of the very few people to have received an Oscar, Grammy, Emmy, and a Tony Award, Mel Brooks first created *The Producers* in 1968 and has been getting revenge on Hitler ever since. He also wrote and directed *Young Frankenstein* (1974; cowritten with Gene Wilder), *Blazing Saddles* (1974) and *History of the World, Part 1* (1981). About his genius, he says, "Oh, I'm not a true genius. I'm a near genius. I would say I'm a short genius. I'd rather be tall and normal than a short genius."
> *Visited the stairwell*
> 5.4.05

80 . LOU REED
> b . 1 9 4 2
> *Musician*

The Pope of the East Village, Lou Reed is the original punk. With wry, sardonic lyrics and deadpan delivery, he's the one who took the world for a Walk on the Wild Side. Reed and his band, The Velvet Underground, released the album *Transformer* in 1972 and, on it, along with "Wild Side" is the song "Vicious," which Reed wrote on the advice of his friend, Andy Warhol. Reed had to take his advice—he was, after all living in Warhol's Factory. Other indispensable contributions include: *All Tomorrow's Parties / I'll Be Your Mirror* (1966), *Sweet Jane* (1973), and *Live at Max's Kansas City* (1989). In 1997 Lou Reed and his Velvet Underground band mates were inducted into the Rock and Roll Hall of Fame.
> *Visited the stairwell*
> 10.13.04

• • •

81 . CINDY SHERMAN
> b . 1 9 5 4
> *Photographer*

Cindy Sherman may *seem* like she's only interested in herself but she actually only *uses* herself as medium. Her antiself-portrait self-portraits serve to critique and question the role of woman and artist in the modern world. Influenced by Guerrilla Girls and Diane Arbus, Sherman was *the* pioneer who introduced photography into the art world and has captured herself featured as everything from a film noir character to Little Bo Peep. About her work she says this: "I don't want to have to explain myself. The work is what it is and hopefully it's seen as feminist work, or feminist-advised work, but I'm not going to go around espousing theoretical bullshit about feminist stuff." In 1999, *ARTnews* named her one of the Top Ten Living Artists and her work has been exhibited in over two hundred exhibits and is collected by upwards of sixty museums.
> *Visited the stairwell*
> 2.7.05

82 . DAVID BYRNE
> b . 1 9 5 2
> *Musician,*
Composer

With his legendary oversized suit, theatrical stage presence, and immeasurable and innumerable accomplishments, David Byrne is a real live wire. Dark, haughty, unconventional, and deliriously otherworldly, the cofounder of the Talking Heads started throwing funk at CBGB when he was still an art student at the Rhode Island School of Design. From his solo *The Catherine Wheel* (1981), which he composed for Twyla Tharp's dance troop, to the band's seminal *Stop Making Sense* (1984), Byrne's genius is almost incomprehensible. And that's precisely the point. In addition to having developed New York underground punk, Byrne is a filmmaker, director, musician, composer, and photographer. He won a Grammy for his score for *The Last Emperor*, and Talking Heads was inducted into the Rock and Roll Hall of Fame in 2002.
> *Visited the stairwell*
> 4.22.05

83 . MARK SELIGER
> *b. 1959*
> *Photographer*

Mark Seliger exceeded even his classmates' expectations when they voted him "Most Likely to Succeed" in high school. Seliger's career took a turn for the better when he went from head stockboy at Bakers Shoe Store in Houston's Sharpstown Mall to chief photographer for *Rolling Stone*, for which he shot more than one hundred covers, to shooting for *Vanity Fair* and *GQ*. He has received innumerable awards and his work has been exhibited in galleries around the world. He has codirected videos with Fred Woodward for Courtney Love, Natalie Merchant, and Lenny Kravitz. His other books are: *When They Came to Take My Father: Voices from the Holocaust*; *Physiognomy*; and *Lenny Kravitz/Mark Seliger*. Seliger is also a singer/songwriter and has a band called Rusty Truck.

. . .

84 . STAIRWELL
> *Né elevator shaft*
> *Built 1852;*
> *Rediscovered 1996*

Before it became "the studio" and perhaps the closest thing to a modern day version of Andy Warhol's Factory, the building 162 Charles Street was used as a storage warehouse and a livery for a women's correctional facility. When Seliger purchased it in 1996, he had to demolish the entire thing to bring it up to code. It was during the demolition that he discovered an old elevator shaft topped by an enormous window—or skylight. It had probably not seen the light of day in nearly a century and a half. The photographer in Seliger knew he had just hit the jackpot: three brick walls and a crown of sun. It was the perfect stage, the perfect place to *become*. And thus it began—nonchalantly at first, as an afterthought. And then, after David Bowie, Paul McCartney, and Julia Roberts, the place where people became itself became a personal atelier . . . a place where anything was possible.

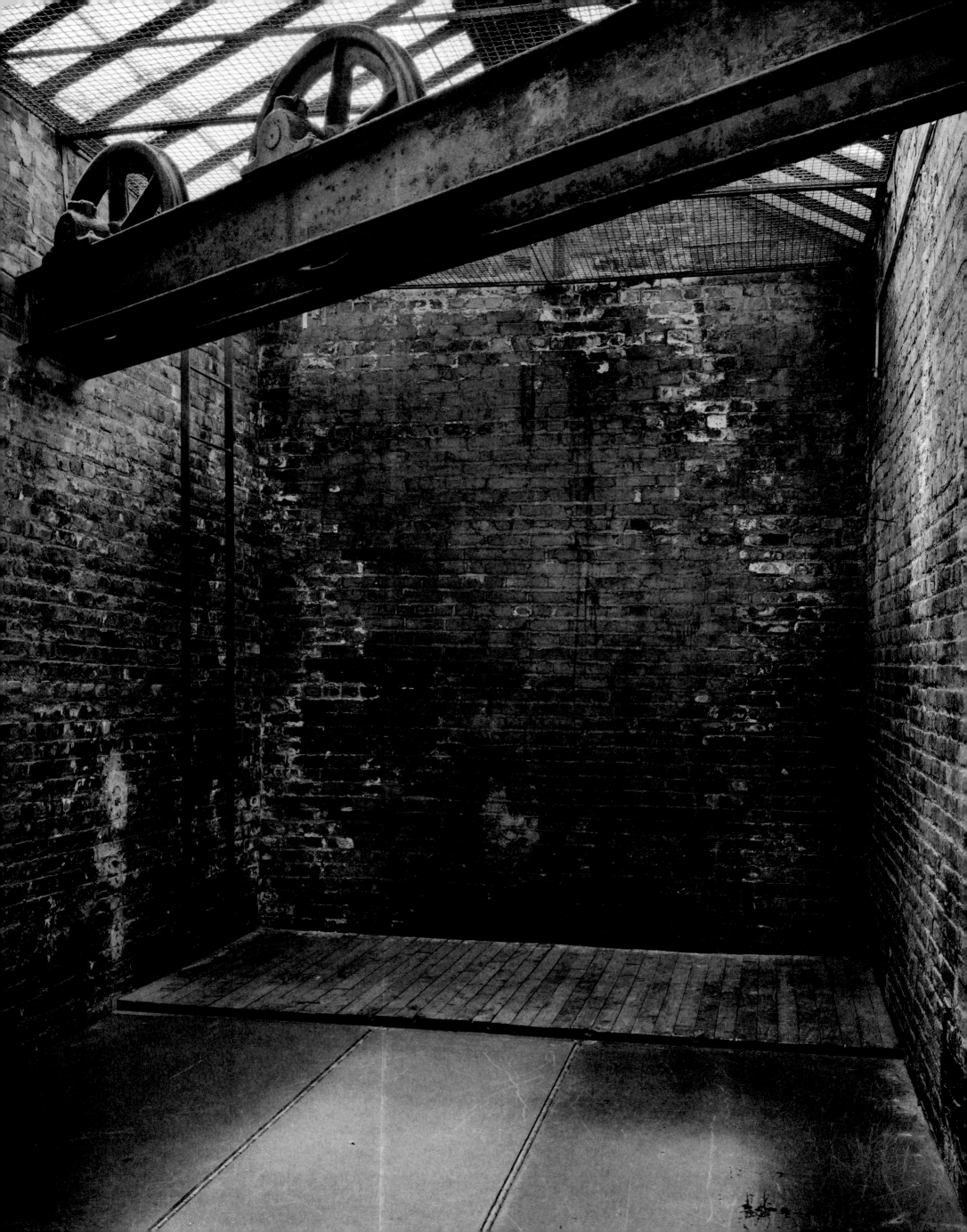

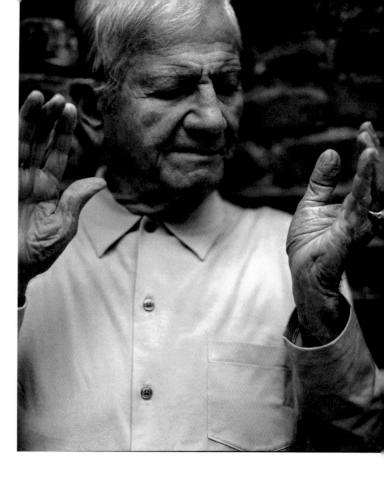

In memory of MAURICE SELIGER

ACKNOWLEDGMENTS

Fred Woodward's timeless design, invaluable guidance, and encouragement have helped to bring these walls to life.

My stairwell project producer Jennifer Hutz has worked with conviction and determination in researching and scheduling to find a range of artists that has given this book a necessary balance. My executive producer and right hand Ruth Levy helped keep the joint in check.

Jann Wenner at *Rolling Stone*, Graydon Carter at *Vanity Fair*, Jim Nelson at *GQ*, and the late Art Cooper at *GQ* assigned some of the most talented and unique artists that subsequently made an appearance inside the stairwell.

Of course, without the support of Joe Melillo, Lynn Stirrup, James Wu, Shoshana Polanco, Mary Reilly, Andrea Salvatore, and Sophia Chang at the Brooklyn Academy of Music, this book could not have happened.

In the care of printmaking, Daniel Belknap has secured the success of the platinum/palladium process and helped to give this book its visual allure. Alex Martinengo's technical expertise has also been a great attribute to this fine art process. Thanks also to everyone at our photo labs: Mark Markheim, Frank Scott at Coloredge Visual; Jim DeYonker, Ché Graham, Christian Ramirez, Jaspal Rai, and Scott Cimock at Lux Imaging; Justin King at 68 Degrees; David Wong; and Silverworks. We are grateful to Jan Letterman at Mamiya America Corporation and Schneider Lens for providing us with the necessary tools.

My photo assistants Ivory Serra, Luke Ratray, Shaune McDowell, Kirk Edwards, and Justin Tellian have helped to find the technical solutions needed to complete this journey.

Periel Aschenbrand for her amazing style and p.o.v. on the bios of the artists.

My archivist, Shelter Serra, with his meticulous organizational skills, kept this project on track.

Samantha Cassidy, Cathy Weiner, Loni Efron, Benny Aguilar, and Yoel Seliger have kept the studio moving in a forward motion so that I can continue to do what is essential as a photographer.

Thanks to Birgitte Philippides who kept everyone glowing and Risa Knight who always kept clothing options plausible, and to Vaughn Acord, Wendy Schecter, and Robert Molnar—I thank you too.

Thanks to my publisher Charles Miers at Rizzoli for seeing the potential and relevance of this collection. And to Ellen Cohen my editor and Holly Rothman for their great advice and insight into publishing.

Thank you, Martin Senn, for making the delicate translation from the original platinum prints to the tritone separations.

Sandra Klimt's great skills in production and her keen eye on the final product made this book come to fruition.

Special thanks to my family: Carol Lee, Lori, Frank, and Yoel Seliger.

Katherine Harrison, Lou Reed, Matthew Barney, Ken DeLago, Vaughn Acord, Wendy Schecter, Robert Molnar, Lee Gillespie, Sam Kusack, Karl Glave, Isaac Gabaeff, Mary Howard, Shane Klein, Jackie Schaffer, Erin Broughton, Eric Feldman, Ron Williams, Julie Wiener, Jodi Ehrens, Christo Shindov, Kitra Chana, Courtney Kotsionis, Kristi Forschen, Mark Owens, Brian Campanelli, Sandy Ko, Chloe Weiss, Chris Wert, John David Raper, Craig Edsinger, Annie Ohayon, Christina Sterner, Terri Robson, Robert Balsm, Terry and Marc Jacoby, Eric Bogosian, Danny Bennett, Ken Shepherd, Lisa Robinson, David Harris, Jodi Peckman, Pippa Cohen, Kristen Ashburn, Marla Kennedy, Robbie Feldman, Hal Goldberg, Sarah Lazin, Andres Levin and Cucu Diamantes, Peter Himmelstein, James Lansill, Neale Albert, Laurie Cohen, Joey Peters, Linda Keil, Kim Meehan, Josh Liberson, Brooke Williams, Amanda Silverman, Robert Garlock, Chris Stern, Pam Hughes, Mark Rothbaum, Mickey Raphael, Renzo Russo, Maurizio Marchiori, Leigh Blake, Ed Keating, Jeff Seroy, Jane Sarkin, Gabby Meriles, Barbara Carr, Donald Farber, Najma Beard, Colleen Atwood, Beethoven Pianos, Helen Uffner Vintage Clothing, Arriane Philips, April Barton, Fred Van de Bunt, Lesley McCloud at Art Department, Michael Angelo, Tina Keyes, Jacqueline Lane, Jessica Brown, Tom Henrikson, Canon Business Solutions, James at Vernon Jolly, Gabe Bartalos, David Wild, Walter Bobadilla at Angouti Construction Consulting, LLC; John, Ellen, Jared and Charlotte Madere, Tom, Jodi, and Maggie Connors, Michel Belknap, and Eve Binder.

The proceeds from the sale of this book will support the Brooklyn Academy of Music.

RIZZOLI EDITOR: Ellen Cohen
DESIGN: Fred Woodward & Ken DeLago
DESIGN ASSOCIATE: Chloe Weiss
AUTHOR OF BIOGRAPHIES: Periel Aschenbrand
BIOGRAPHIES RESEARCH: Katherine Harrison
PROJECT COORDINATOR: Jennifer Hutz
PRODUCTION SUPERVISION: Sandra M. Klimt
TRITONE SEPARATIONS: Martin Senn
PLATINUM PALLADIUM PRINTER: Daniel Belknap
PRINTING & BINDING: Elegance, Hong Kong

First published in the United
States of America in 2005
by Rizzoli International
Publications, Inc.
300 Park Avenue South
New York, NY 10010
www.rizzoliusa.com

2005 2006 2007 2008 2009 /
10 9 8 7 6 5 4 3 2 1

Printed in China

ISBN: 0-8478-2760-7

Library of Congress Control
Number: 2005926162